Living Faith

INSIDE THE MUSLIM WORLD
OF SOUTHEAST ASIA

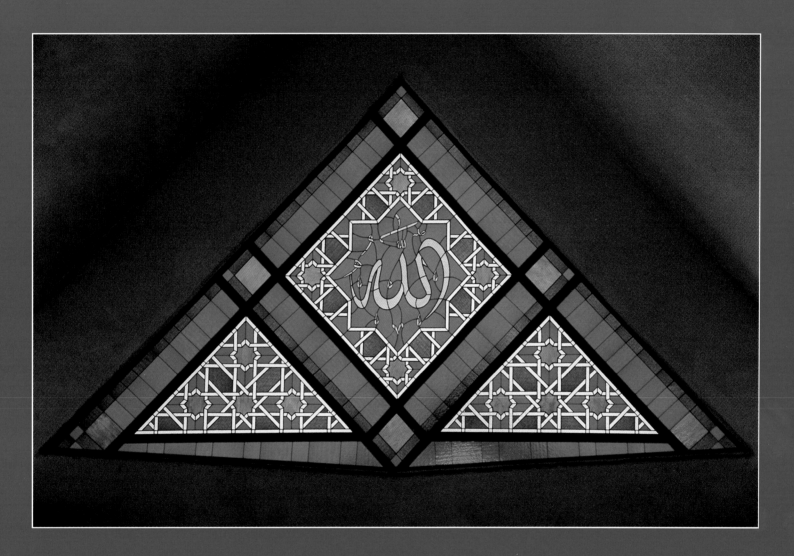

Steve Raymer

FOREWORD BY TAN SRI RAZALI ISMAIL,
SPECIAL ENVOY TO THE SECRETARY GENERAL OF THE UNITED NATIONS

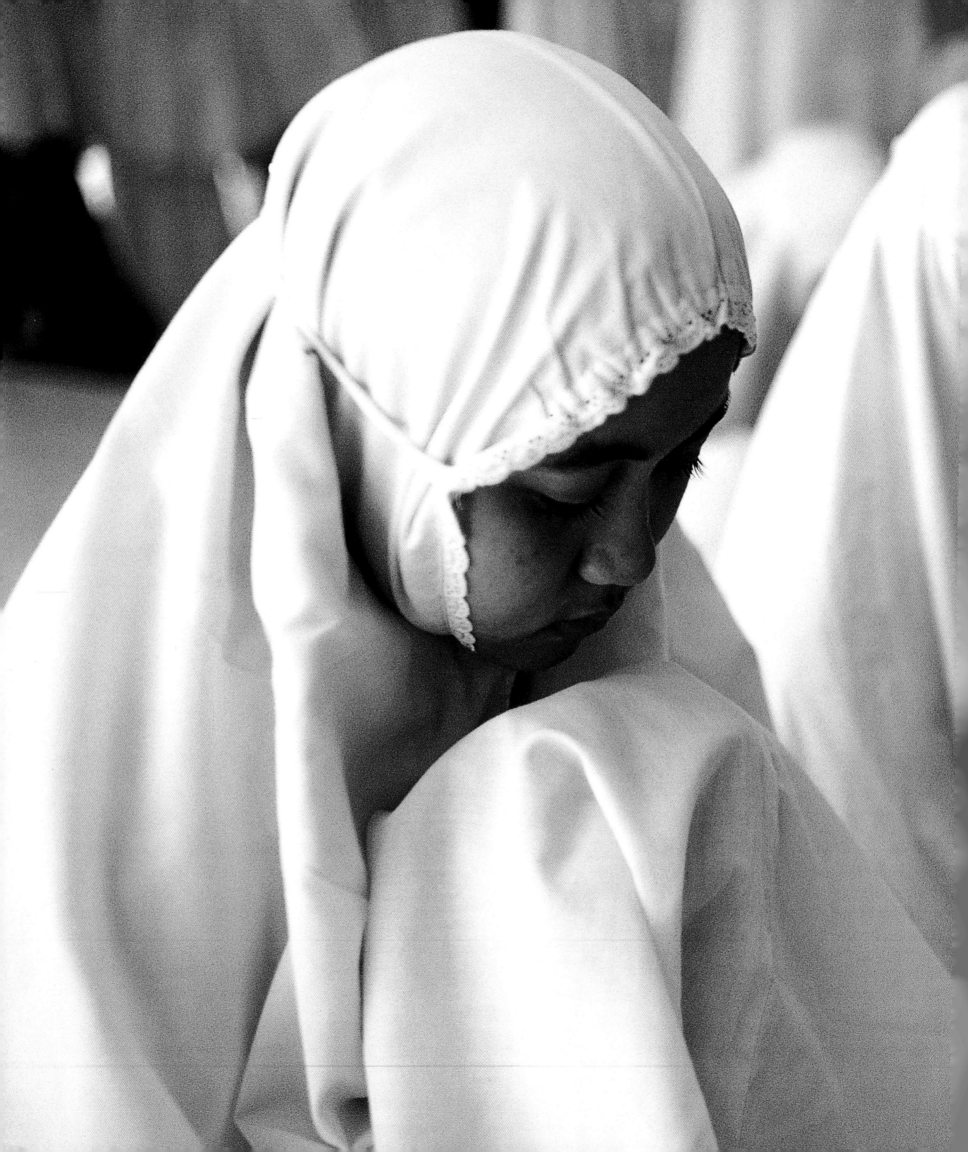

Living
Faith

INSIDE THE MUSLIM WORLD
OF SOUTHEAST ASIA

STEVE RAYMER

ASIA IMAGES EDITIONS

PAGE 1

The word *Allah,* or "the one who is God," is inscribed in Arabic calligraphy in windows of the *Masjid Negara,* or National Mosque, in Kuala Lumpur, Malaysia.

PAGES 2–3

Knowledgeable in the ways of the world but not corrupted by it, students recite verses from the Koran at Asshiddiqiyah Islamic College outside Jakarta, Indonesia.

Living Faith
Inside The Muslim World Of Southeast Asia

Text and Photographs by
Steve Raymer

Produced by
Charles O. Hyman
Visual Communications, Inc.
Washington, DC

Designed by
Kevin Osborn
Research and Design, Ltd.
Arlington, Virginia

asiaimages

Published by
Asia Images Editions
An Imprint of Asia Images Group Pte Ltd
15 Shaw Rd. #08-02
Teo Building
Singapore 367953
www.asia-images.com

ISBN: 981-04-4207-6

PRINTED IN SINGAPORE

Contents

INTRODUCTION
A JOURNEY OF DISCOVERY FOR ONE AMERICAN JOURNALIST

I have traveled the world for three decades, first as a *National Geographic* photographer and more recently as a university professor and freelance photojournalist. Through the camera lens, I have seen Muslims prostrate in prayer in every country of the Arabian Gulf, in Africa, Iran, and distant Uzbekistan. But until I began this journey, I knew more about Muslims with fists clenched in rage than I did about Islam — the religion. Unfortunately, this is often the case in journalism. We live in a world that thirsts for symbolic images — images that move at the speed of light over the Internet to feed an insatiable 24-hour news cycle.

My superficial acquaintance with Islam might have remained unaltered were it not for a 1998 trip to Southeast Asia, a region that has held my heart captive since I went to report on its wars and discovered its ravishing beauty so many years ago. Setting off for Indonesia, I was rerouted to the Malaysian capital of Kuala Lumpur because Jakarta was convulsed by revolution and its airport closed. It was a fateful change of plans. In Malaysia — and later in Indonesia — I discovered a renewed commitment to an Islamic way of life worthy of a book. Yet where to begin?

More than a billion people call themselves Muslims, believers in an all-encompassing God whose teachings were handed down in the seventh century to the Prophet Muhammad in the Arabian Desert. Over the centuries, Islam — a creed of unshakable beliefs and a code of conduct that regulates every facet of a Muslim's daily life — has spread far beyond Arabia to Southeast Asia, China, India, Africa, the former Soviet Union, and the United States, where some five million Americans embrace Islam. At its core, to be a Muslim is to submit to God.

Contrary to popular belief in the West, most Muslims are not Arabs, nor are they wealthy. By any measure, Indonesia, a country of immense wealth and heartbreaking poverty, is the world's largest Muslim nation, followed by two Asian neighbors — Pakistan and Bangladesh. The weight of Indonesia's numbers — some 198 million believers — makes Islam one of the dominant faiths of Southeast Asia, a region already rich in Hindu, Buddhist, Confucian, and Christian creeds.

Yet to the Western eye, Islam and its believers are often seen as extremists intent on overturning governments, revolutionizing societies, and mistreating women and nonbelieving "infidels," sometimes at the point of a gun. Violence and Islam have become almost synonymous in much of the Western media and public opinion, an exaggeration that slanders millions of African, Arab, and Asian Muslims. Yet most Muslims live their faith far removed from the flashpoints and headlines, dedicated to prayer, charity, piety, and pilgrimage.

Arab and Indian traders brought Islam to the coastal trading ports of the Malay Peninsula, Sumatra, and Java between the 11th and 15th centuries, gradually assimilating Hinduism, which then dominated the region, as well as local animist sects with strong supernatural overtones. Over the centuries Southeast Asian Muslims became known for their tolerance of religious beliefs, including those of their European colonial masters and imported laborers from India and China. As recently as

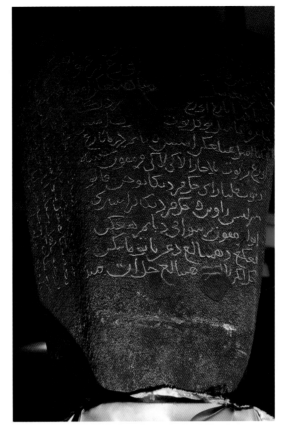

The Terengganu Stone, so named for the Malaysian city near where it was discovered, provides the earliest evidence of Islam in Malaysia — A. D. 1303. The granite monolith is inscribed with Islamic law in a mixture of Sanskrit, Malay, and Arabic.

the 1970s, Muslims in Malaysia and Indonesia were considered complacent in faith and anything but dogmatic in practice. But no more. An Islamic zeal — some Muslims call it a reawakening — has caught fire in Southeast Asia, a region where religious fault lines already run deep.

For a half-century or more, brushfire wars for independence or autonomy have simmered in Muslim dominated areas of the Philippines, the southern provinces of Thailand, and oil-and-gas-rich Aceh on the island of Sumatra. But the intensified fighting of recent years — and thousands of additional deaths — has put these Islamic revolts on the front pages of the world's newspapers and on television broadcasts. Meanwhile, Southeast Asian countries with Muslim majorities have their own problems with religious radicals and reformers.

In Malaysia, where ethnic harmony has been an article of faith since independence in 1957, increasing numbers of Muslims want a more orthodox Islamic code to govern everything from supermarket checkout lines — separating men and women — to alcohol sales. In one conservative region, women have been banned from Koran reading competitions, a popular Malay pastime, on the theory that a female voice is too seductive to read the Islamic holy book aloud. Increasingly, being a devout Muslim now defines self and state in Malaysia, where 40 percent of the people are non-Muslims of Chinese and Indian origin.

More ominously, Indonesia's slow social dissolution

has given license to gangs of Muslim vigilantes who have rampaged through the cities of densely populated Java and inflamed Christian-Muslim tensions in the Maluku or Spice Islands in eastern Indonesia. Today Indonesia finds itself being redefined by a growing Islamic identity that threatens to erode the country's well-known religious tolerance, which was written into the 1949 constitution to protect Christian, Buddhist, Hindu, and other minorities. There has been an explosion in the number of Islamic schools, businesses, civic groups, and media outlets. New Islamic political parties now make up a powerful block in the Indonesian parliament. And neighborhood Islamic banks are lending money to poor families still recovering from the Asian financial crisis of the late 1990s that drove millions deeper into poverty. Indeed, about 75 percent of Indonesia's Muslims now want Islam to play "a very large role" in society and government policy, according to a study commissioned by the United States government.

Yet no one group or big idea has captured the imagination or the allegiance of all Southeast Asian Muslims. The only thing that unites Muslim revivalists is their use of the green flag of Islam as an all-purpose banner to rally support for their many causes. The poor and those with little or no stake in the system want their own Islamic states. Fundamentalists seek an end to government corruption and social decadence, which

they define as everything from Western television and popular music to alcohol and sex outside of marriage. But the young toughs who have incited a religious war in the Malukus and bombed churches in Jakarta have nothing in common with the peaceful Muslim reformers in Malaysia, who have used the ballot box and the media to advance their ideas. Thailand's tiny band of diehard secessionists are cut from a different cloth than, say, the well-heeled conservatives of oil-rich Brunei or the self-assured, computer-savvy Muslim professionals of Singapore. The tattered militias of Java, West Kalimantan, and Sumatra stand in bold contrast to the gentle Cham of Cambodia and Vietnam — Muslims who were persecuted by Pol Pot or forced into agricultural collectives by commissars from Hanoi at the end of the Indochina War.

Going behind the headlines to tell complex stories is the photo essayist's challenge — and never has it been more difficult than in the Muslim World of Southeast Asia with all of its fault lines and fractures. To learn how the Islamic revival has affected ordinary Muslims, I have traveled the length of the Malay Peninsula, including to southern Thailand. I also have crisscrossed the Indonesian Archipelago, and journeyed to Cambodia, Singapore, and Brunei to look at the impact of the Muslim resurgence on mosques, schools, villages, cities, and families. My goal: To put a human face on Islam. Based on nine trips to the region, I have sought to show how an essentially imported religious creed has transformed the culture and institutions of modern Southeast Asia, sometimes buttressing them again the advance of global capitalism and Western popular culture, at other times accommodating notions of democracy and universal human rights.

The story, however, is unfinished. Dreams of Islamic purity show no signs of diminishing — just the opposite. Undiminished, too, are the global markets and entrepreneurs who are transforming immense swaths of Southeast Asian rain forest and jungle into some of the most densely packed cities on Earth, complete with discos, megamalls, and Western TV beamed from a

constellation of satellites orbiting overhead. The subsequent clash of values and ideas will undoubtedly foster continued tension and uncertainty throughout the region.

Some might call my pursuit of this story an impossible task for a non-Muslim. But journalists are by nature and temperament professional "outsiders." We are used to thrusting ourselves into unfamiliar places where we might be suspect or even unwelcome. Indeed, we are supposed to be expert at getting inside peoples' lives. Colleagues in academia sometimes call us "parachutists" for the way we land, seemingly from another galaxy in deep space, in the middle of alien cultures and languages, usually for a shorter period of time than we would like. In telling this story, I have tried to live up to the best traditions of journalism — impartiality, judiciousness, fairness, and balance. There are no axes to grind in these pages, no heroes or villains, only people getting on with their lives regardless of wealth and social position — or lack of it. In the interests of clarity and readability, I have used spellings and transliterations from Arabic that are standard in global journalism.

If this undertaking has been successful, it is because of the many friends, colleagues, and acquaintances who have opened their homes, their offices, and their hearts to help me better understand the Muslim world of Southeast Asia. It is a long list.

In Asia, I wish to thank Ami Azril Abdullah, Datin Dr. Jamaliah Muhammad Ali, Anandan Adnan Abdullah, Dr. Syed Muhammad Naquib Al-Attas, Tan Sri Dato Haji Ani bin Arope, Charles Barclay, Dato Dr. Osman Bakar, Beth Brown, James and Debbie Ellickson-Brown, Richard Borsuk, Margot and William Carrington, Dr. Chan Kwai Weng, Nancy Chng, Wing Foong Chew, Thomas Eapen, Dr. Balwant Singh Gendeh, Dato Dr. Ismail bin Ikbrahim, Waedureh Imron, Sidin Ishak, Abdullah and Zainab Ahmad Shiyuti Juhaidii, Abtar Kaur, Jeffery Wong Mun Kit, Kala Kovan, Zakiah Koya, Jamin Lai, C. Y. Leow, Celin Leung, Dr. Abu Bakar bin Abdul Majeed, Fareea Ma, Nasreen Rosey Ma, Ranjit Singh Malhi, the Islamic Arts Museum Malaysia, Yvonne Menon , Teuku Mufizar Maumud Mufi, Seth Mydans, Anandan Narayanan,

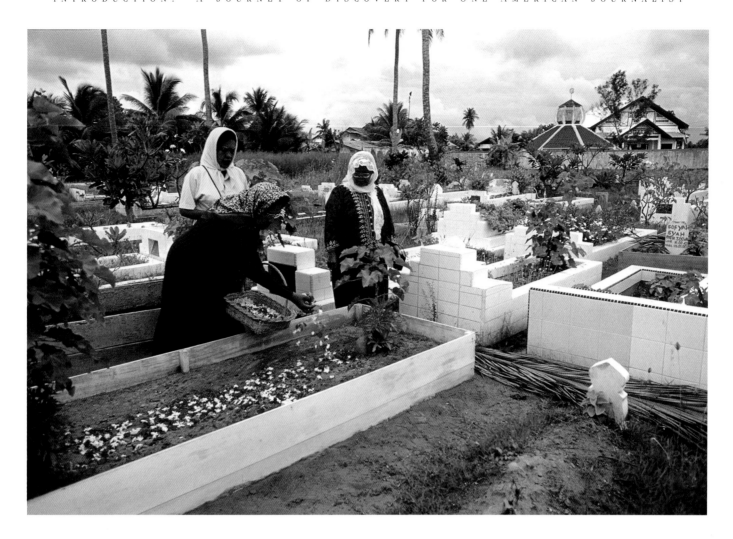

Mark Pinkstone, Bakhtiar Rahman, Muhammad Abdul Rahman, Victor Santhanam, Kamatchy Sappani, Sarjit, Parsudi Suparlan, Shyam Tekwani, S.N. Thayaparan, the Terengganu Museum Malaysia, Vincent Thian, Allen and Irene van der Beek, and Maya Vidon.

From the United States and Europe, more friends, colleagues, former students, and "old Asia hands" helped make this book possible. I wish to thank Joe Breen, Trevor Brown, Kevin Davis, Marco DiPaul, Deborah and Jeremy Dunning, Michel duCille, Mary Lou Foy, Wendy Gaylord, Elizabeth Grady, Bryan Hodgson, Kent Kobersteen, Lynn Kryvoruka, Maria Mann, John McDermott, John G. Morris, Roland Neveu, Roxana Newman, Patrick O'Meara, Linda Meyerriecks, Faridah Pawan, Frank Proschan, Charles Reafsnyder, Beth Richardson, Leah Painter-Roberts, Kevin Stuart, Bryan van der Beek, Jensen Walker, Jim Warren, and Jayne Wise.

Mourning the dead of Aceh, where a civil war for a separate Muslim state has claimed hundreds of lives, a mother and daughters sprinkle flowers on the grave of a loved one.

A special word of thanks goes to my publisher Alex Mares-Manton, director of Asia Images Group in Singapore, and his able assistants Linda Tan and Leta Duong. Without Alex's excitement and commitment to this costly project, there would be no book. Once again, I am also indebted to Charles O. Hyman, who has been my picture editor and mentor on this book and others about Russia and Vietnam, and to Paul Martin, my able text editor and friend. Finally, I owe the greatest debt to my wife, Barbara Skinner, whose patience, humor, and love helped sustain this project along with many others.

— Steve Raymer, Bloomington, Indiana, 2001

FOREWORD

TAN SRI RAZALI ISMAIL

SPECIAL ENVOY TO THE SECRETARY GENERAL OF THE UNITED NATIONS

This book is a commendable effort to look at the many facets of Islam in Southeast Asia, a huge part of the world's most populous continent. Muslims share this diverse world with two major religions –– Hinduism and Buddhism -- both of which took root well before the spread of Islam from the Middle East. Today, although every Muslim still faces Mecca while observing daily calls to prayer, the Islam of Southeast Asia is no longer simply an ancillary part of Arabic Islam. Contact with other religions and cultures, joined with the enormous forces of economics and ethnic politics, have profoundly influenced Muslims in the region's several nations.

Globalization has brought up many defining moments. Buffeted by the sweep of Western-style modernization, the Faithful must balance tradition with modern necessities to effect the right spiritual response to the changing patterns of their lives.

Outside commentaries largely tend to see or predict only the worst: Muslims in varying states of contradiction, resorting sometimes to extremism to overcome neglect and marginalization, or retreating to inwardness and intolerance in the name of the purity of religion. This is the face of Islam that is often and widely projected by powerful media.

Professor Raymer has done well to recognize these negative aspects while declining to sensationalize them. Instead, he emphasizes the Islamic doctrine of tolerance that nourishes the lives and spiritual well-being of countless millions in the region. Indeed, this book does provide a balanced cross-section of Islam and the lives of Muslim people in the region, written in a thoughtful manner and illustrated with magnificent photographs that reveal the color and excitement and deep faith of their world.

Millions of Muslims, predominantly of the Malay race, thrive both as family units and as communities, interacting with other religions and other races. For the majority, even if identification is felt to be necessary by way of headgear and dress, they are aware that their historical accommodation to existing in the multi-ethnic, multi-religious matrix of Southeast Asia must endure, at least in countries like Malaysia.

It is not applicable here to talk of distancing the secular from the religious, since Islam makes no such distinction. This in no way means that the 'mullahs' will in the end seek to be in charge of society, even though their firm influence on the age-old cycle of people's lives in ceremony and ritual will continue.

Today a battle is being waged between political parties that seek to harness religion to the ballot box and those believers who hesitate to take that road but nevertheless need to reconcile the promises of modernization and science with bedrock religion. It is doubtful that any side will succeed fully. In the future, there will unavoidably be degrees of tension and uncertainty affecting the political landscape.

Whatever will be in store for the future, throngs of Muslim men—and, increasingly, Muslim women—will take fateful decisions to improve their lot and secure better places in society. The sciences, money and free market, and the seemingly limitless possibilities of information technology have transported them from an agrarian society to one striving for success and advancement. There has been a great surge of knowledge gained in multiracial institutions. These Muslims are competitive, ambitious and all too often overly attracted to ostentatious materialism, but contend that their advancements have not been at the expense of religion and mosque.

Strong cases are being made that a Muslim who interacts with all before him, showing a bias for the sciences, jazz, and karaoke, etc., can nevertheless maintain faith in Islam. There will be no retreat or denial of the attributes of democratic structures and the benefit of an increasingly interconnected world for the Muslims who are preparing for the changes ahead. The women, who have in many cases left the sedate life of the villages to join the frenetic pace of the cities, increasingly demand to be heard, to be counted for in what is seen as basically a masculine structure. The region is seeing more and more Muslim women, though not enough, who demand to be freed from being marginalized in public life.

I hope this book, suitably titled *Living Faith*, will contribute to a better understanding of Islam and Muslims in the region by portraying the rich tapestry of their lives, their hopes, and their deep spirituality.

Muslim women in scarves and prayer robes (right) ascend the steps of Malaysia's National Islamic Center.

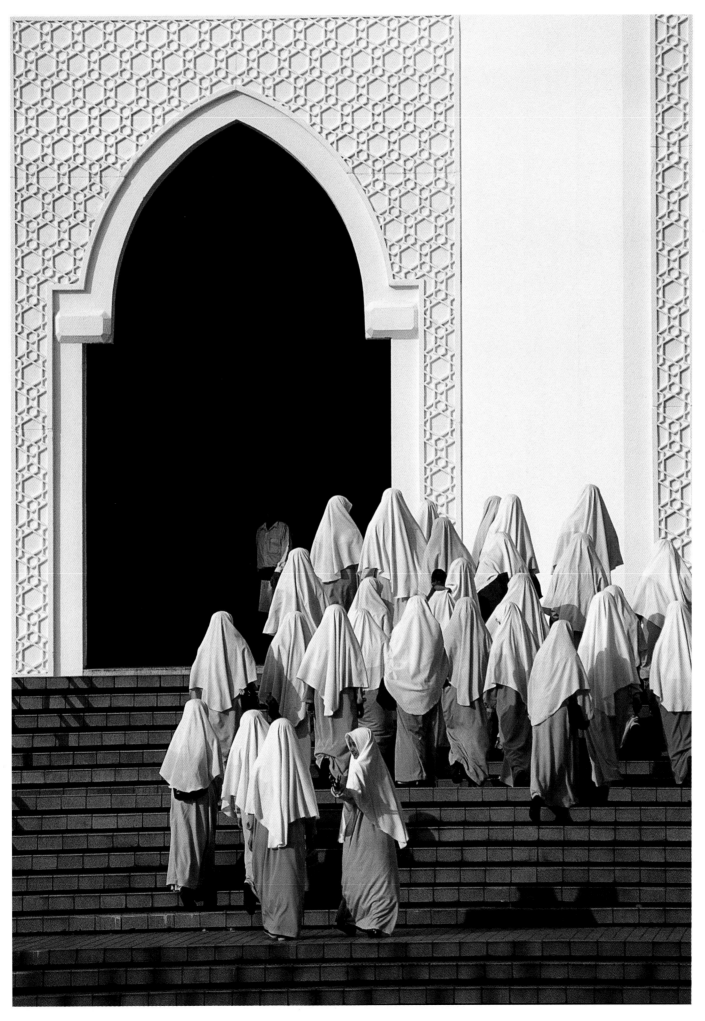

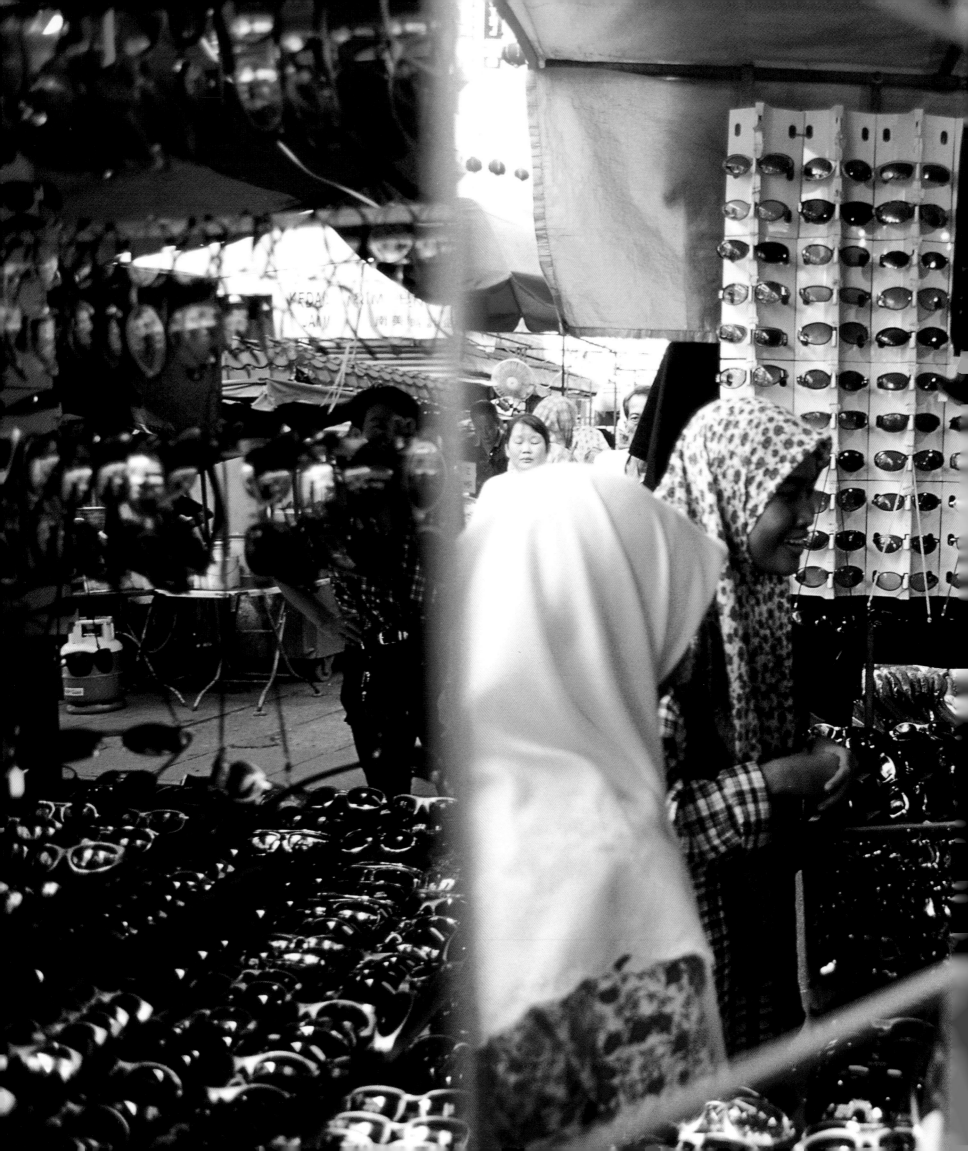

Islamic head scarves signify Muslim women in a Kuala Lumpur market. Young women have embraced the scarf, called a *tudung* in Malay, both as a sign of piety and as a symbol of pride in being a Muslim in a multicultural society like Malaysia. Once, few Malay women covered themselves in public, but the practice has become increasingly popular since the Iranian revolution — an event that influenced Muslims worldwide — and with the increasing numbers of Malaysian students studying at universities in the Middle East.

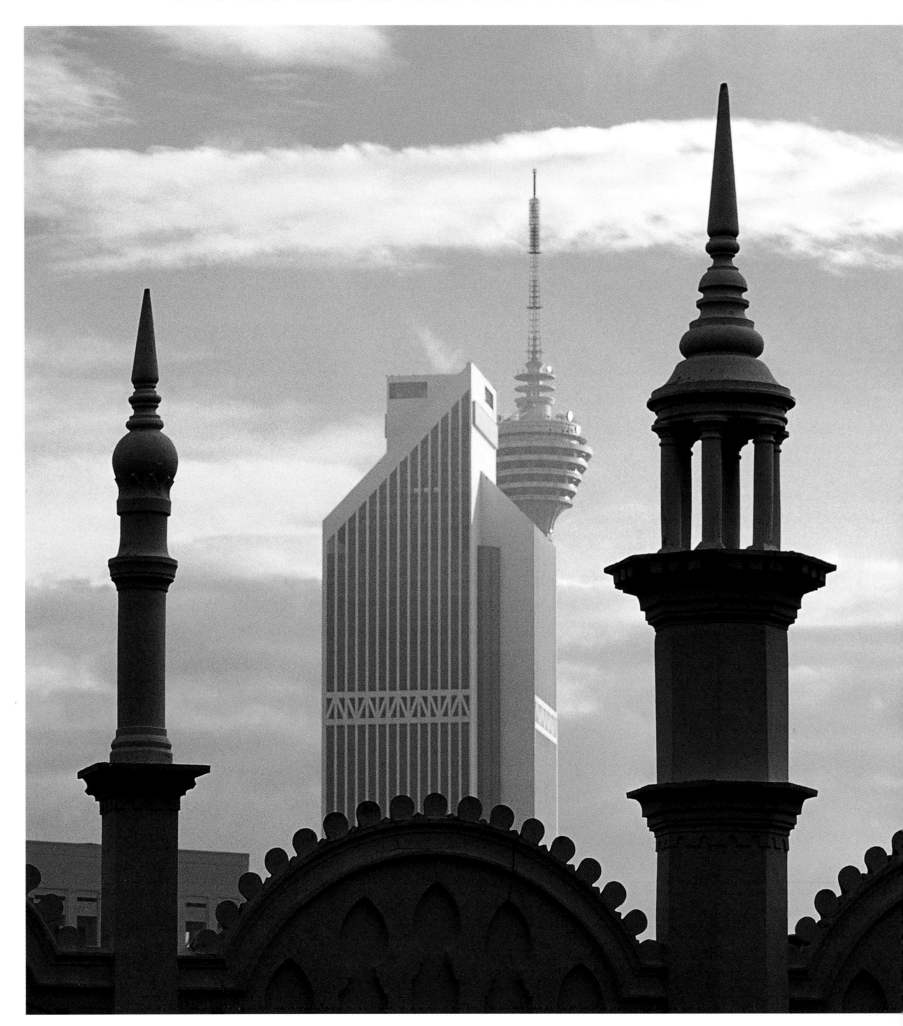

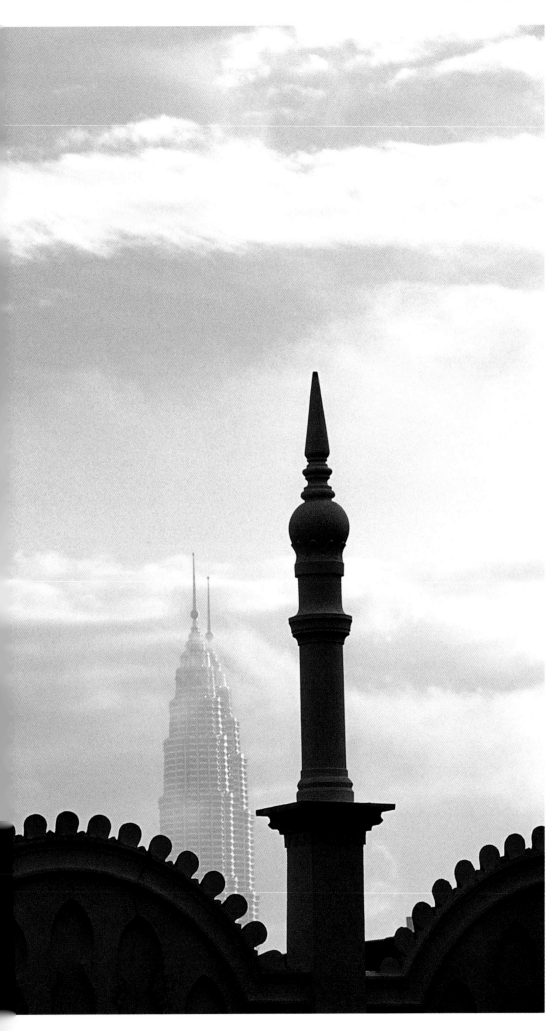

Typical of the British Raj architectural style, spires of the Kuala Lumpur Railway Station — foreground — frame the soaring skyscrapers of a modern Islamic state in Kuala Lumpur, capital of Malaysia. British colonial architects favored the domes, arches, and airy interiors typical of Muslim India and the Middle East. But today's sleek office towers of glass, steel, and concrete put a premium on function over form — a trend that has transformed the skylines of Asian cities.

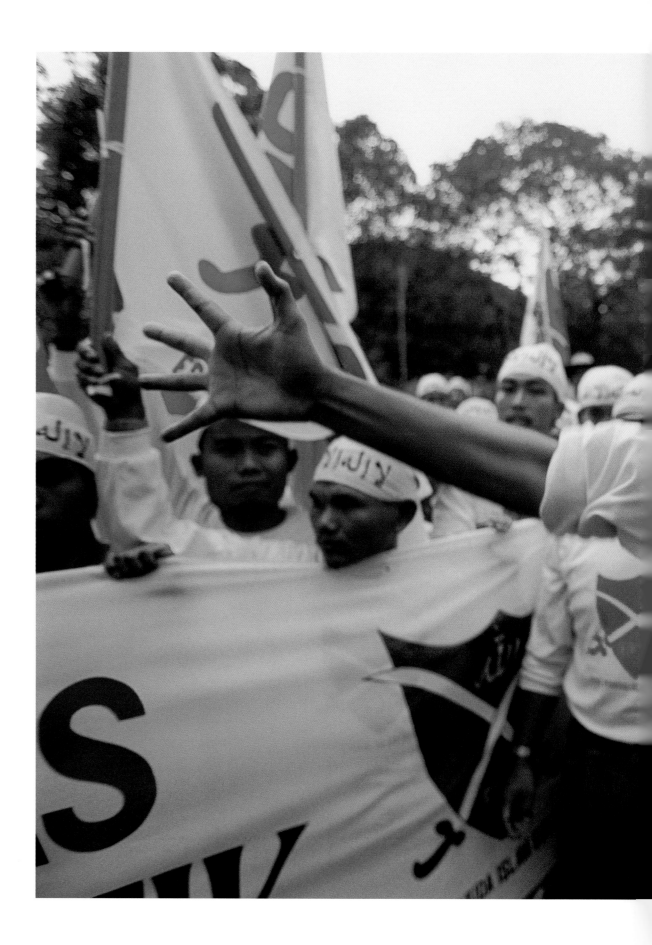

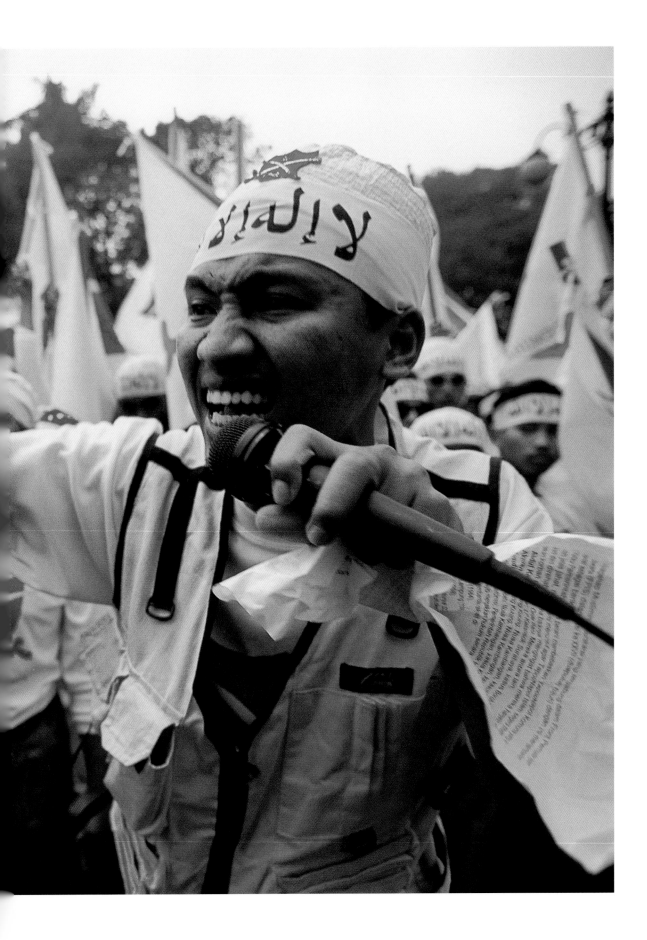

Religion and politics meet on the streets of Jakarta, the convulsed Indonesian capital, where Muslim demonstrators demand *jihad*, or holy war, against government corruption. Rival groups with radically different visions of Islam — and of Indonesia's future — have shaken the most populous island of Java, reflecting a combustible split between rural Muslims known for their religious tolerance and a conservative urban elite.

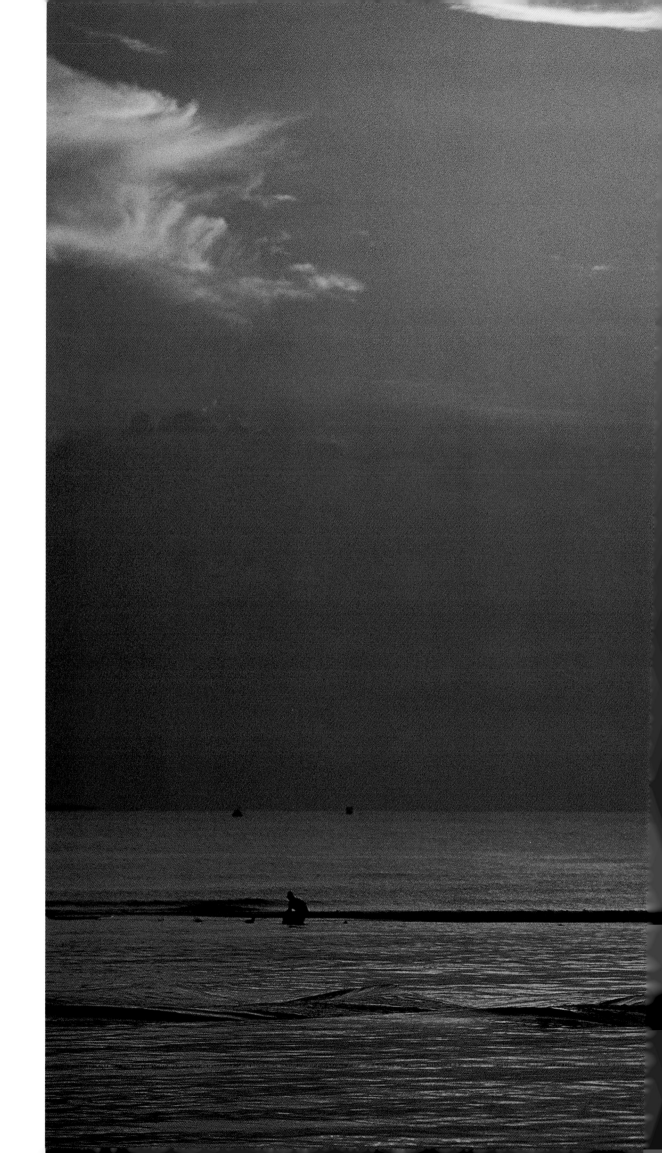

Dawn breaks behind fishermen on the South China Sea off Malaysia's east coast. Teaming with prawns and squid, the sea nourishes tradition-rich Muslim villages, which at first glance seem impervious to the unrelenting demands of global markets. Yet fishermen worry about rising costs of equipment — and whether their children will follow them to sea or seek better jobs and educations in Asia's crowded cities.

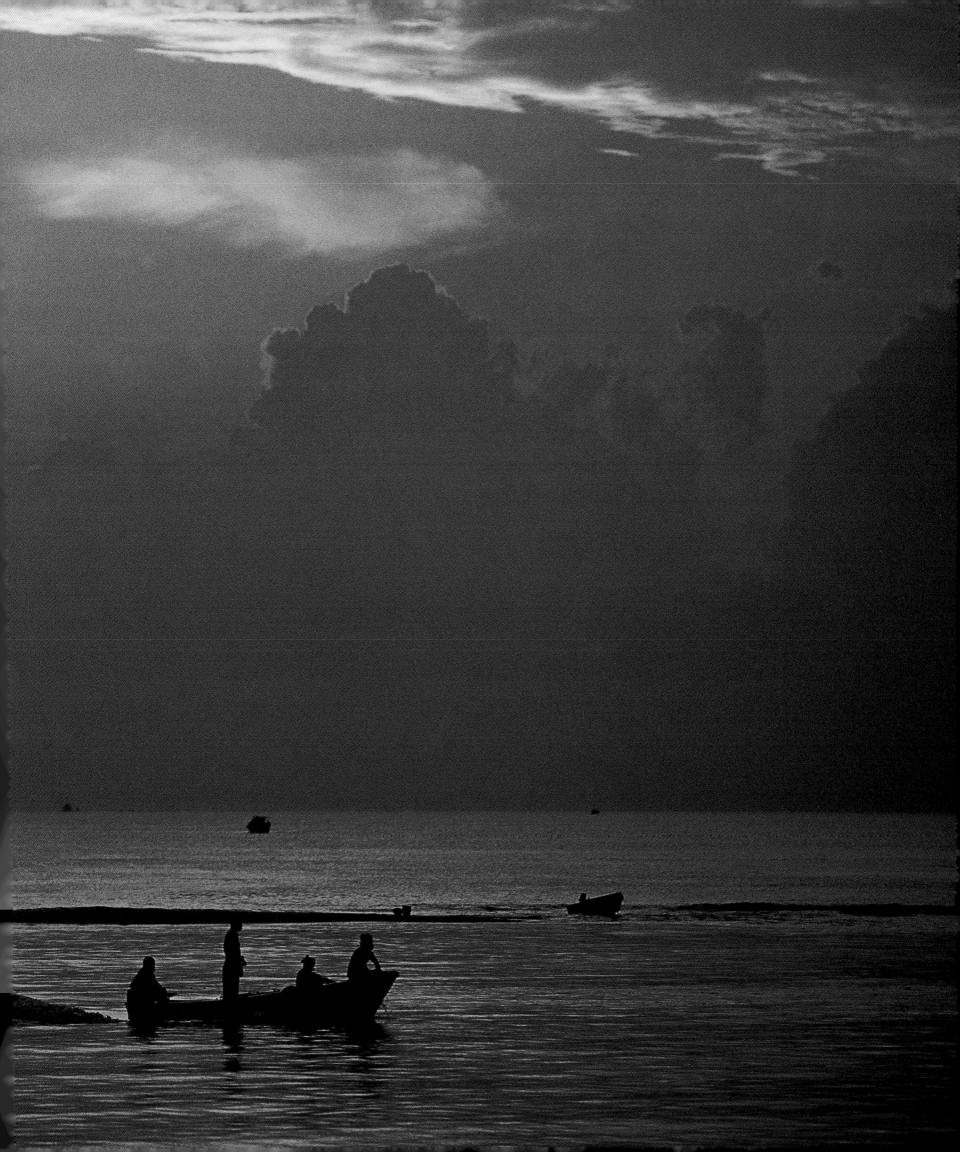

THE MOSQUE:
FOCAL POINT OF ISLAMIC LIFE

The faithful, and that includes almost everyone in Indonesia's beleaguered Aceh Province, find solace in the *muezzin's* mournful call to prayer. Chanted in Arabic, it proclaims, "God is great, God is great…Come to prayer, come to prayer…Come to salvation, come to salvation.…"

This evening, the *muezzin's* tape-recorded summons is played through the shrill loudspeakers of the Baiturrahman Great Mosque, reverberating through the dusty streets of the provincial capital of Banda Aceh. One of several Indonesian regions defiantly seeking independence, resource-rich Aceh occupies the northern tip of Sumatra island some 1,750km (1,100 miles) northeast of Jakarta.

Young couples and families savor the last magenta hues of a sunset over the distant Indian Ocean, then silently shuffle toward the mosque. Worshippers wash hands, face, and feet — a ritual of ablution that signifies purity of body as well as soul — and take their places in long rows inside the mosque, which was built more than a century ago by the Dutch who sought to pacify this once powerful Islamic sultanate. Women in hooded prayer shawls of white cotton settle into a discreetly partitioned alcove that is segregated from male worshippers, as is the custom throughout the Islamic world. But because all men and women are thought to be equal in the eyes of God, or *Allah*, there are no reserved places for the rich or powerful. The scruffy sandals, athletic shoes, and polished slip-ons shed before entering the mosque testify to its powerful function as a social and economic leveler.

This evening's prayers follow long-established formulas of praise and obedience to God. But it is the opening line of the *muezzin's* call to prayer — "*Allahu Akbar* — God is great" — that resonates most profoundly through Aceh and throughout the Islamic world — a world that extends from Indonesia and the rest of Southeast Asia to China, India, Africa, the Middle East, Europe, parts of the former Soviet Union, and the United States. While the term "Islam" is an Arabic word, it embraces a universal concept accepted by 1.2 billion Muslims worldwide: Submit to the will of God and you will find peace and security. Muslims everywhere, in fact, find unity in the idea of one God — worshipped without images or symbols — and in the Prophet Muhammad's messages of piety and racial and social equality. These powerful ideas govern nearly every facet of life in the Muslim world, Southeast Asia included. It is a reason to believe and often a consolation for the downtrodden, whose swollen numbers in places like Indonesia shatter the Western stereotype that most Muslims are rich and of Middle Eastern or Arab ancestry.

Of all the Muslim institutions, the mosque is the most important place for the public expression of Islamic belief and community identity. And it is where Muslims make their presence known in the multiethnic world of Southeast Asia. Historically, the mosque has been the center of social and intellectual life for Muslims, and it seems no less so in the age of megacities and the Internet. The most commonly used word for mosque is the Arabic *masjid*, which literally means a "place of prostration before God." Mosques are mentioned in the Koran, and according to historians, the earliest model

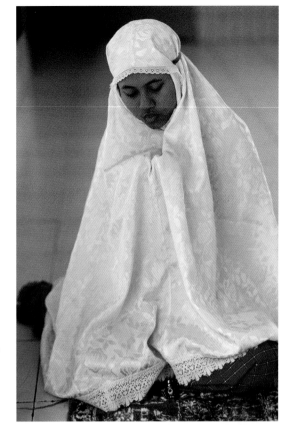

for a mosque was the home of the Prophet Muhammad.

Across Southeast Asia, thousands of mosques — many new and wildly expensive — pierce the tropical skyline. Their minarets, which summon the faithful to prayer, remain an enduring symbol of Islam during a time of rapid social and economic change that has brought riches to some and hope to many millions more. At its core, the mosque is a place where Muslims gather to pray, to learn, to contemplate, and to socialize away from the din of surrounding bazaars and with a dignity that is not always theirs in the world outside. The mosque is not a church or sanctuary; God is no more present here than He is anywhere else. Indeed, the only thing all mosques have in common is the *mihrab*, a niche or indentation in the wall indicating the direction to Mecca, Islam's most holy city to which all believers face when they pray.

Over the centuries, the design of Southeast Asian mosques has evolved from simple timber structures built on stilts, as are most village houses, into breathtaking structures with domes of marble and gold that symbolize the beauty of the heavens. Today some of the region's most splendid mosques show the influence of 20th-century modernists who advocated form following function. For example, the open-air *Masjid Negara*, or National Mosque, in Kuala Lumpur was considered a radical departure from the popular Indian Mogul and Middle Eastern designs when it was built in 1965. The mosque's blue umbrella roof covers two floors with separate and distinct functions: A vast main hall devoted exclusively to prayer and rituals and a lower floor for administrative offices, a clinic, and classrooms.

Indeed, there is no one architectural style for Southeast Asian mosques. With the arrival of Muslim merchants and missionaries between the 11th and 15th centuries came mosques of Indian, Arab, and Chinese designs. The devout praised God in places like the Agung Mosque, built in the 15th century by a Chinese shipwright on the northern coast of Java with pyramid roofs like those of a Buddhist pagoda, and in fanciful royal mosques built by the British for Malay sultans along the lines of grand mosques of the Indian Raj. People of all faiths today marvel at the grand Sultan Salahuddin Abdul Aziz Shah Mosque outside Kuala Lumpur, where worshippers can stand beneath the largest dome of any religious structure in the world.

But it would be a mistake to think that mosques of grand design or noble ancestry make God more accessible. Most Southeast Asian Muslims pray in unassuming neighborhood mosques and small prayer rooms called *suraus* inside factories, offices, schools, airports, rail stations, and freeway gas stations. For most Muslims, the size or cost of a mosque matters little. It is what takes place inside that is of consequence. Indeed, the *muezzin's* long plaintive chant is forever timeless and universal in what it asks and what it promises.

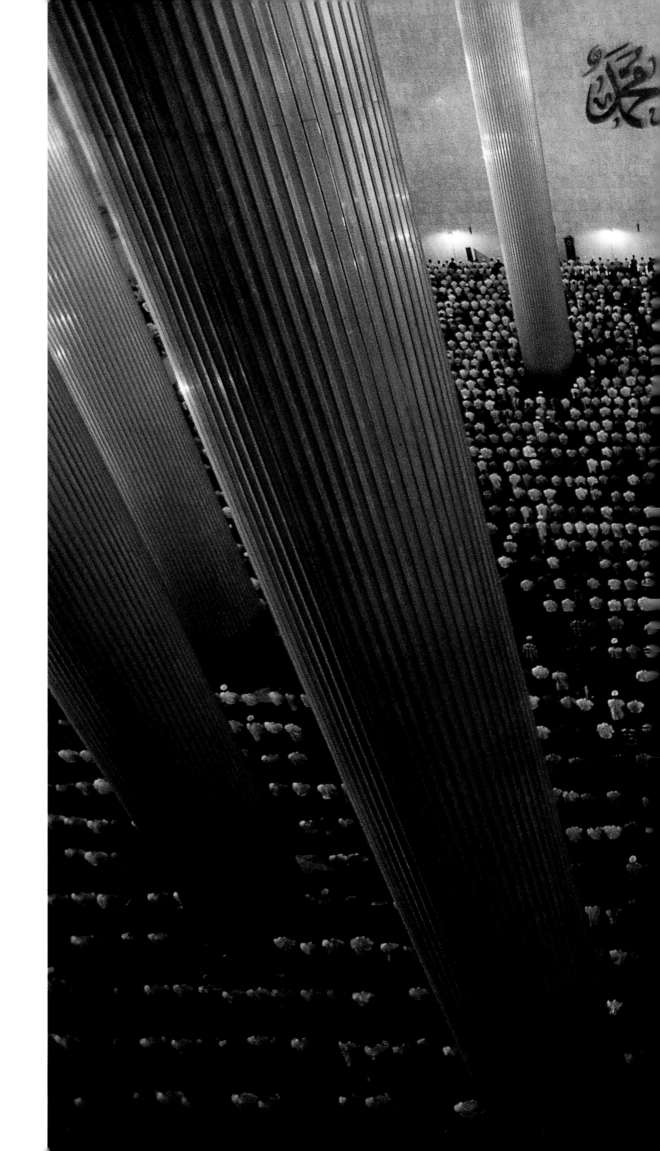

Prostrate before God, some 20,000 worshippers fill Jakarta's Istiqlal Mosque — the national mosque of Indonesia — for Friday prayers. When the mosque opened in 1978 after 17 years of construction, Indonesians of all religions took pride in the colossal achievement — one of the country's first big post-independence building projects. The Istiqlal Mosque is sometimes compared to other mammoth places of worship on the island of Java — the Buddhist pyramid of Borobudur and the Hindu temples of Prambanan.

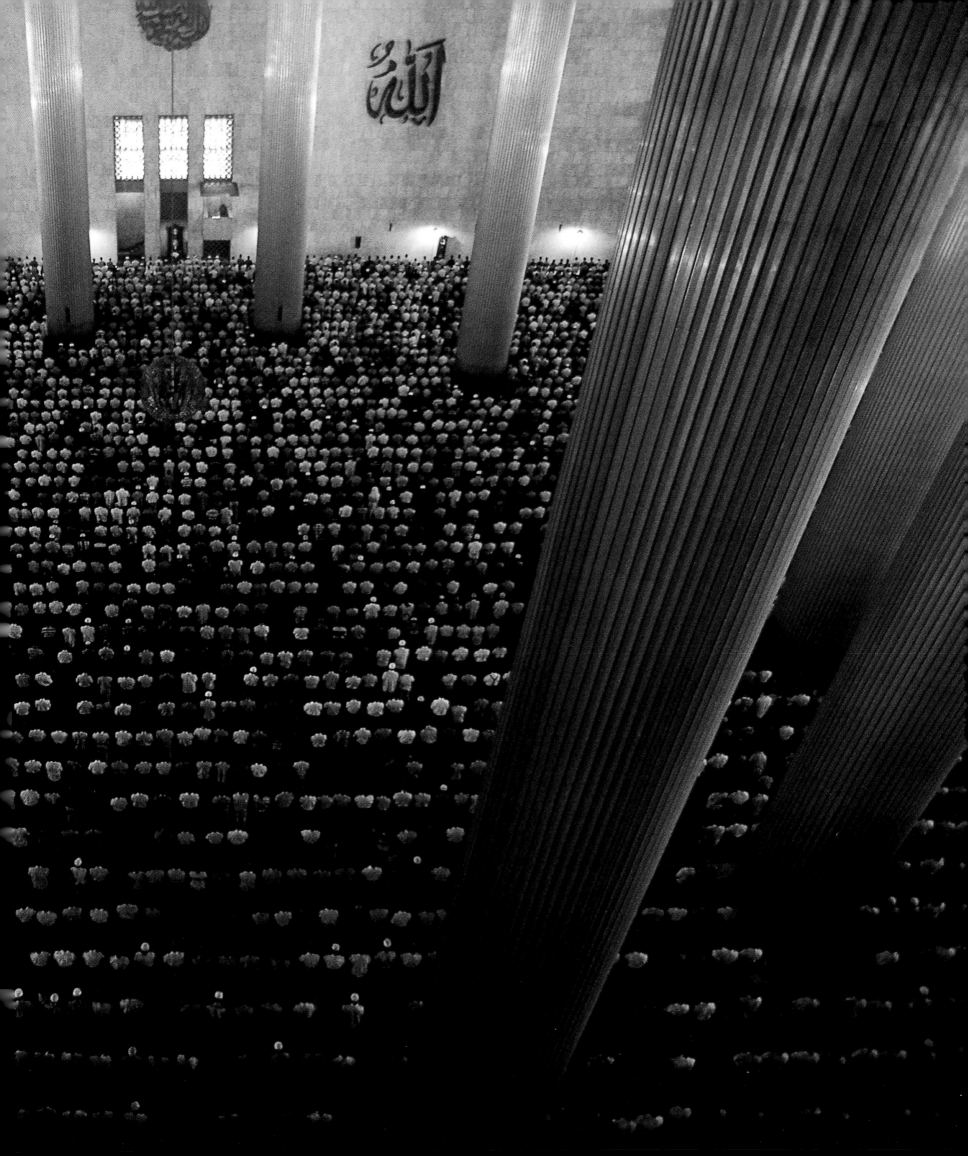

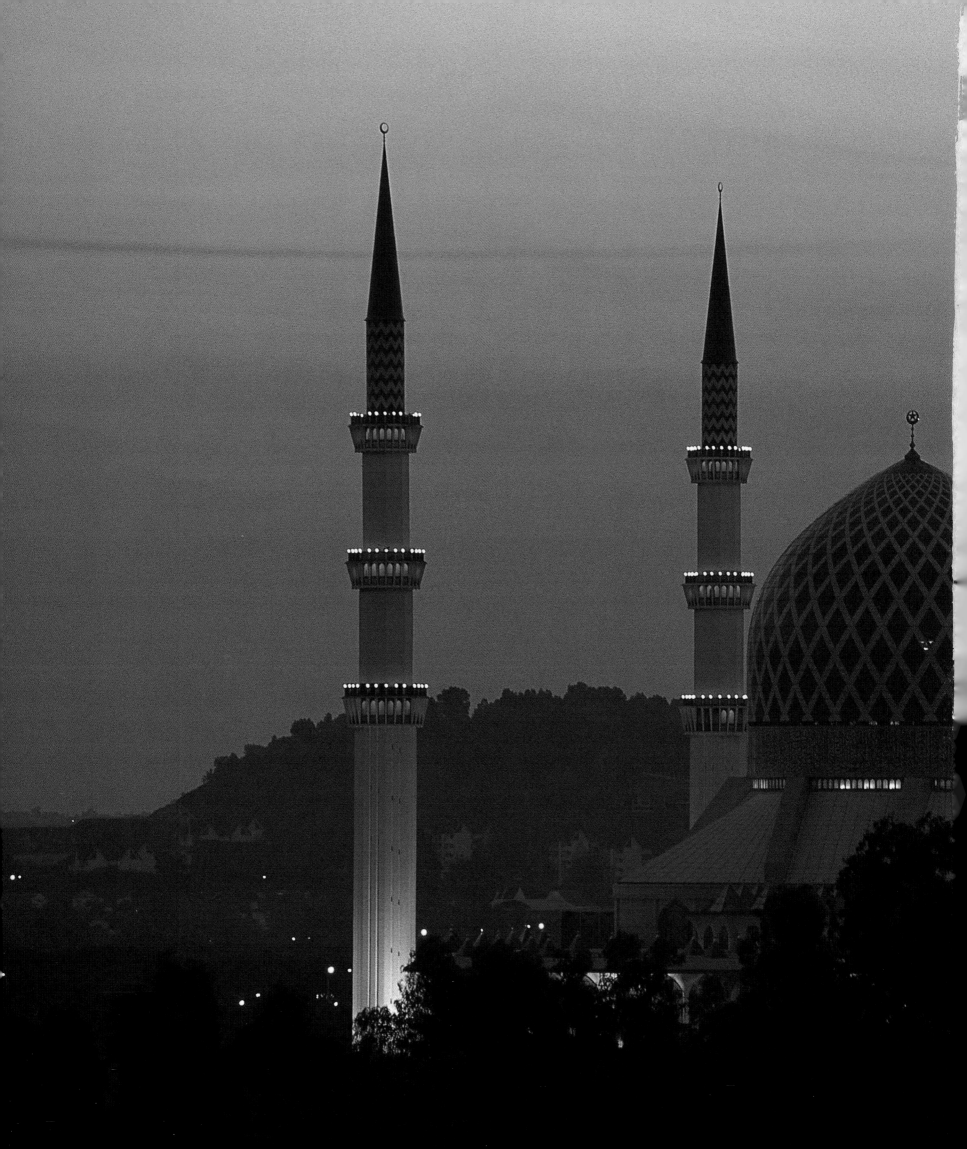

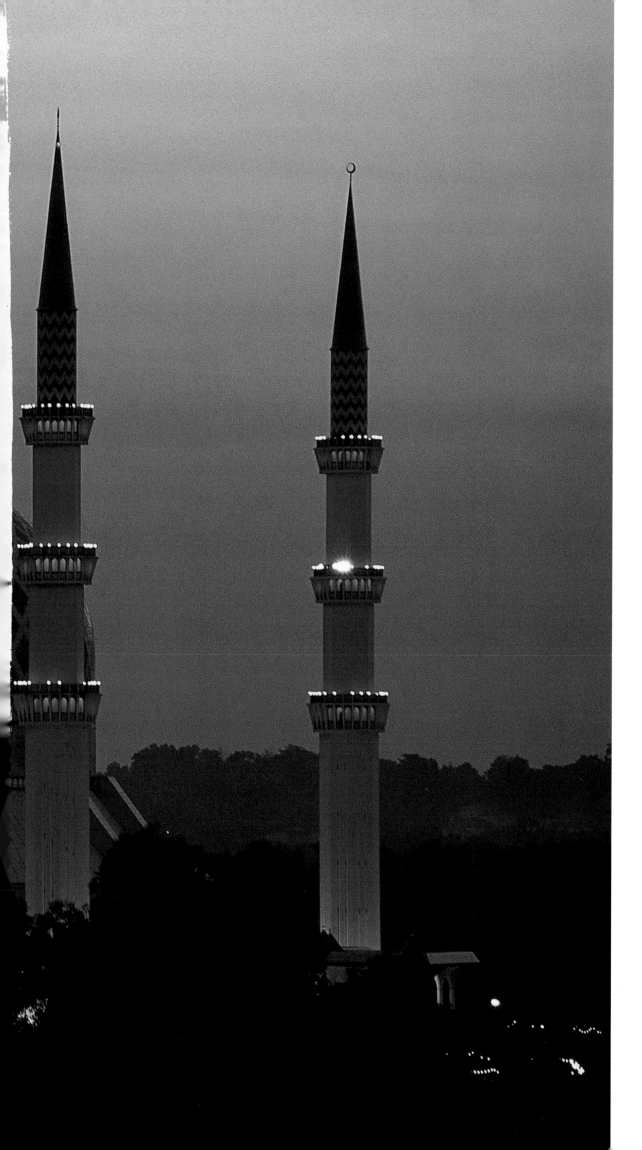

Reaching for the heavens, the Sultan Salahuddin Abdul Aziz Shah Mosque dominates the skyline of Shah Alam, capital of Selangor State in Malaysia. The mosque is a holy place of superlatives with four 40-meter-high (132-foot) minarets — some of the tallest in the world. It can accommodate about 24,000 worshippers under a computer-designed dome whose lighting system creates the illusion of being in the desert on a star-filled night.

A Muslim scholar — and Burmese political refugee — studies Islamic histories in the stillness of the Kapitan Kling Mosque in Georgetown on Malaysia's Penang Island. Troops of the British East India Company — Penang's first Indian Muslim settlers — built the mosque in 1802 with onion-shaped domes and the arched verandas typical of Indian Mogul design.

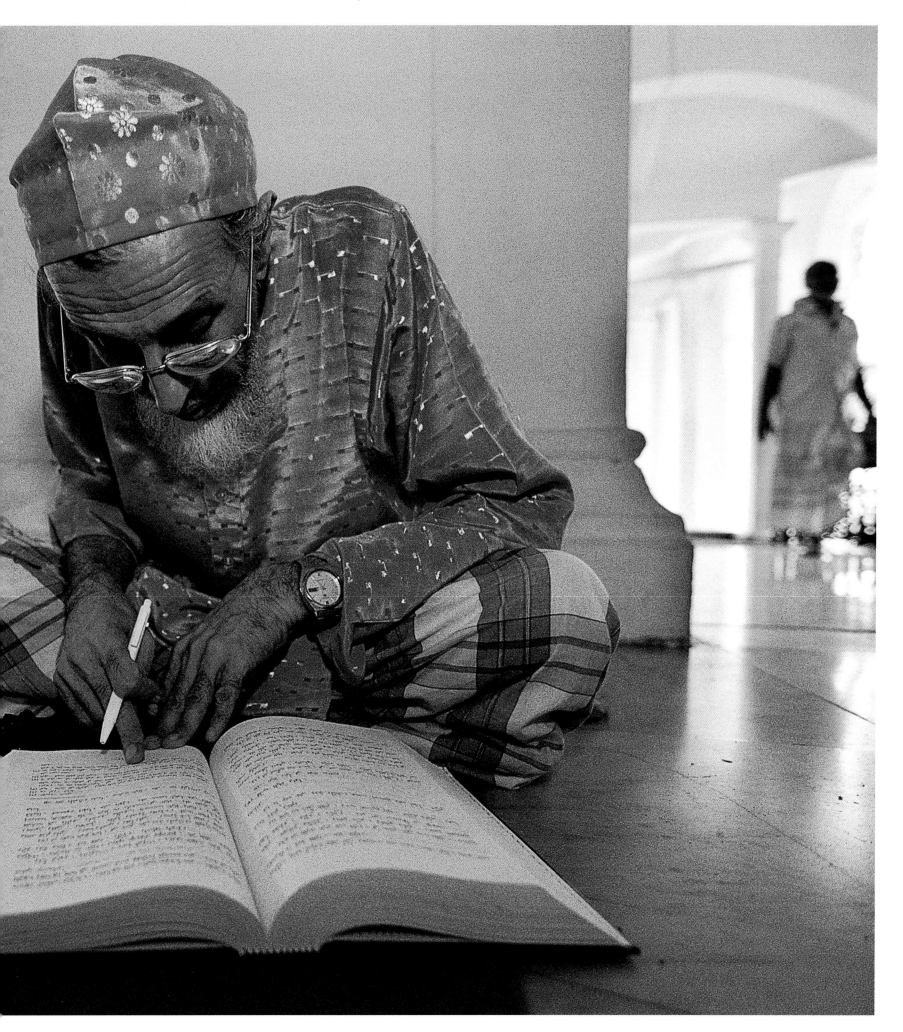

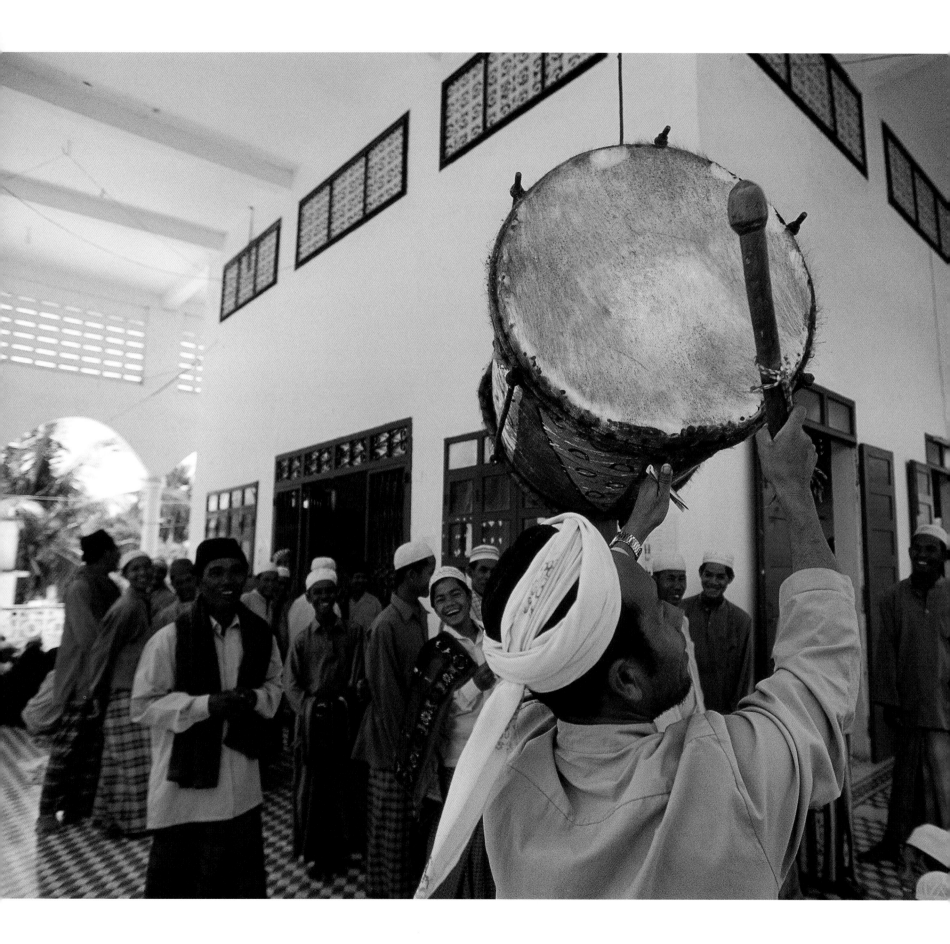

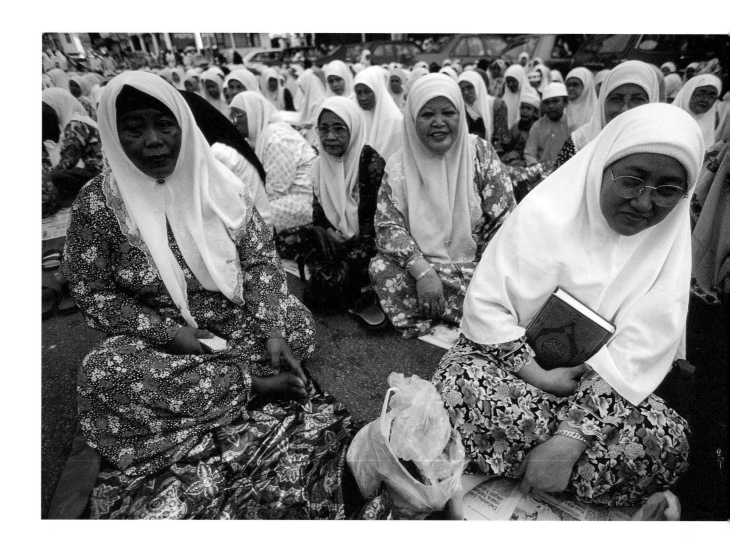

Summoning worshippers to Friday prayers (left), the *muezzin* of a mosque at Kompong Cham in Cambodia beats a drum called a *kouv* by ethnic Cham Muslims. Descendants of an ancient Southeast Asian empire called the Kingdom of Champa, the Cham live along the Mekong River in Cambodia and neighboring Vietnam. Piety takes a different form in Malaysia (above), where an overflow crowd of women listens to a sermon in a dusty Kota Bharu street outside a local mosque.

Adhering to the ritual of ablution, a Muslim of Indian descent splashes water on his feet before prayers at the Kapitan Kling Mosque in Georgetown on Malaysia's Penang Island. Some Muslim worshippers symbolically sprinkle water on their hands and feet, but others wash themselves thoroughly, especially after an illness or sexual intimacy.

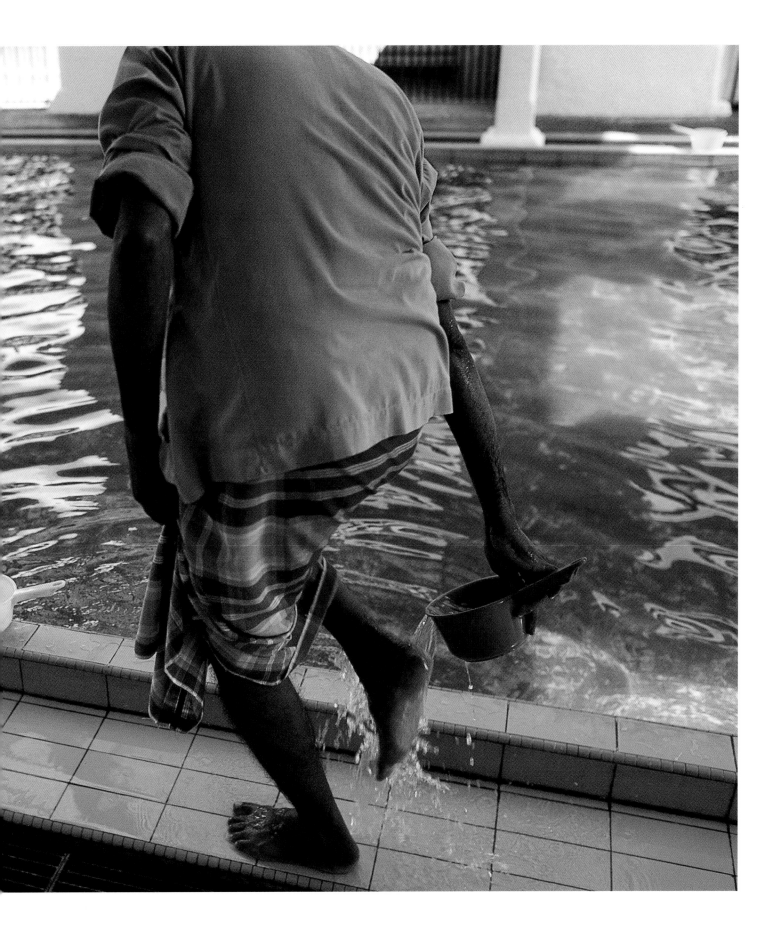

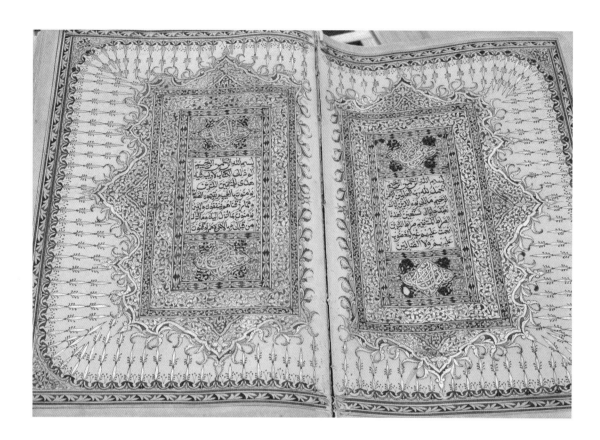

A gold-adorned Koran that once belonged to the Sultan of Terengganu dazzles visitors to the Islamic Arts Museum Malaysia in Kuala Lumpur — the first museum in the Asia-Pacific region wholly dedicated to the arts and culture of Islam. Muslims believe the Koran is the timeless word of God, so it is no surprise that ancient Korans are one of the centerpieces of the museum's collection.

Dressed in prayer robe, an elderly Cham Muslim enters the Derosalam Mosque in a village of the same name near the Cambodian capital of Phnom Penh. Today the Cham number about 203,000 — roughly 2 percent of Cambodia's 11 million citizens — after being decimated by Pol Pot's Khmer Rouge army between 1975 and 1979. Fervent communists, the Khmer Rouge also destroyed most Korans and executed Muslims found praying.

Paddy farmers and fishermen turn to the serious business of devotion on Fridays at the Al-Shan Mosque in Kompong Cham, Cambodia's third largest city and home to about 100,000 ethnic Cham Muslims. Known locally as the Khmer Islam, the Cham have rebuilt many of their mosques, which were either destroyed by the Khmer Rouge or used as warehouses and livestock pens.

At the Kampong Kling Mosque in Malacca, a Muslim boy with his prayer rug nestles beside his father before Friday prayers. The Koran says the place of devotion should be clean — hence the widespread use of woven prayer rugs or mats in Southeast Asia and much of the Islamic world.

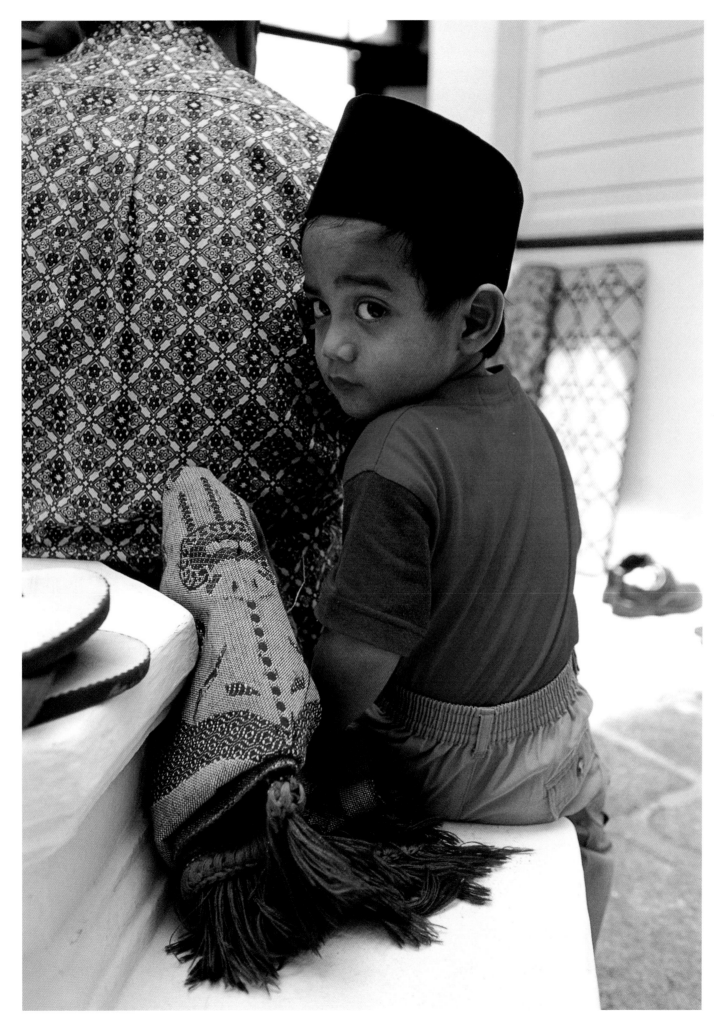

Alone with his God, a worshipper wears an embroidered prayer cap called a *songkok* or *kopiah* at Jakarta's Istiqlal Mosque. White caps usually signify that a Muslim has made the once-in-a-lifetime pilgrimage to Mecca and Medina called the *hajj*.

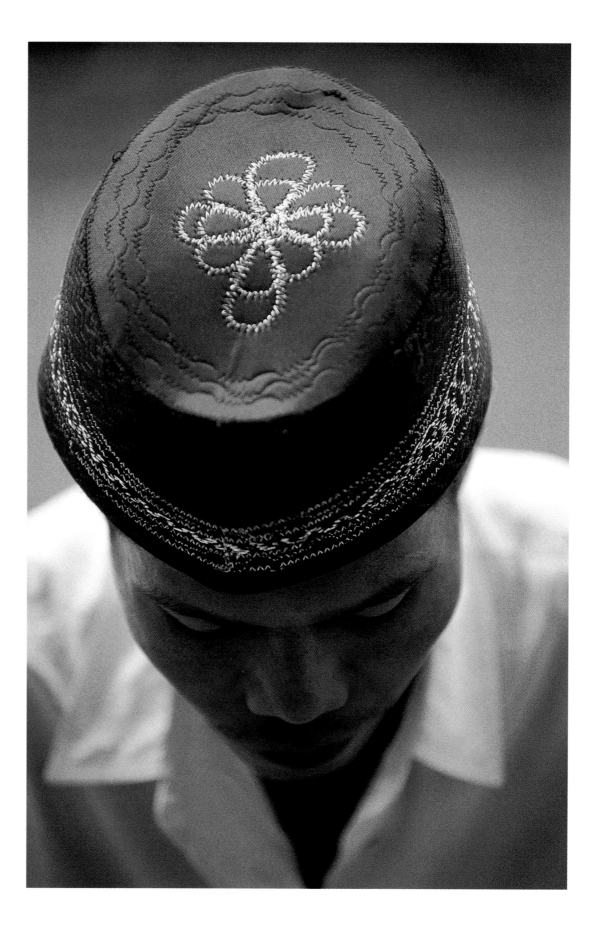

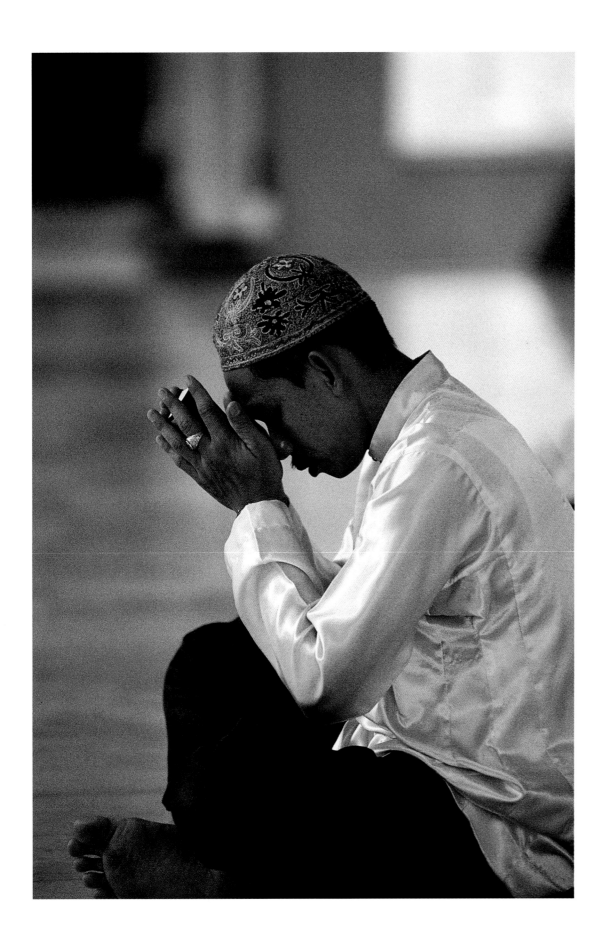

Clutching a small Koran, Islam's holy book that reveals the literal word of God and the teachings of the Prophet Muhammad, God's messenger, a Malay worships at the *Masjid Jamek*, or Friday Mosque, in central Kuala Lumpur.

Cambodian Cham Muslim worshippers execute their proscribed "bowings" or "bendings", so called because each part of the prayer ritual marks a change of position — between two and four depending upon the time of day. For Friday prayers, overflow crowds likes this one in the city of Kompong Cham often spill outside the main prayer hall. The Cham were relatively late converts to Islam, according to scholars, adopting the Muslim faith only after the fall of their kingdom to the Vietnamese in the late 1400s.

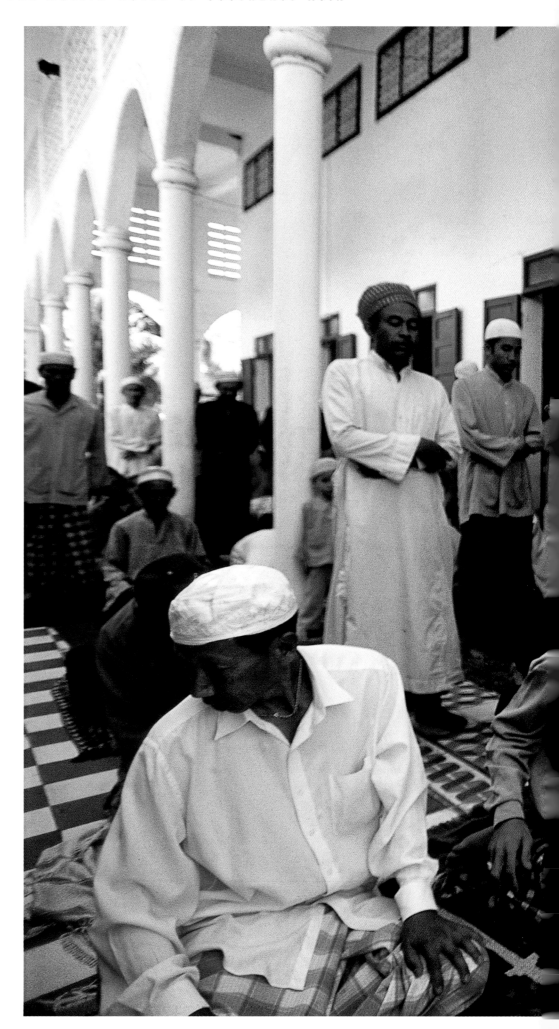

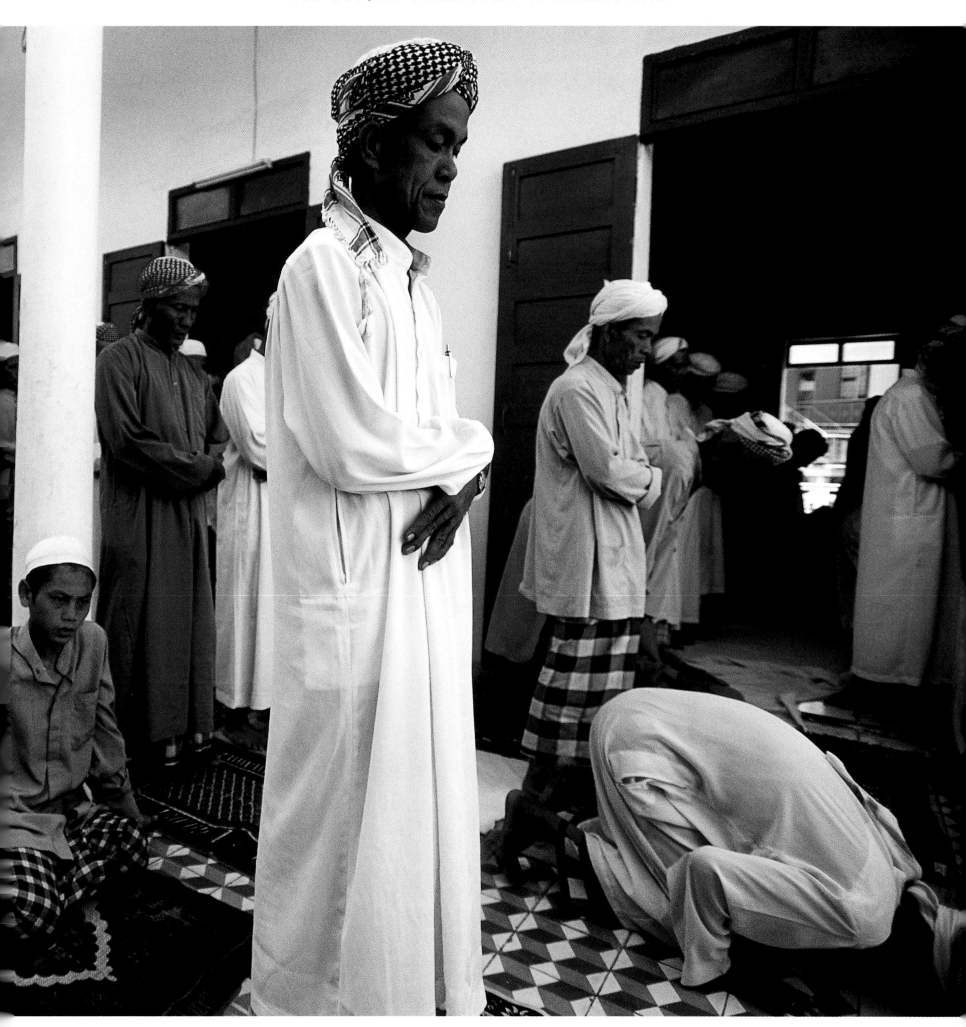

A light moment precedes a solemn occasion, as women prepare to pray — the second of five pillars of Muslim faith — at the Omar Ali Saifuddien Mosque in Brunei's capital of Bandar Seri Begawan. Mother and daughters wash before entering the prayer hall, following the Koran's command that worshipers should be clean of body as well as soul.

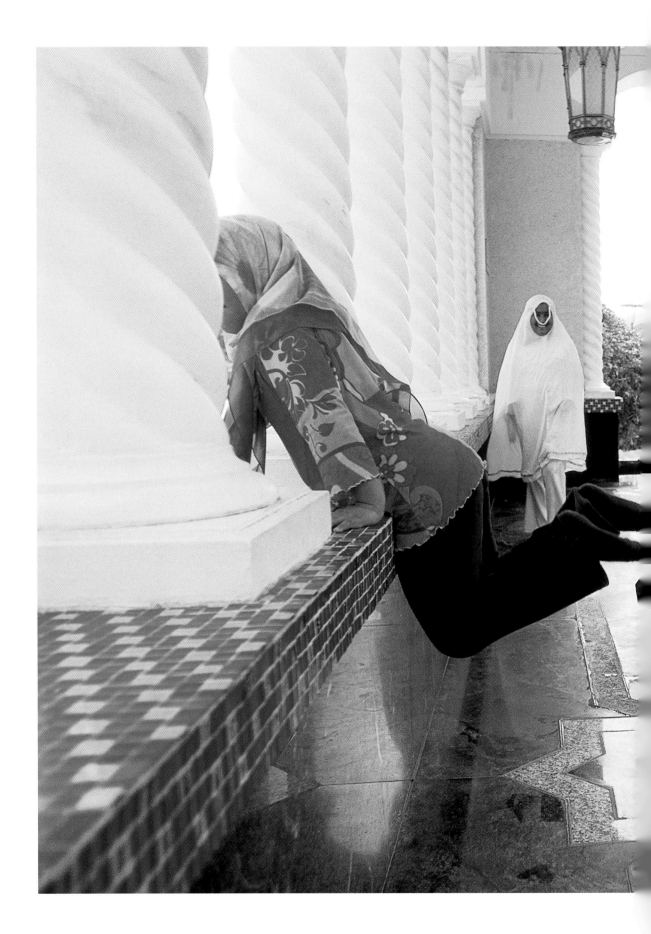

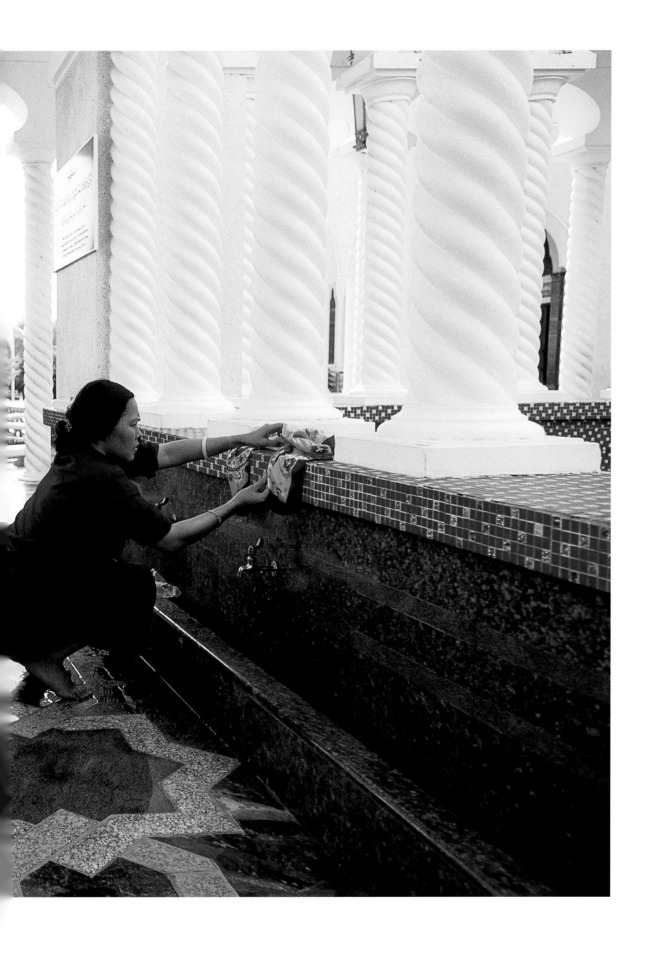

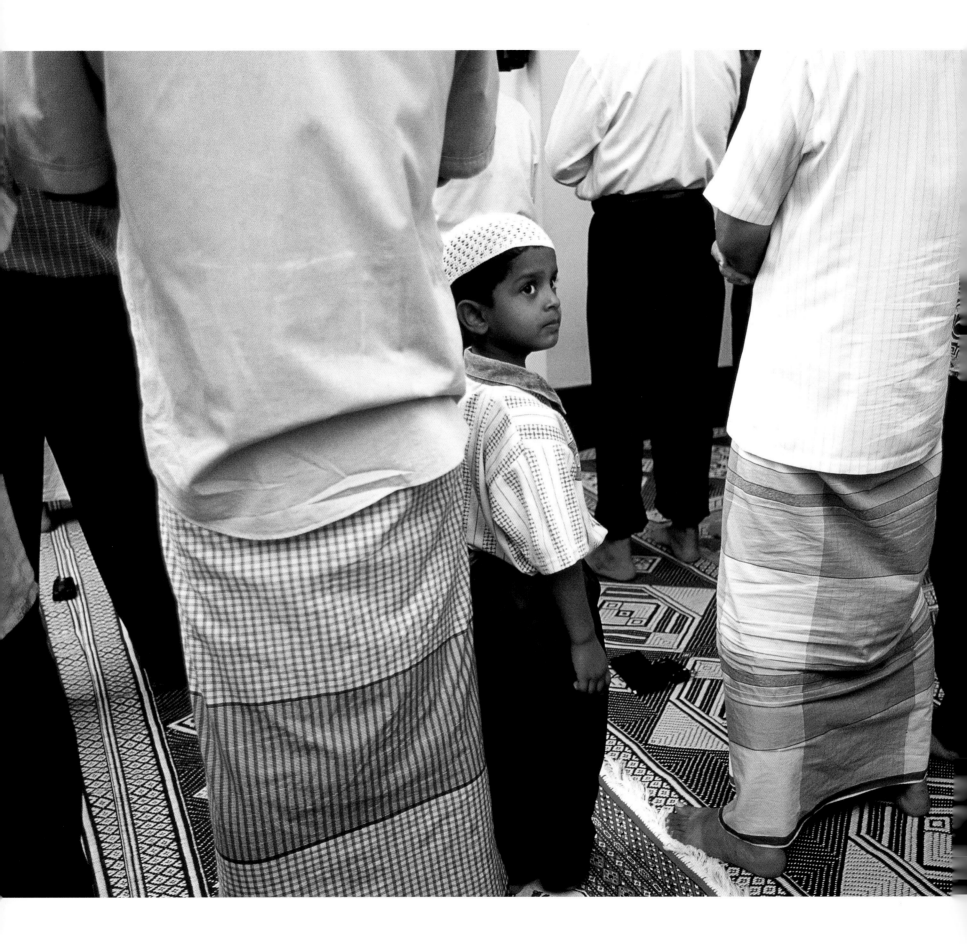

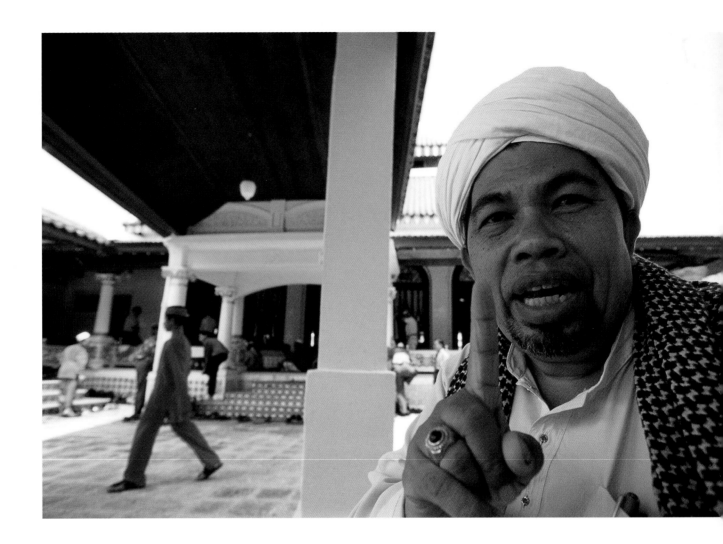

Friday prayers in a mosque are required of all Muslim men, and many Muslims say they prefer congregational worship, seeing it as more exemplary than individual devotion. In Singapore, a boy wearing a *songkok* prayer cap (left) stands among men worshipping at the Hajjah Fatimah Mosque in the Arab Street Quarter.

Beckoning Muslims to Malacca's Kampong Kling Mosque, Hajji Muhammad Jaafar Bin Fakeh (above) invokes one of the Koran's central commands: "Believers, when you are summoned by Friday prayers, hasten to the remembrance of Allah and cease your trading."

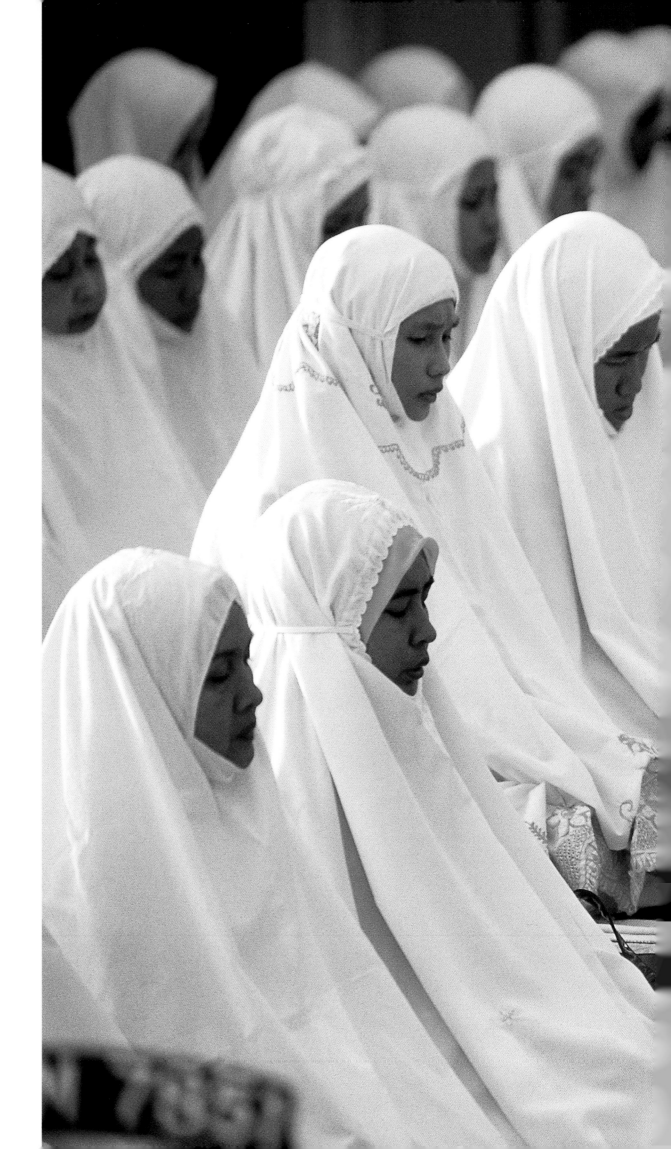

Women in white prayer shawls follow the Koran's dictate that "prayer is a duty incumbent on the faithful" at the Kubang Kerian Mosque on Kota Bharu on Malaysia's religiously conservative east coast. Children sometimes accompany their mothers to special areas of a mosque set aside for women, whose modesty would be compromised by the ritual kneeling and bowing required of all Muslims if they were to pray among men. Contrary to popular belief, the Koran does not stipulate that women must be veiled or secluded.

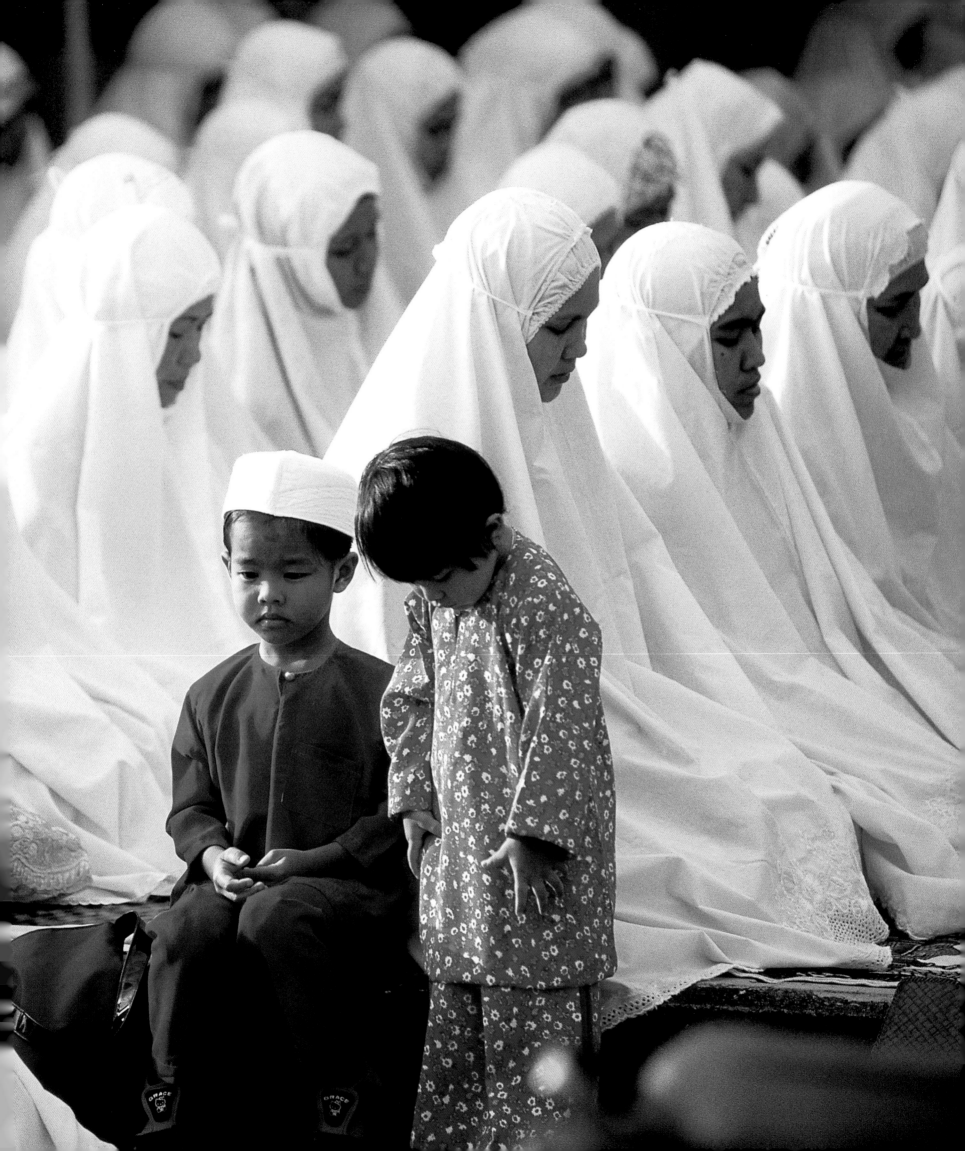

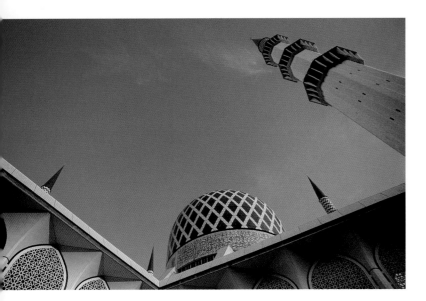

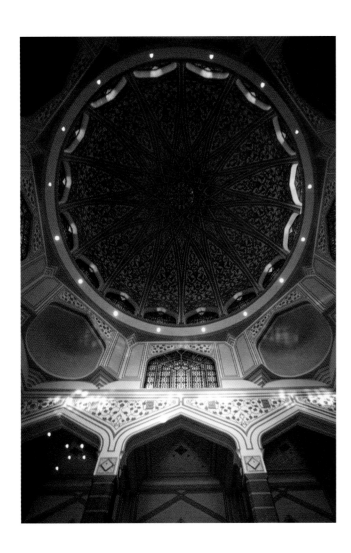

Verses from the Koran (right) grace the Sultan Salahuddin Abdul Aziz Shah Mosque, one of the grandest in Asia and centerpiece of Shah Alam, capital of Selangor State in Malaysia. Built in 1988, the mosque (upper left) is covered by one of the largest domes in the world. Malaysian government workers at the new Malaysian Government administrative capital of Putrajaya, outside Kuala Lumpur, need only walk a few steps to pray beneath the dome of the Persian-influenced Putra Mosque (lower left). Under the 36-meter-high (118-feet) dome are the focal points in every prayer hall – the *minbar*, or pulpit, and the *mihrab*, the niche denoting the direction of Mecca. Both are adorned with Islamic calligraphy called khat in Malay.

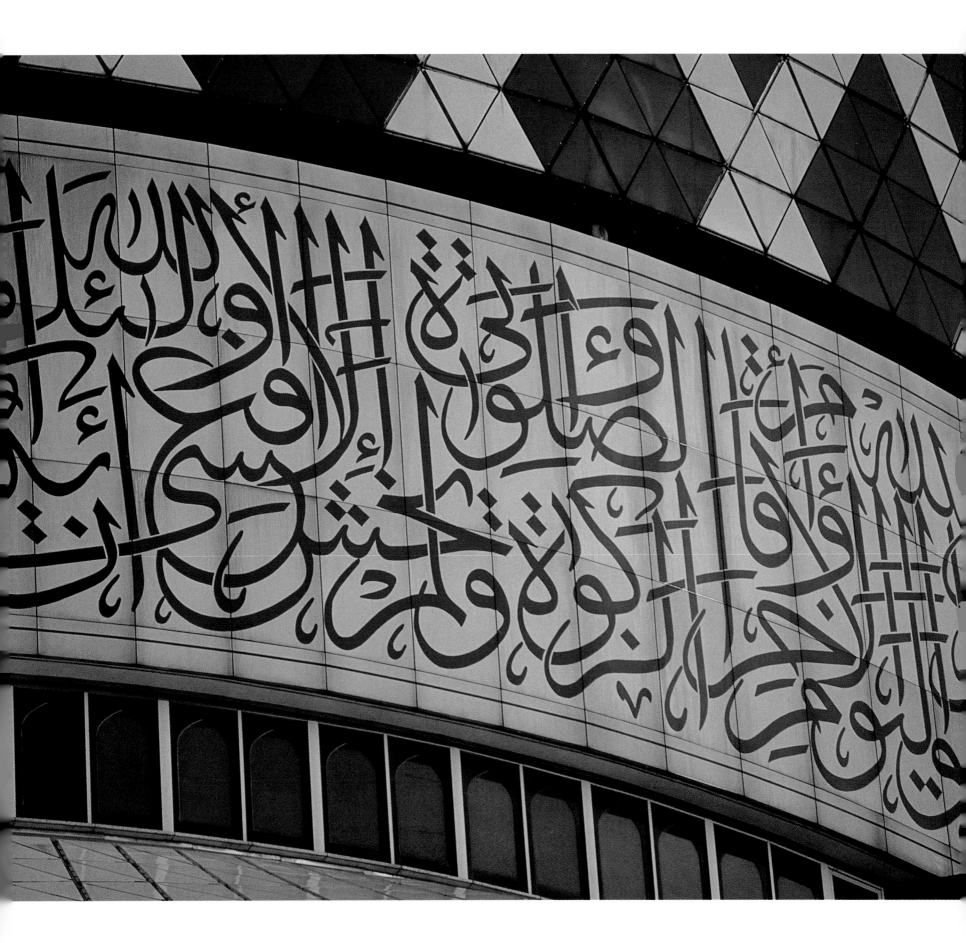

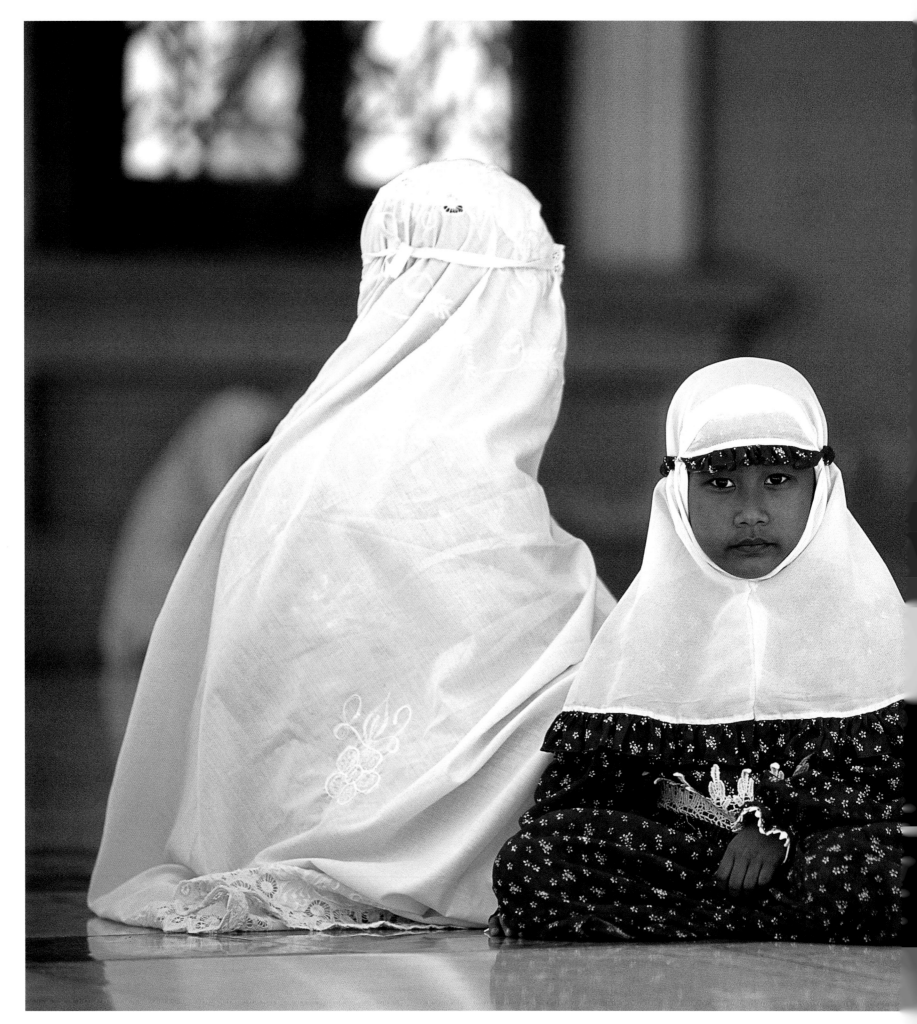

Dressed in prayer robes called *mukenahs* or *kerudungs*, a Muslim girl and her mother savor the serenity of the Baiturrahman Great Mosque at Banda Aceh, capital of Indonesia's troubled Aceh Province. Descendants of a powerful Islamic sultanate, the devout Acehnese were the first Southeast Asians to embrace Islam, perhaps as early as the ninth century. Acehnese traders roamed the Indonesian archipelago until the early 17th century, spreading the Muslim faith and monopolizing the pepper, clove, and nutmeg business.

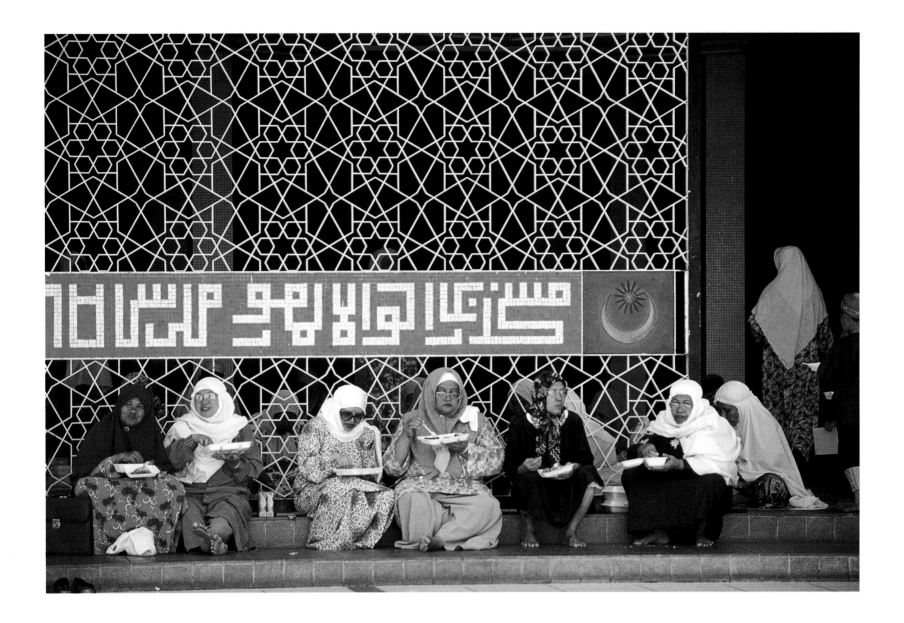

Taking a break from learning the rituals of the *hajj,* the pilgrimage to Islam's holiest places, in Saudi Arabia, women finish their lunch at the National Mosque in Kuala Lumpur. The mosque sponsors weekend practice sessions for thousands of pilgrims bound for Mecca and Medina, where Muslims perform a complex and sometimes arduous series of rituals that last for several days.

Schoolgirls visit the National Islamic Center in Kuala Lumpur, where they learn that being a good Muslim means following a strict code of conduct that is much a system of ethics as it is law. For example, the Koran commands Muslims to be "devout, sincere, patient, humble, charitable, and chaste." To break the law is both a crime against society and a sin against God.

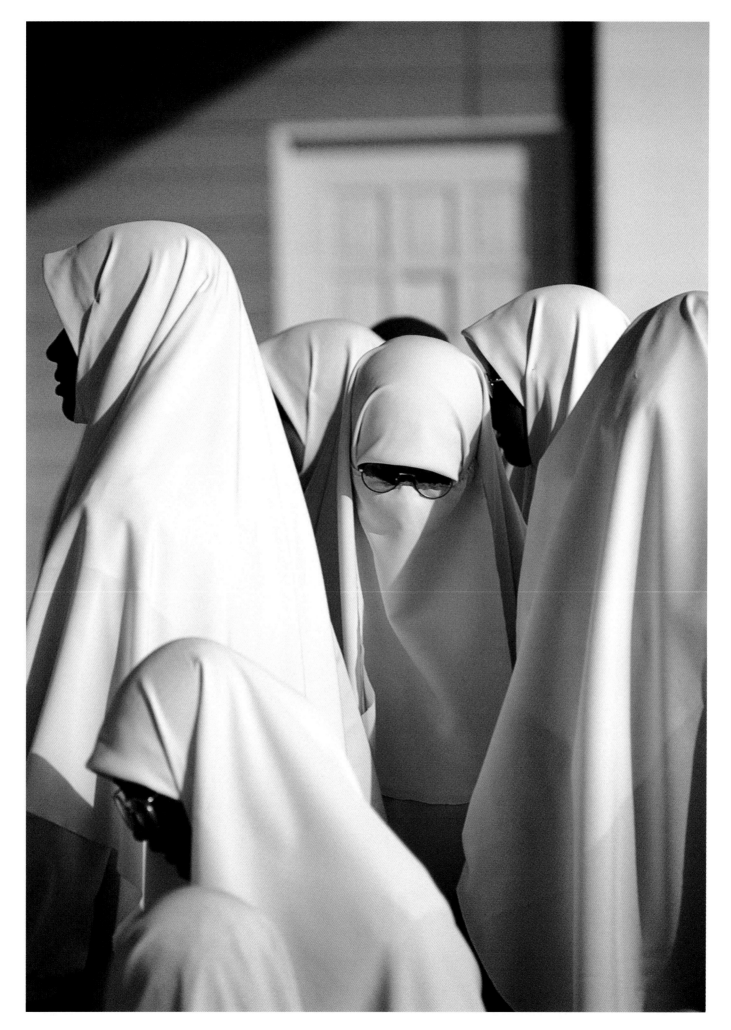

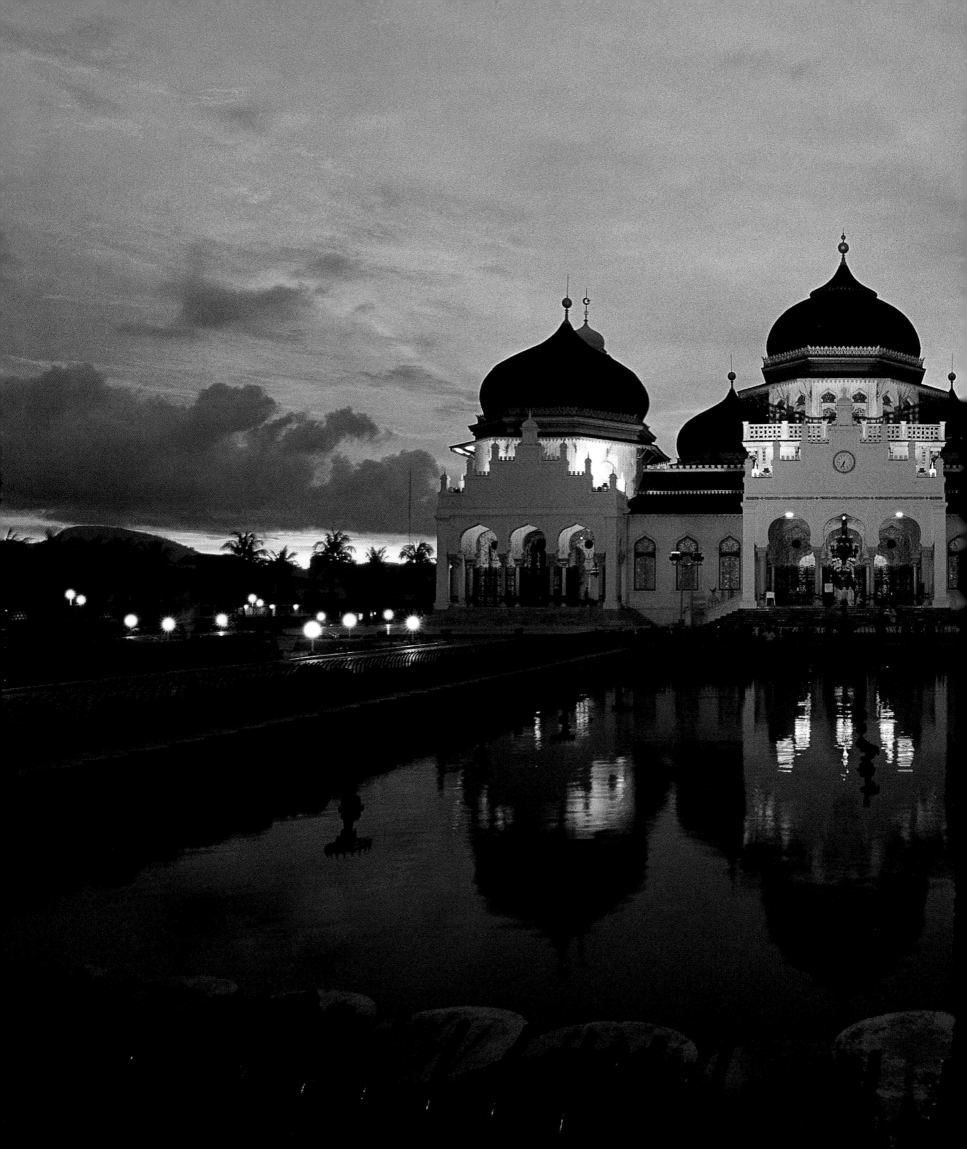

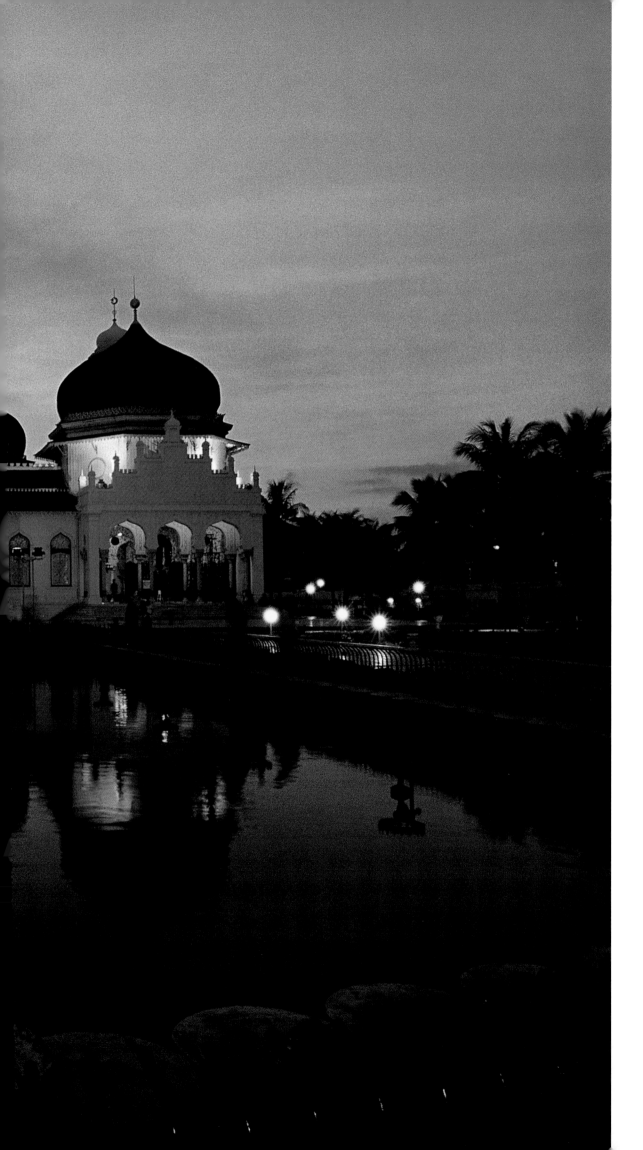

Fiery hues of a setting sun backlight the Baiturrahman Great Mosque in Banda Aceh, capital of resource-rich Aceh Province on the Indonesian island of Sumatra, where a civil war for a separate Islamic state threatens the disintegration of the world's fourth most populous nation. The onion-domed mosque was designed by an Italian architect and built by Dutch colonialists between 1879 and 1881, reflecting Indian Mogul influences.

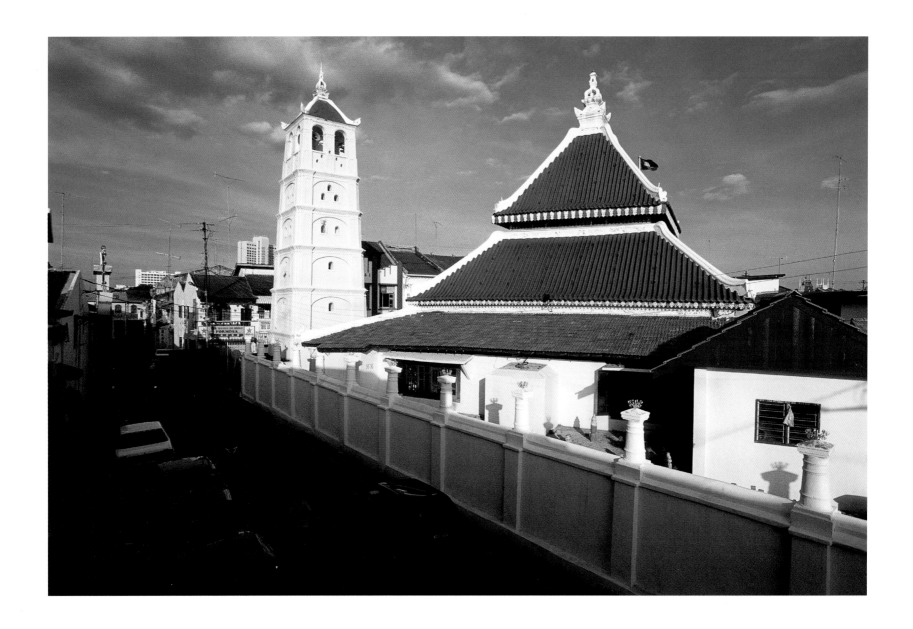

With its Chinese pagoda-like minaret and Javanese-style roof (above), the storied Kampong Kling Mosque in Malacca is one of the oldest on the Malay Peninsula, dating back to 1748. Muslim merchants from China, Java, and Sumatra all left their mark on the architecture of local mosques during Malacca's heyday as a major trade center. On the distant Indonesian island of Lombok, a caretaker (right) watches over a thatched-roof mosque of the Waktu-telu, whose customs incorporate Islam, Hinduism, and local animistic rituals.

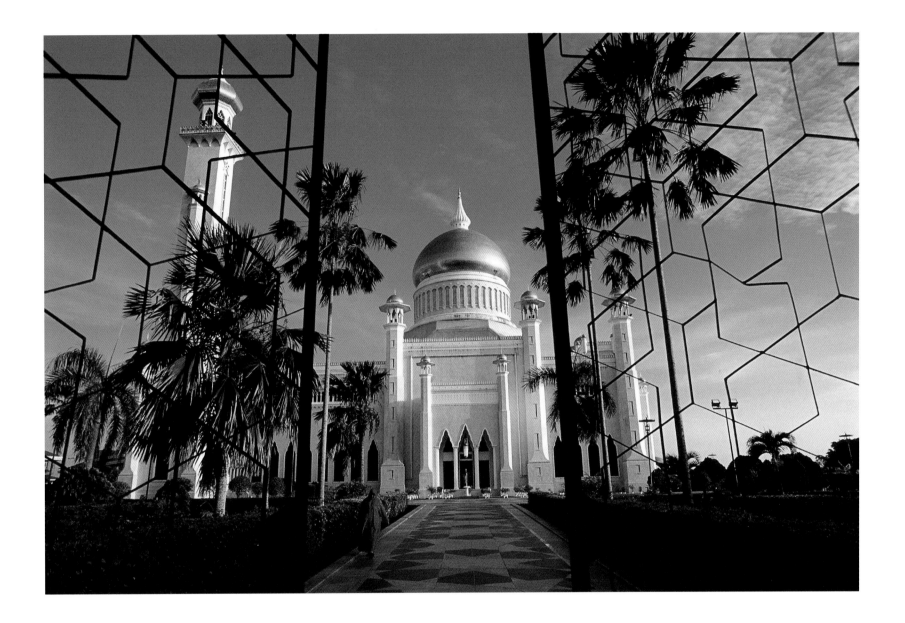

The gold-domed Omar Ali Saifuddien Mosque, named after the 28th sultan of oil-drenched Brunei Darussalam, looms over Bandar Seri Begawan, capital of the devout Muslim sultanate on the island of Borneo. A Venetian mosaic of 3.5 million pieces adorns the interior of the mosque's main dome, complementing stained-glass windows from England and walls and floors of Italian marble.

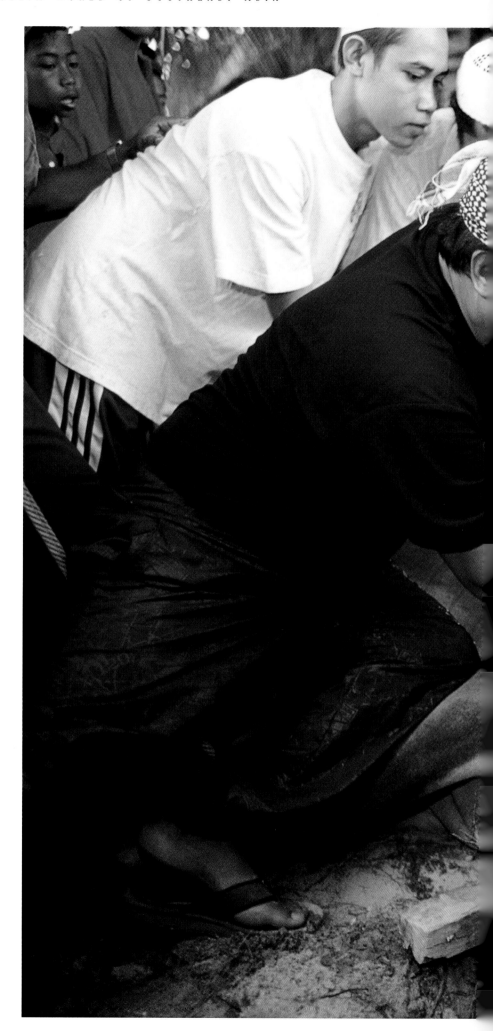

"God, this is a sacrifice to you," chant Muslims as they severe the head of a cow at the Tengku Tengah Zaharah Mosque near Kuala Terengganu in Malaysia to mark the *Eid al-adha* festival of sacrifice, sometimes called *Hari Raya Aidiladha* or *Hari Raya Haji*. The holiday, celebrated throughout the Muslim world, comes at the end of the annual pilgrimage to Mecca and Medina and symbolically recalls Abraham's willingness to sacrifice his son Ismail (Isaac in Jewish and Christian traditions). Meat from such sacrifices is given to the poor, sometimes touching off food riots in Indonesia.

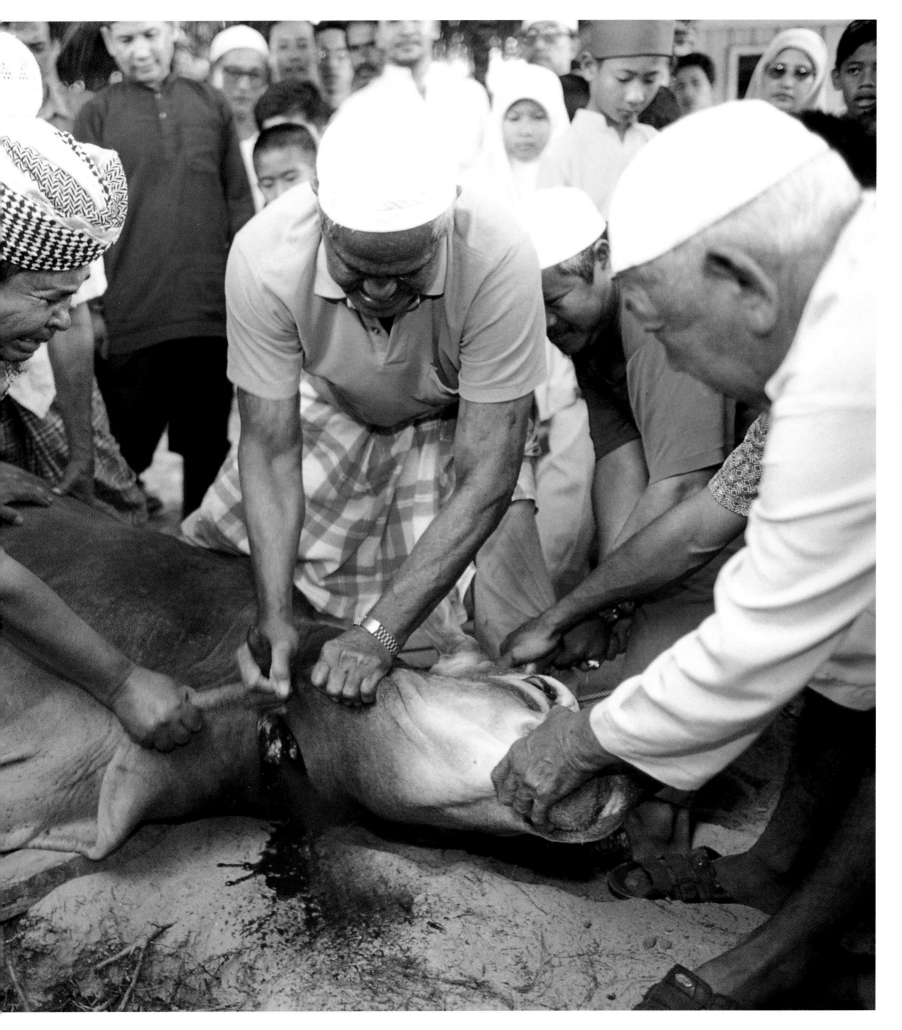

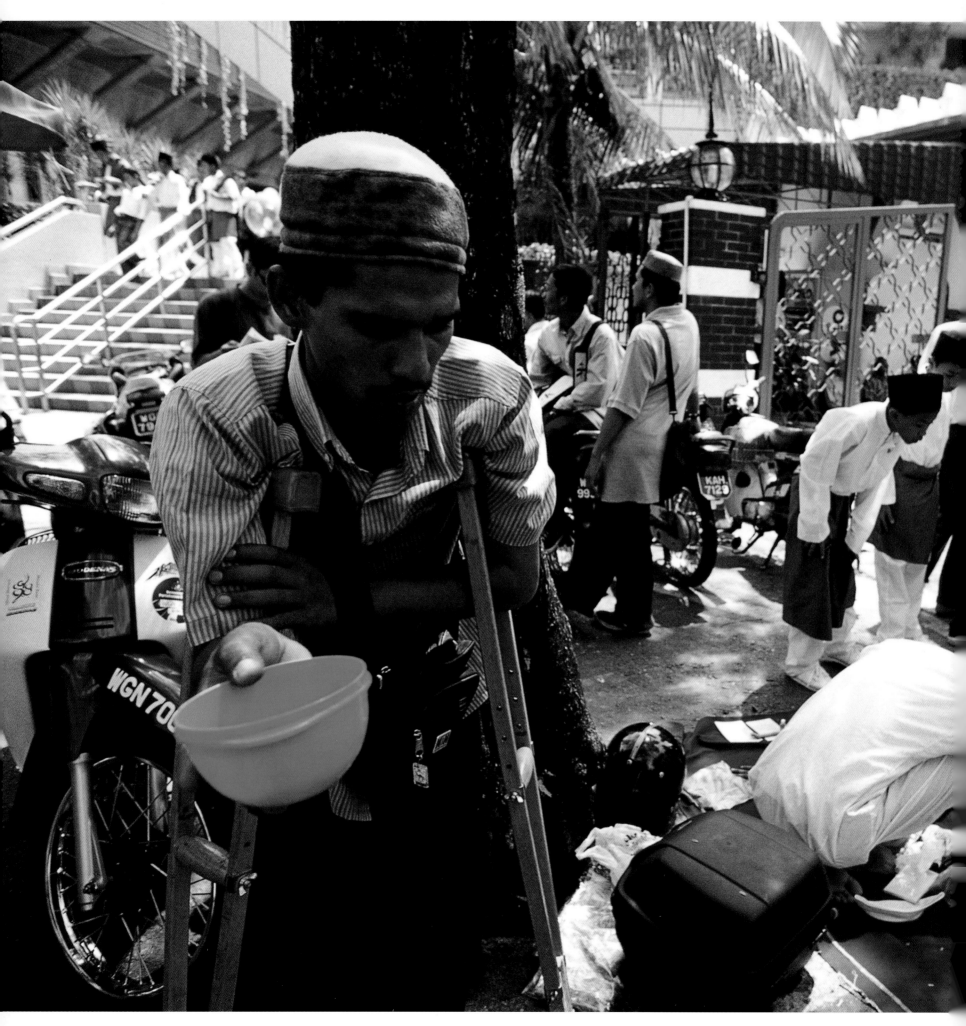

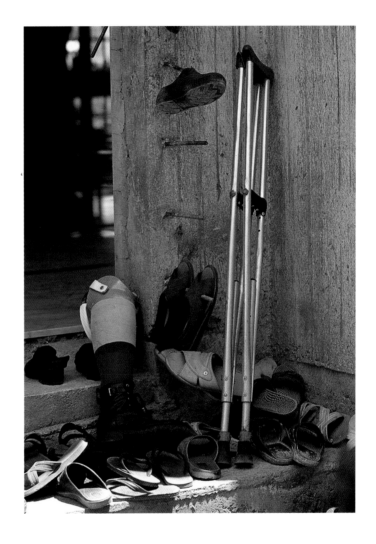

A beggar outside the Friday Mosque in Kuala Lumpur (left) tests Muslims' obedience to the third pillar of Islam — charity for the less fortunate, an obligation that is stressed throughout the Koran. Muslims are expected to pay a wealth or alms tax — called *Zakat* in Arabic — for the care of widows, orphans, and the poor. Following custom, worshippers in Yala, Thailand, leave shoes, sandals, and an artificial limb at the entrance to their mosque, where everyone is considered equal before God.

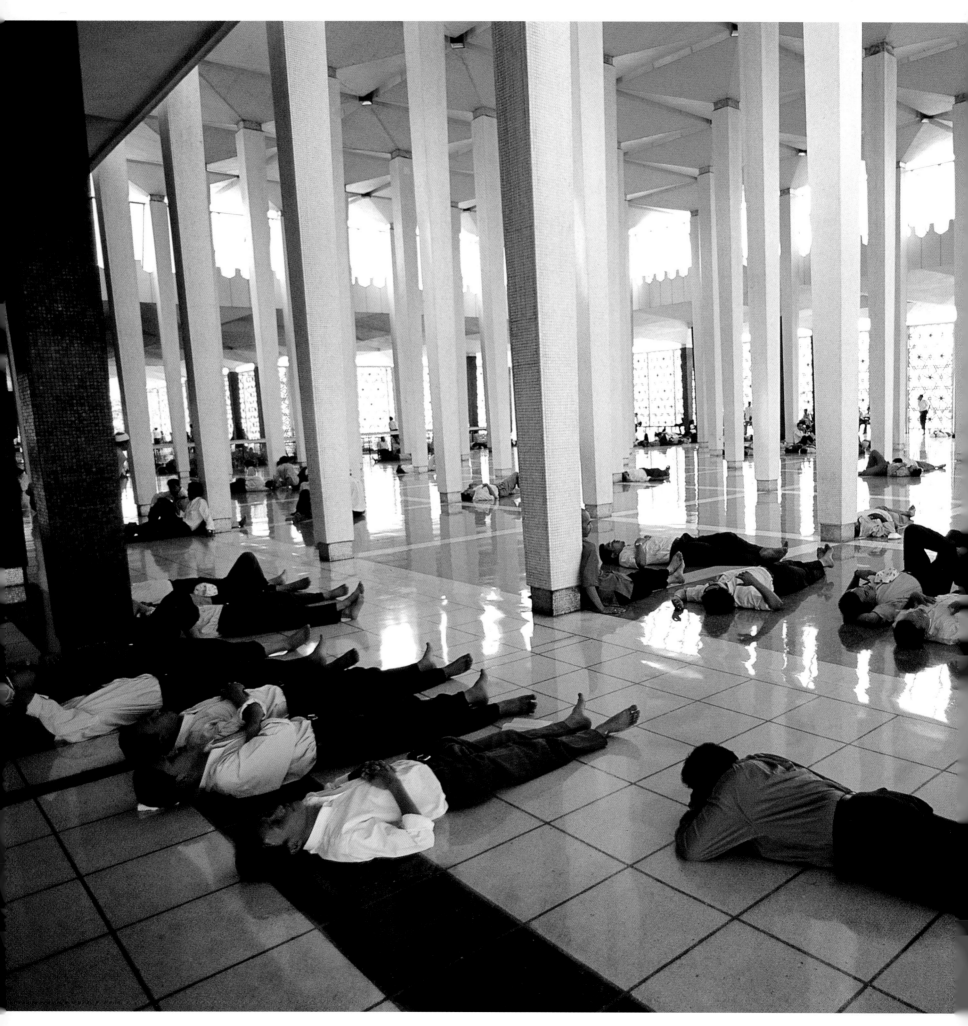

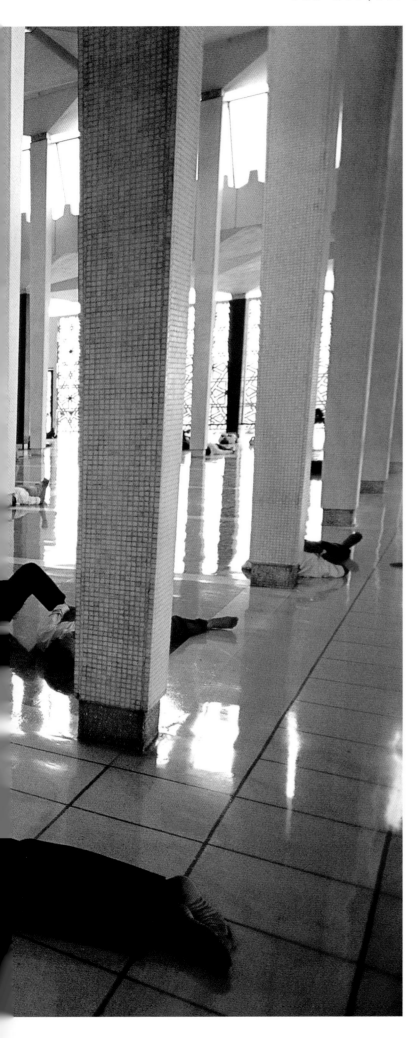

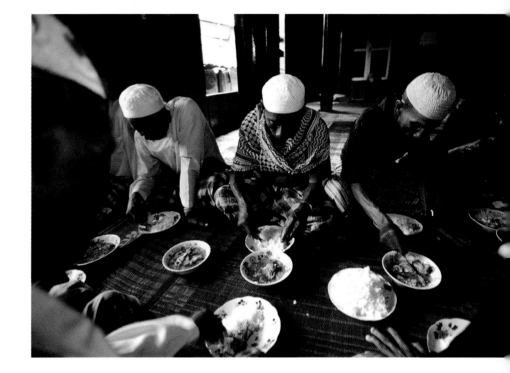

Friday prayer-goers (left) are in no hurry to return to their offices or homes, preferring instead to slumber in the cool of the open-air National Mosque in Kuala Lumpur. Part shelter and meeting hall, mosques serve as a buffer from the turmoil of the outside world, especially in the crowded cities of Southeast Asia. Cambodian Muslims at a mosque outside Phnom Penh (above) celebrate the return of *hajj* pilgrims from Saudi Arabia with a simple meal of rice and curry.

Cradle of 19th-century Malay civilization, the Royal Mosque on Penyengat Island — a one-hour high-speed boat ride from Singapore — served as the spiritual home of the Riau sultans, who laid the foundation for the modern-day Indonesian and Malay languages. *Imams* — spiritual leaders schooled in the Koran — came to Penyengat from as far away as Mecca to teach in the mosque, where some 60 works of Malay literature are thought to have been composed. Today the mosque, like the island, languishes in the shadow of nearby Bintan Island with its multibillion-dollar factories and tourist resorts.

MUSLIM SCHOOLS
CUSTODIANS OF TRADITION, ARCHITECTS OF CHANGE

For Muslims, it is not enough simply to profess faith in God inside a mosque. For life to have meaning, Muslims must spread the message of *Allah* and do good works in ways both large and small. They also must obey a set of laws, sometimes called the Five Pillars of Islam: Profess an uncompromising faith in God and His messenger Muhammad, pray five times a day, pay a charitable tax called *zakat*, fast during the month of Ramadan, and make a once-in-a-lifetime pilgrimage to Mecca called the *hajj*. Nowhere do these beliefs resonate more powerfully than in the tens of thousands of Islamic schools that have flourished throughout Southeast Asia.

At Asshiddiqiyah Islamic College outside Jakarta, several hundred young women in immaculate white uniforms and embroidered black headscarves gather in the school courtyard for the beginning of a new school term. They pray, listen attentively as their rector calls Islam "an important force for the whole Asian family," and then, in a stirring display of patriotism, salute the Indonesian flag as it is raised above the white stucco compound. After classes, the girls don flowing white robes called *muknas* and kneel on tiny carpets for noon prayers, leaving a pile of thick-soled sneakers outside the school's mosque. On their way to lunch, they gossip about pop music stars like Jewel, Mariah Carey, and the Backstreet Boys and giggle over American sitcoms like "Friends."

But this is no ordinary corner of a globalized world. Young women at Asshiddiqiyah College say they revere the Prophet Muhammad and, like their peers in the West who have heard God's call, see themselves as His lifetime messenger. But they also want to be doctors, lawyers, and business executives. They plan to marry for love, and many are more fluent in English than in Arabic, which they must learn in order to read the Koran in its original form.

Asshiddiqiyah College is called a *pesantren*, an Indonesian word for a school with an Islamic focus. There are several thousand of them throughout the Indonesian archipelago and they count among their alumni an Indonesian president, cabinet ministers, and top business leaders. *Pesantren* students follow a standardized curriculum, approved by the government in Jakarta, that is heavy with classes in Arabic, Koranic literature, and Islamic law. Their lives are rigidly structured around the five daily prayers required of all Muslims. Teachers are known as *kyai*, devout men who are sometimes thought to have supernatural powers, such as the ability to throw fire or absorb a bullet without injury, though it is more common today for faculty members to have degrees from Indonesia's best universities. It's not uncommon to see students kissing their teacher's hand as a sign of respect. Rector Noer Muhammad Iskandar says he believes in encouraging students to follow their ambitions. "Why not have a woman president?" he asks. "Islamic law allows it. We are a Muslim country, but not a fundamentalist Islamic state."

Indonesia's *pesantren* receive generally good marks for their academic standards and inclusive worldview. But Muslim education elsewhere in Southeast Asia faces an array of challenges. In Thailand, Cambodia, and the Philippines, which have substantial Muslim minorities, parents and clergy complain about the lack of Islamic schools and the uneven quality of teachers. Singapore's

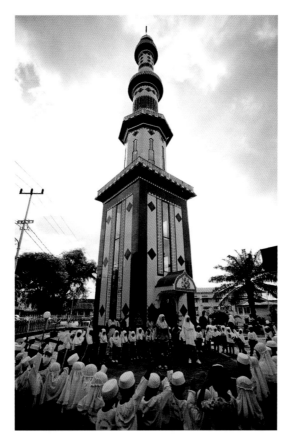

In Indonesia's Riau Islands, students at an Islamic school, called a *madrasah* in Arabic, play beside the minaret of a nearby mosque.

Muslim schools must compete with well-funded public institutions that produce high school students with some of the highest computer, math, and science test scores in the world. And Malaysia, which prides itself in giving citizens a choice of educational opportunities, now has a bewildering array of religious schools with few national standards.

The federal government in Kuala Lumpur operates Muslim schools, as do the powerful state governments, Muslim religious groups, Muslim political parties, and private Muslim charities. In fact, Malaysia may have as many as 3,000 Islamic schools, but only a handful come under the national Ministry of Education. All this makes it difficult to measure academic achievement, scholars say. Some researchers worry that the country's Malay majority has used religious schools to strengthen Muslim identity and orthodoxy, sometimes at the expense of subjects like science, mathematics, and foreign languages. Unhappy university students from big cities or more Westernized families have occasionally taken their grievance to the press, complaining of being publicly scolded by teachers for dyeing their hair, wearing too much makeup, or failing to wear the Muslim headscarf, which has become something of a fashion statement for women on college campuses.

Scholars see irony in all this turmoil. Malay Muslim students who are the beneficiaries of preferences designed to bring them into the economic mainstream are instead sidetracked with worries about Islamic identity. Meanwhile, their Chinese and Indian peers are casting aside long-held prejudices about race and religion and cashing in on a global economy that has made Malaysia a center of high-tech manufacturing and one of Asia's Internet powerhouses.

Still some parents and teachers see religious schools as a way to inoculate young people against Western popular culture, which dominates every shopping mall, movie theater, and television station in Asia. "Islam is a vaccination against problems like drug and alcohol abuse and lack of respect for authority," says Abdul Halim bin Mohammad Hussin, a school counselor in Kuala Lumpur. Many more Malaysians take justifiable pride in institutions like Kuala Lumpur's International Islamic University, the Institute of Islamic Understanding Malaysia (IKIM), and the International Institute of Islamic Thought and Civilization (ISTAC), seeing in their sprawling and manicured campuses a scholarly tradition that began in antiquity. Islamic universities, after all, kept Greek thought and scholarship alive while Europe slumbered during the Dark Ages. Today Malaysia's institutions of higher learning graduate thousands of young people in subjects ranging from Islamic art and architecture to law and ethics. "In a free society, any Tom, Dick, or Harry can talk about Islam," notes Syed Muhammad Naquib Al-Attas, director of the ISTAC, "but you can not democratize knowledge. We contribute to it through rigorous scholarship just like the finest universities in the West."

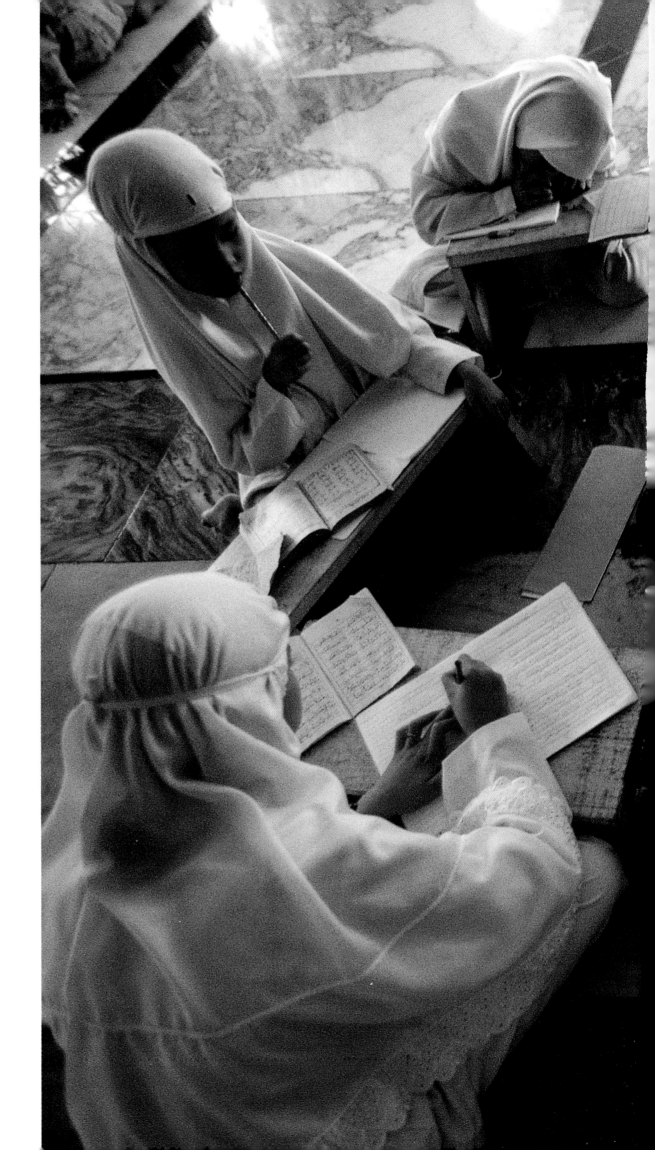

Learning the Koran in the original Arabic, students meet in small groups after school to study with a tutor at the Baiturrahman Great Mosque at Banda Aceh, capital of the Indonesian province of Aceh. Parents pay what they can afford for the Koran reading classes, which are a rite of passage for young people in devoutly Muslim Aceh — and much of the Muslim world of Southeast Asia.

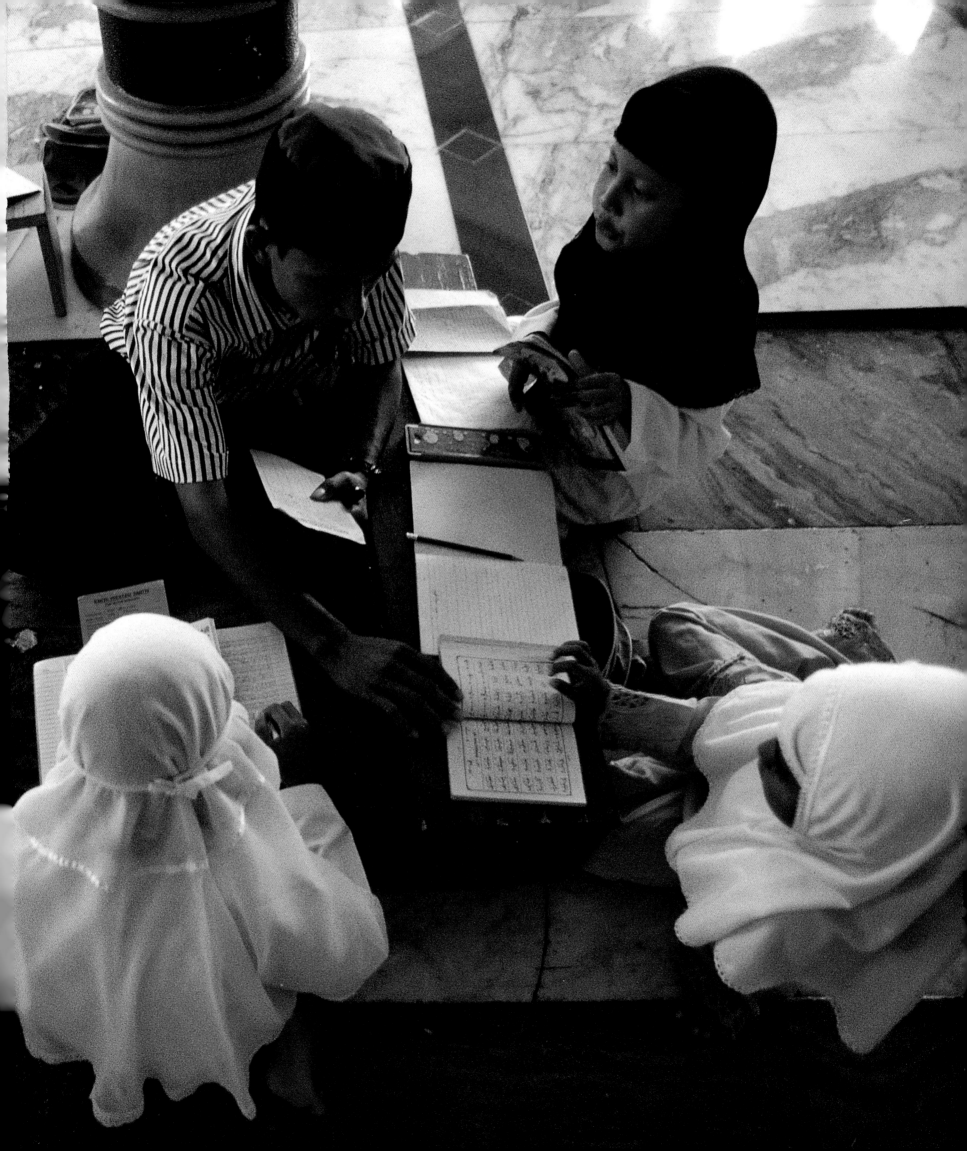

Muslim students cross the Sungai Golok River from the Thai border town of the same name to attend Islamic schools in Malaysia. Southern Thailand has a substantial Muslim minority though not enough Islamic schools — and hence the informal travel across the international border between the Southeast Asian neighbors. Supporters of Muslim schools say they imbue students with the Islamic traditions of learning and scholarship much the same way Catholic and Judaic schools do for Christian and Jewish children.

Fresh from a final examination in Islamic studies, commuter students at the University of Malaya suit up for their motorbike ride home despite the oppressive tropical heat of Kuala Lumpur. UM, as it's called, is Malaysia's most prestigious institution of higher learning. But a decades-old affirmative action policy that gives preference to the majority Malays, who hold proportionately fewer professional and managerial jobs in Malaysia, remains a source of tension with students of Chinese and Indian ancestry.

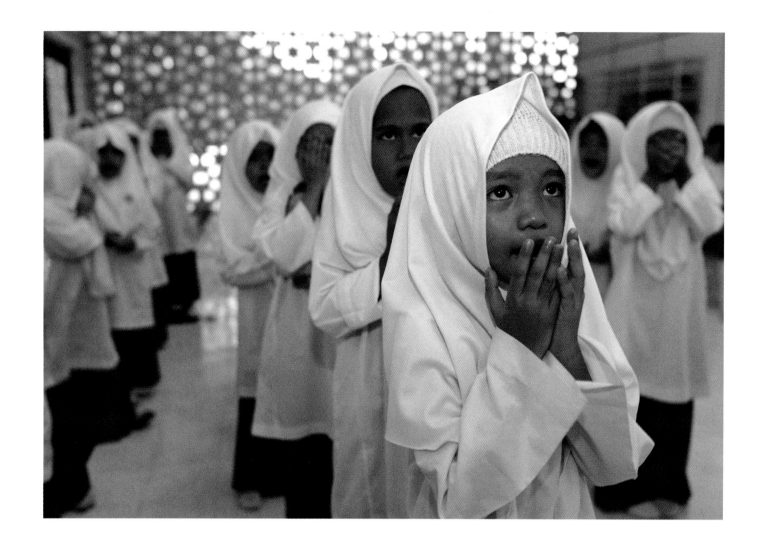

Learning the ways of Islam at an early
age, children pray in unison at an
"Islamic kindergarten," as it is called, at
the *Masjid Negara*, or National Mosque,
in Kuala Lumpur. Large mosques in
Southeast Asia often run their own
religious schools, where students
learn Arabic and study the Koran
and religious law.

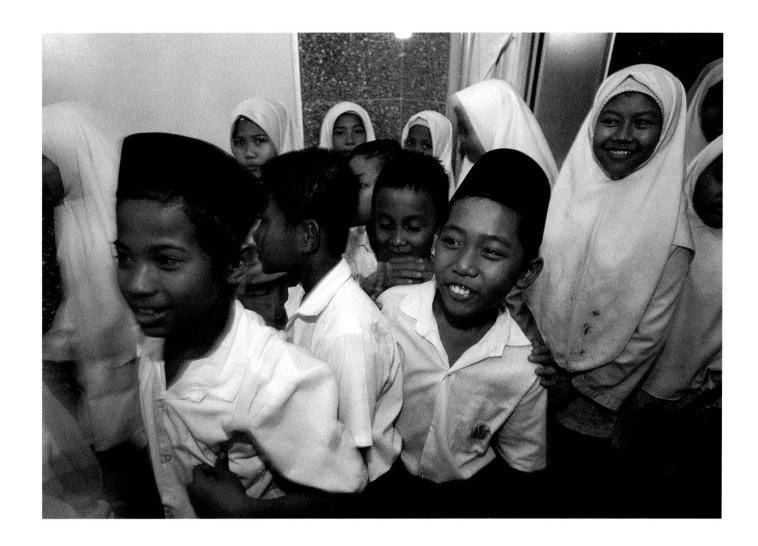

Ready for a mid-morning snack, students file out of their classroom at the National Mosque in Kuala Lumpur. Islamic schools runs by states and the federal government in Malaysia generally receive high marks for the quality of their instruction and teachers, but private religious schools have a more mixed record of academic achievement.

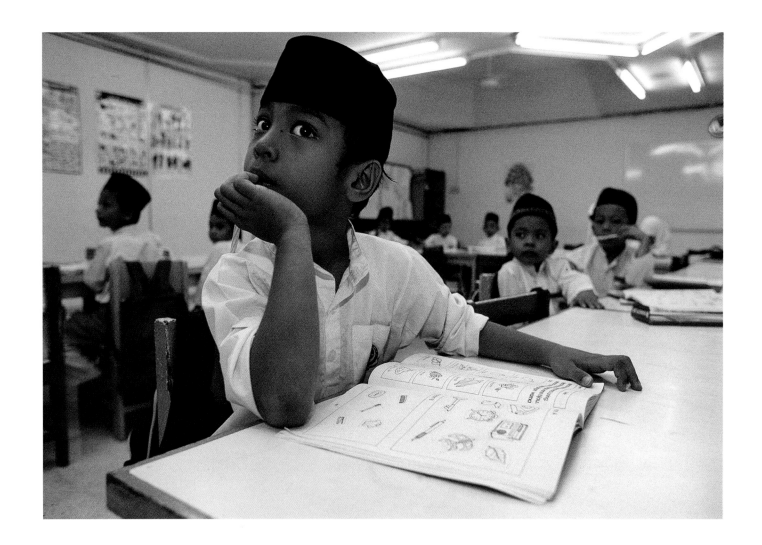

Reading the Koran in the original Arabic (right), a Malay girl in rural Selangor State discovers the subtlety and resonance of Islam's glorious holy book — something translations inevitably lack. Islamic schools like this one at the National Mosque in Kuala Lumpur (above) use Malay and English for academic subjects and Jawi, the Malay language written in Arabic script, for most religious instruction.

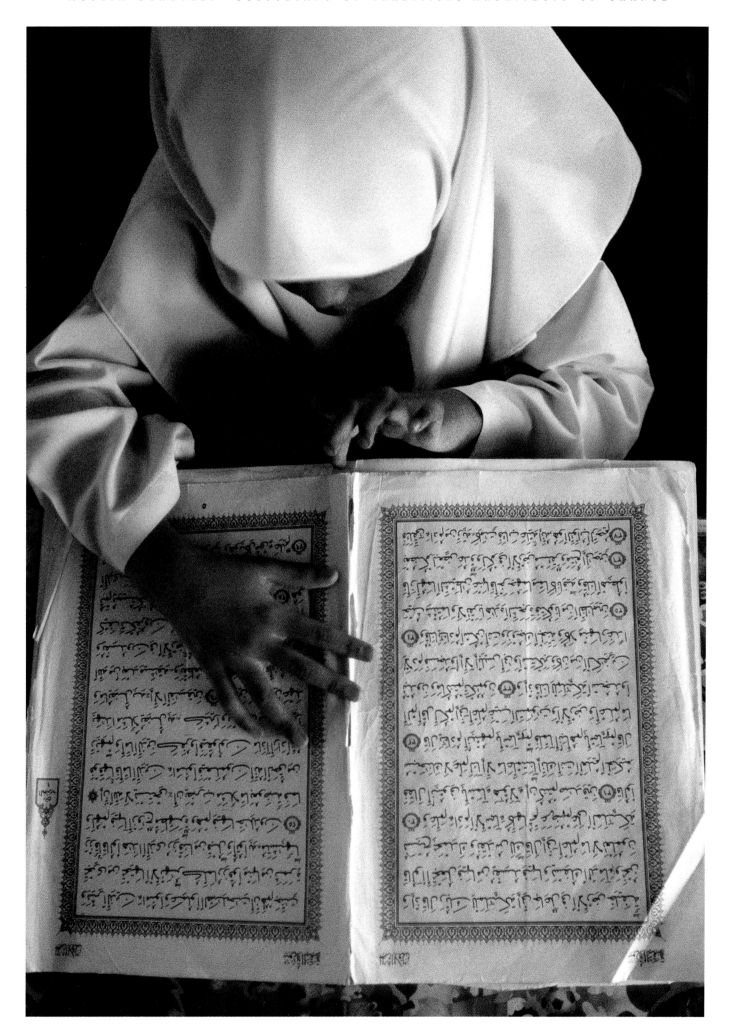

Even on the playground, students at Muslim schools like this one in Tanjung Pinang in Indonesia's Riau Islands learn the values of Islam — justice, charity, mercy, self-denial, and tolerance — that guide their daily lives. Launched as an alternative to deteriorating public education, thousands of new Islamic schools in Indonesia are graduating a generation of students who want Islam to play a greater role in setting a national agenda.

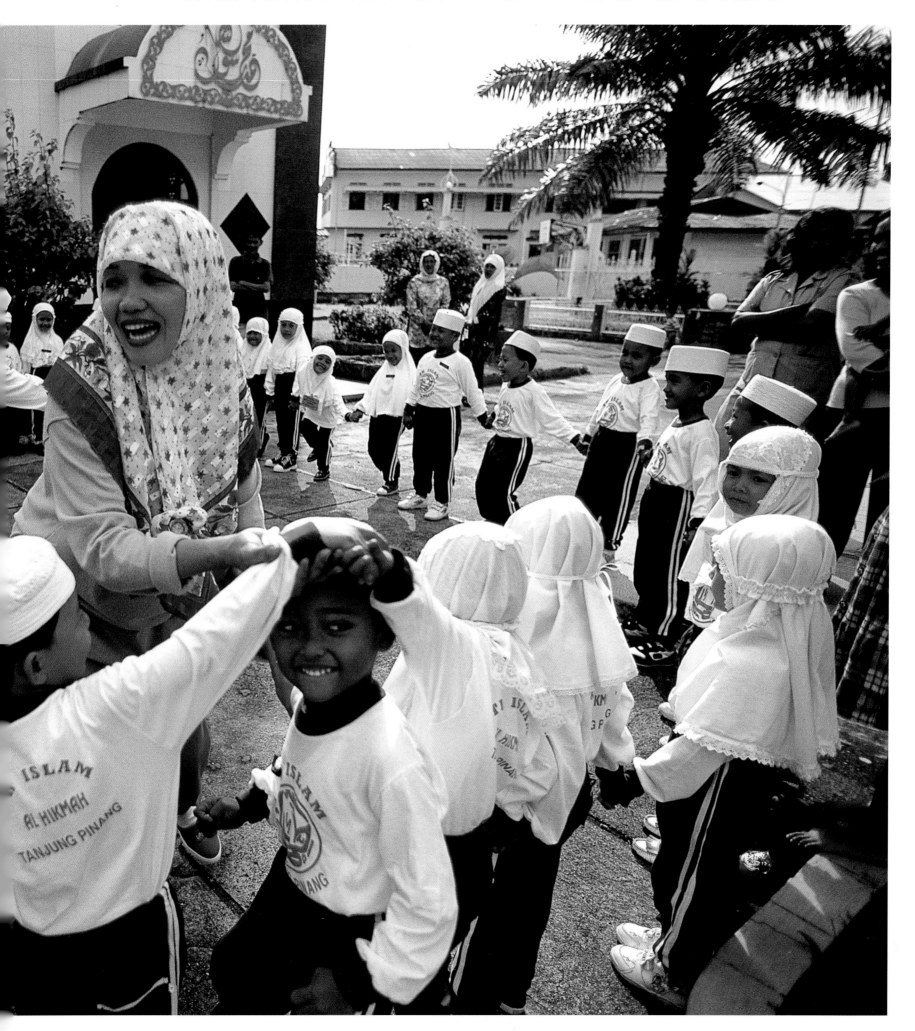

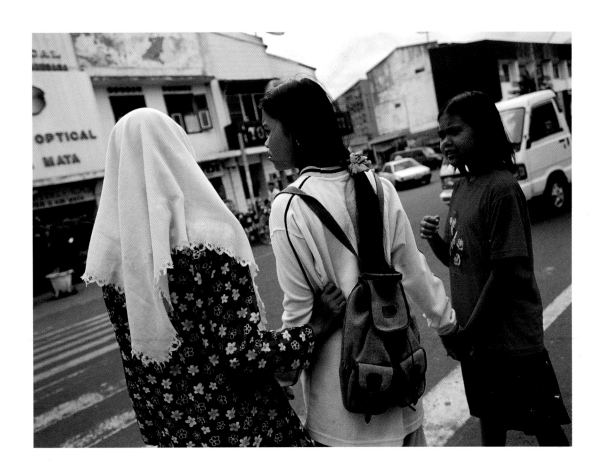

On the polyglot island of Lombok, Indonesian schoolgirls navigate the streets of Mataram, the modern capital of West Nusatenggara Province. Home to a mix of Sasak, Balinese, Chinese, and Arab peoples, Lombok practices a more easygoing form of Islam, with truncated holy periods and three daily calls to prayer instead of the customary five.

A gigantic Malaysian flag, painted on the wall of a public school near Kukup on the Straits of Malacca, summons students to identify with a multiethnic nation state. Traditional symbols of Islam, the crescent and star dominate the Malaysian flag, which is loosely modeled on the United States' Stars and Stripes.

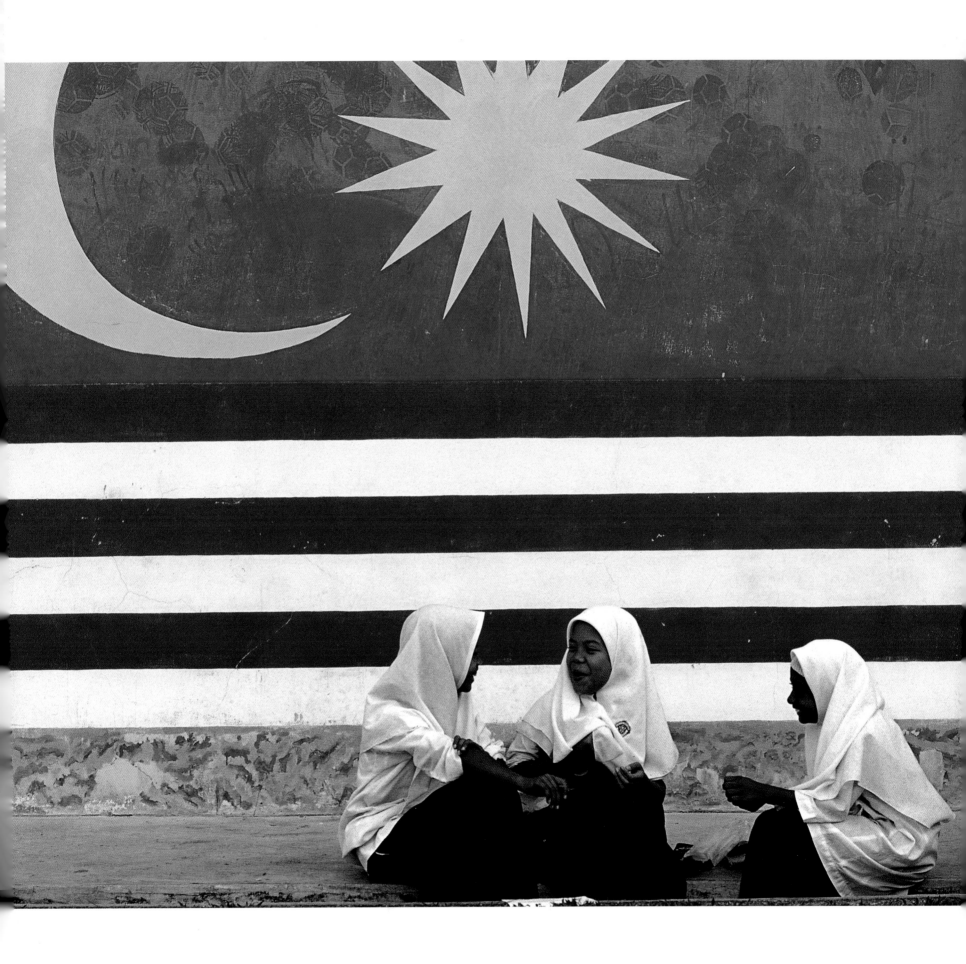

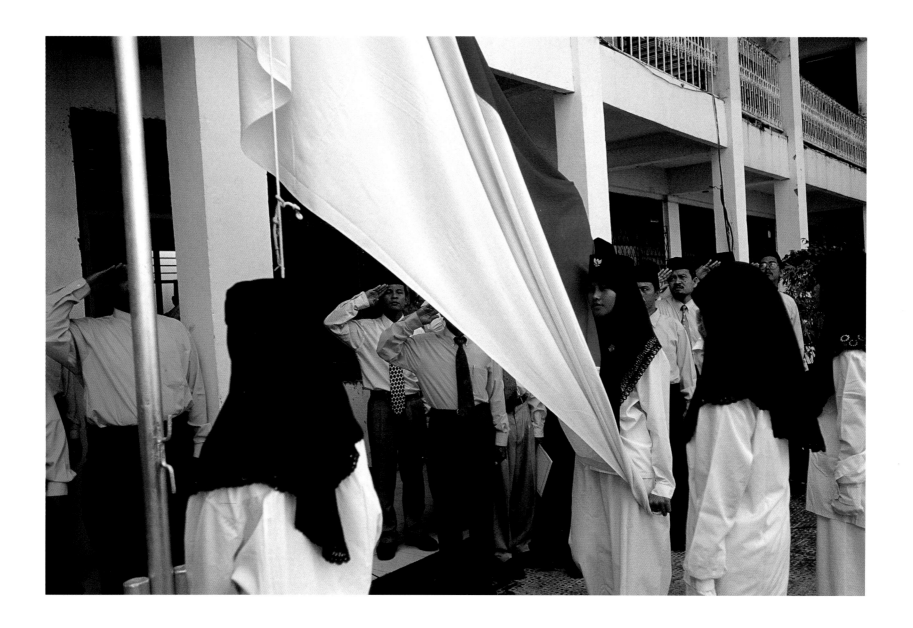

Religion and state are celebrated on the grounds of Asshiddiqiyah Islamic College outside Jakarta (above). A student honor guard raises the Indonesian flag while teachers and students salute the banner to the tune of the national anthem. Asshiddiqiyah School has three branches and 66,000 students, graduating record numbers of young people who say they favor greater democracy and stronger ties to the rest of the world.

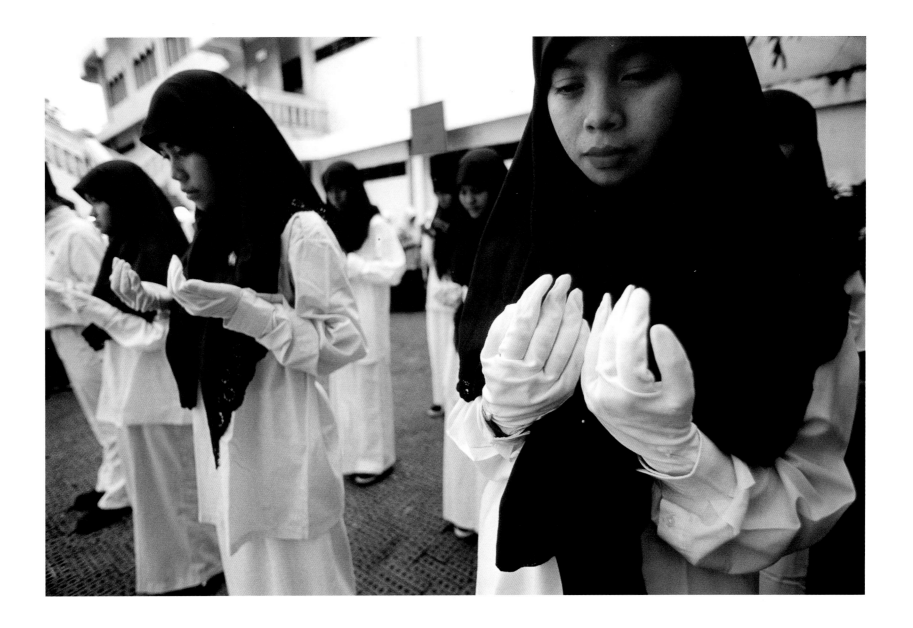

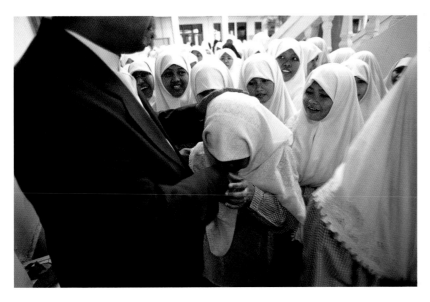

Asshiddiqiyah students also offer prayers at the beginning of classes (above), asking the blessings of God on Indonesia, their Southeast Asian neighbors, and leaders searching for peace in trouble spots around the world. Students say they want to help shape the nation's future, but not turn the world's fourth most populous society into an Islamic state. As a sign of respect (left), they kiss the hand of Rector Noer Muhammad Iskandar.

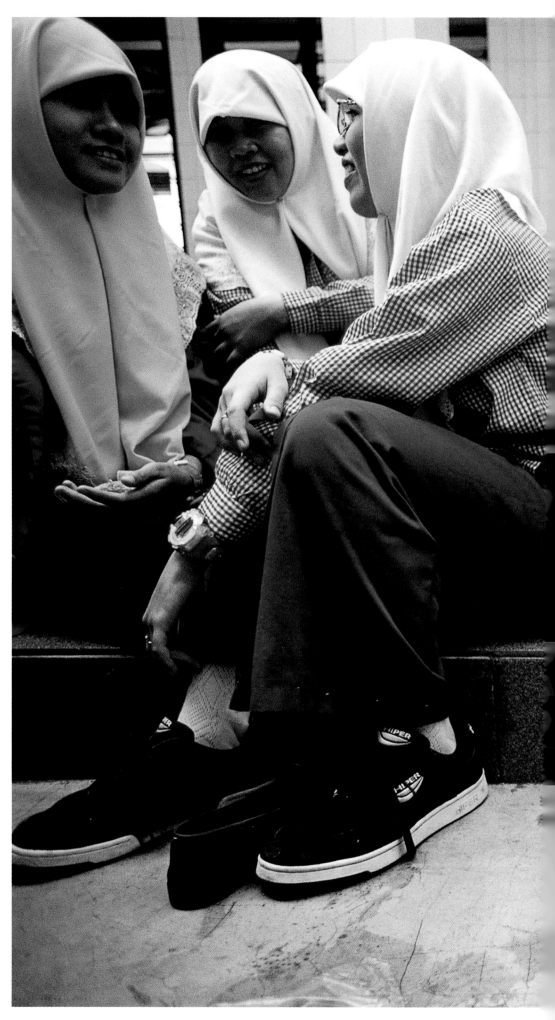

Gossiping about boys and popular music after noontime prayers, students at Asshiddiqiyah Islamic College outside Jakarta put on the thick-soled sneakers popular with teens everywhere. Students talk of pursuing careers in medicine, law, and education. A few want to enter politics to counter what they see as a rise in Islamic fundamentalism that threatens to undermine Indonesia's traditions of tolerance and secularism.

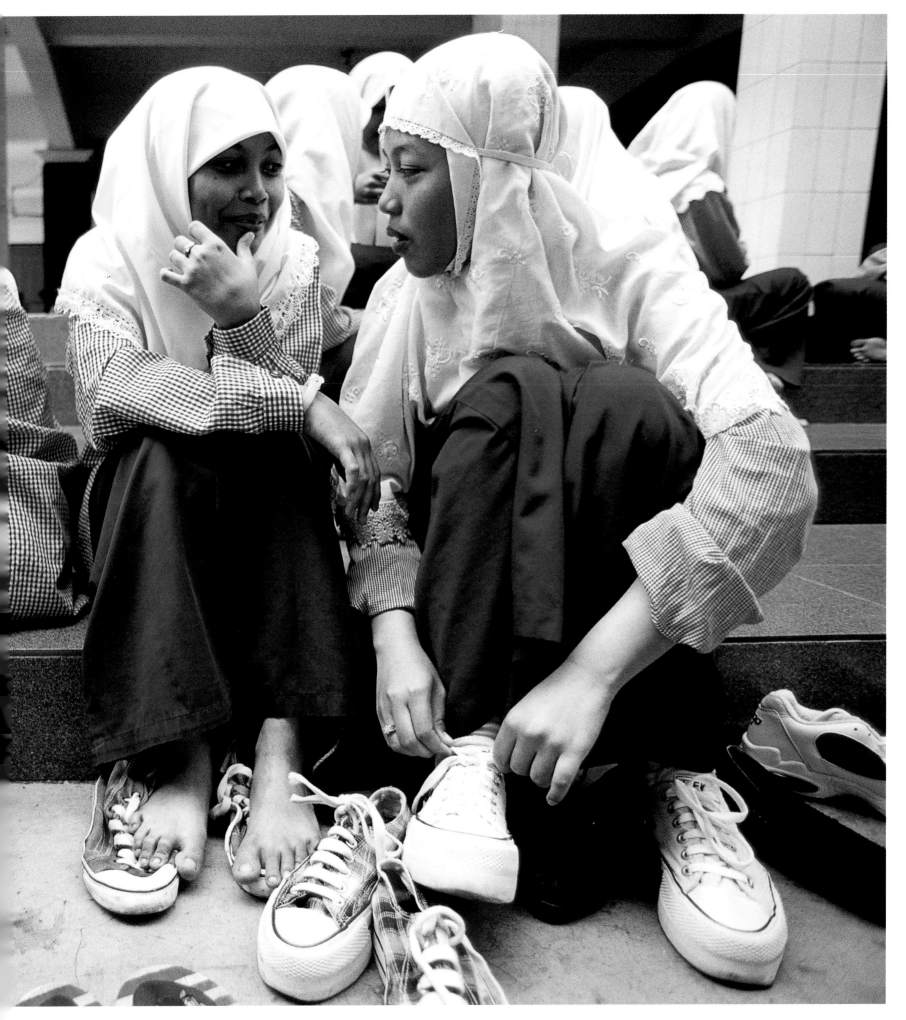

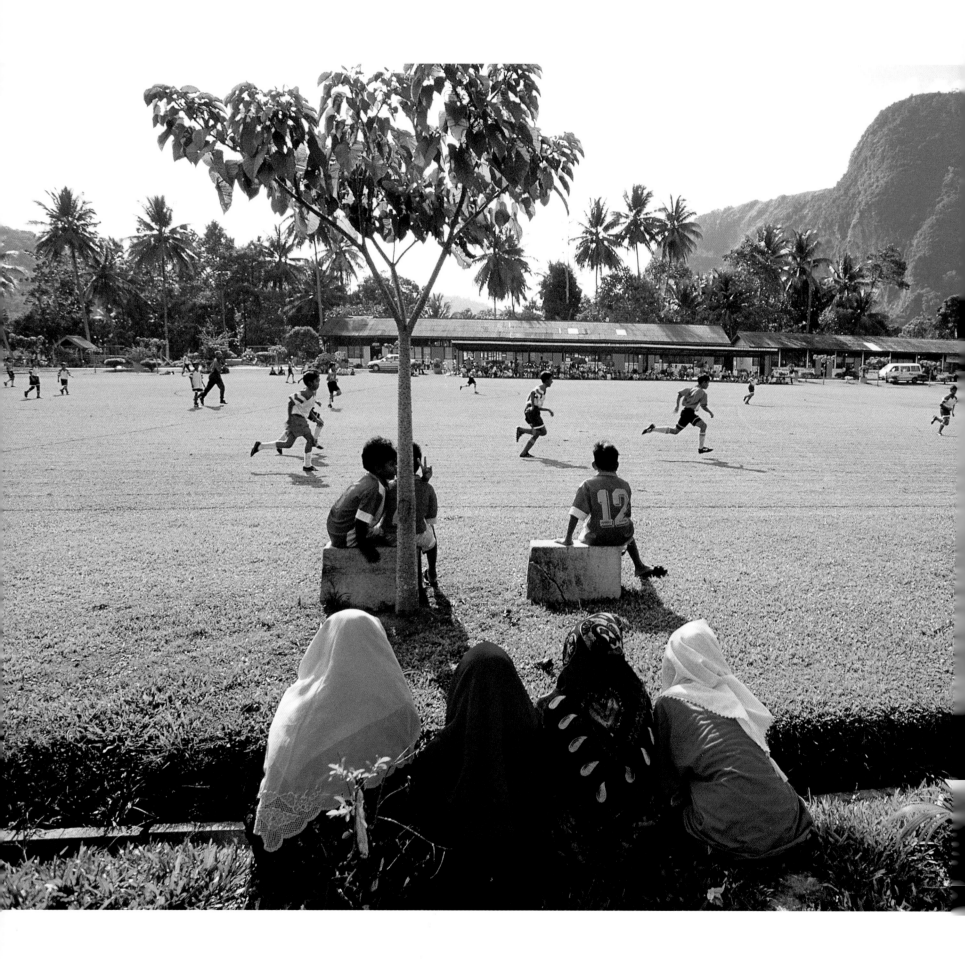

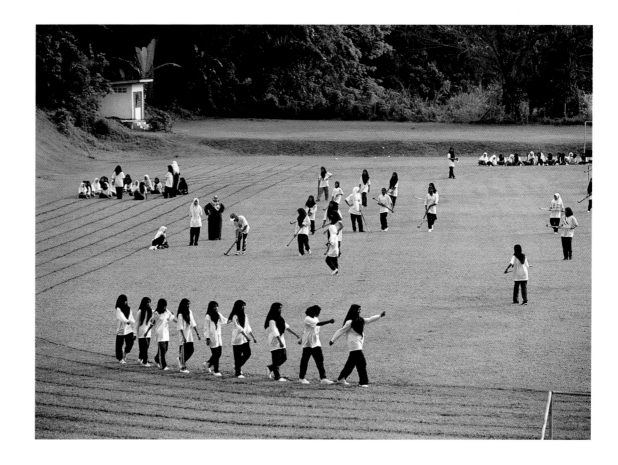

Like young people the world over, Malaysian students at a school near the provincial city of Taiping (left) are passionate about European-style football. The mountains of peninsular Malaysia, where British tea planters and tin barons once held sway, rise behind the city.

In the royal city of Kuala Kangsar, capital of Perak State and sultanate, the Raja Prempuam Kalsom girls' boarding school occupies the leafy grounds of the former British district commissioner's residence, where students practice for an upcoming field hockey match.

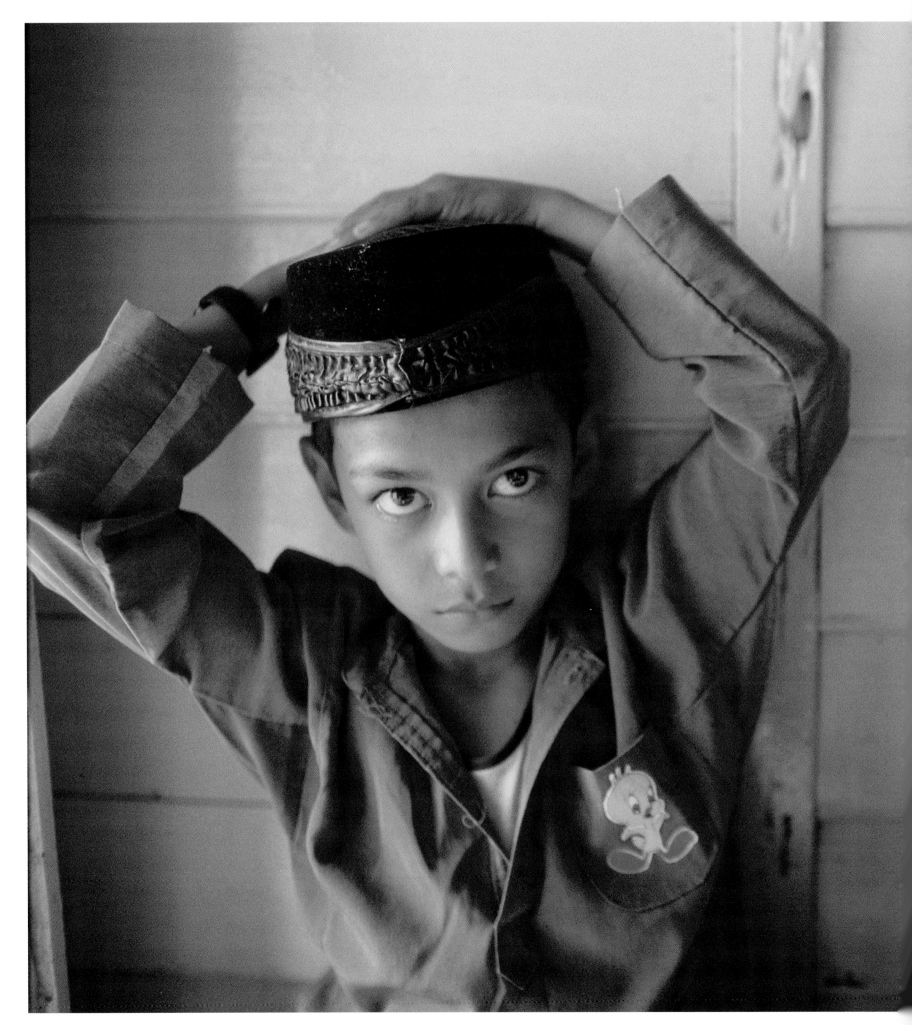

Boys in Kota Bharu await their Koran reading class, where they learn that Islam's supreme religious text has played an important role in the development of Arabic grammar, vocabulary, and syntax. In addition to state-sponsored religious schools, hundreds of austere and unregulated *sekolah pondok*, literally small hut schools, have grown up around Malaysia to satisfy a demand for grass-roots Islamic education. But officials worry that pondok may also fuel Muslim fundamentalism and antigovernment sentiments.

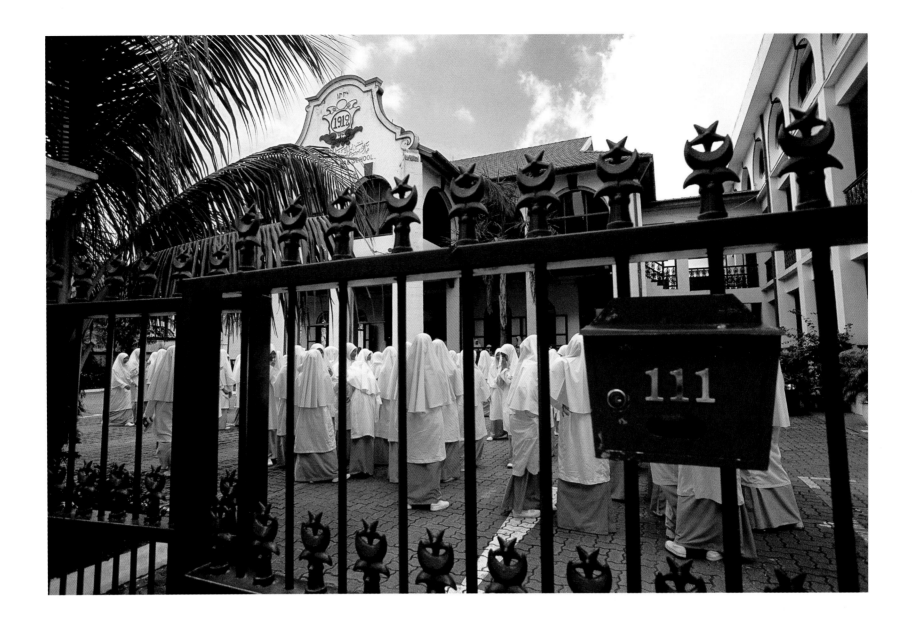

Students assemble inside the
gates of the Madrasah Alsagoff
Al-Arabiyah in the Arab Street Quarter
of Singapore. The school was built in
1912 by an Arab businessman, Syed
Mohammed Alsagoff, and is the oldest
of six full-time Islamic schools on the
island city-state. Students attend
classes in Islamic studies and Arabic, in
addition to the standard curriculum of
English, mathematics, and the
Malay language.

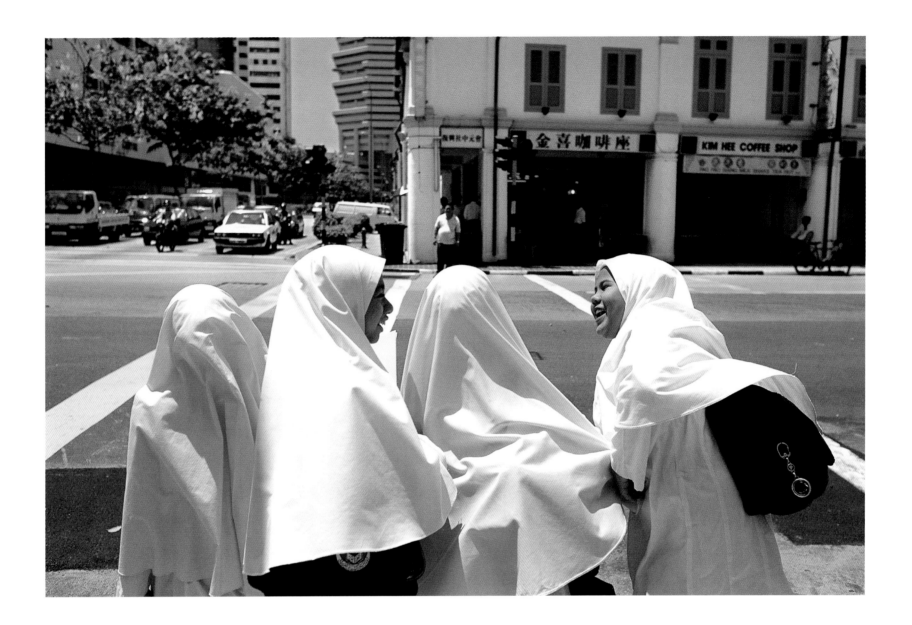

Finished with classes, students of Singapore's Madrasah Alsagoff Al-Arabiyah wait for a bus along crowded North Bridge Road, where the sidewalks are lined with Islamic restaurants and stores selling prayer mats, carpets, and alcohol-free perfumes. In addition to the full-time schools like historic Madrasah Alsagoff, Singapore has 27 part-time Islamic schools affiliated with mosques.

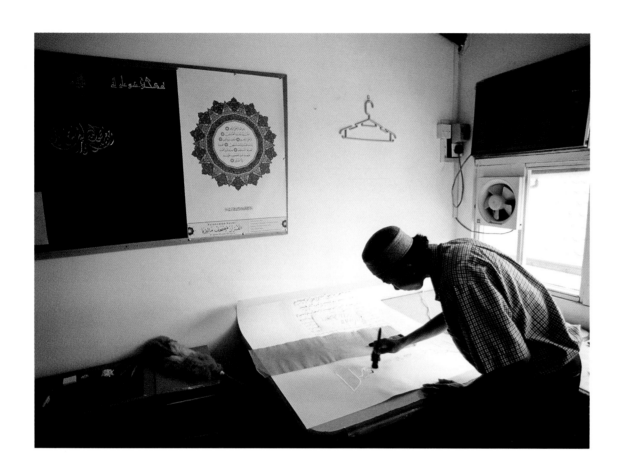

A specialized form of calligraphy called "text illumination" is a traditional Islamic art form being rekindled through a project called Al-Quran Mushaf Malaysia in Kuala Lumpur. Calligraphy (above) has been combined with decorative art, including colors and materials native to Malaysia, to create a 630-page manuscript of the Koran. Begun in 1997, the five-year-long project combined the skills of engineers, graphic designers, artists, gold-leaf specialists (right), and many student artists and assistants.

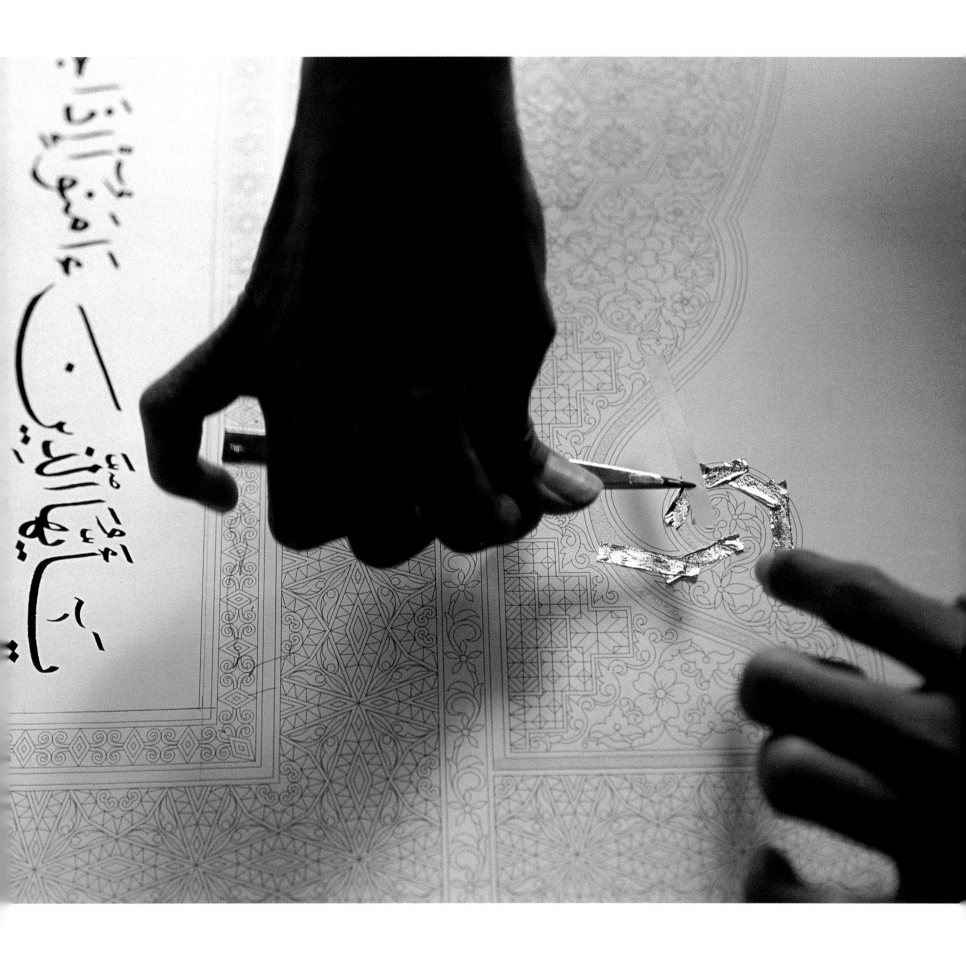

A schoolgirl dashes for home in tiny Brunei Darussalam, a sleepy country of some 330,000 devout Muslims who enjoy free education and healthcare — and at $25,000, the highest per capita income in Southeast Asia. Brunei derives its wealth from offshore oil and natural gas fields, whose earnings help send university-age students to study abroad. Another 2,800 students attend the University of Brunei Darussalam, a teaching and research institution that opened in 1985 with faculty from Malaysia, Singapore, and Great Britain.

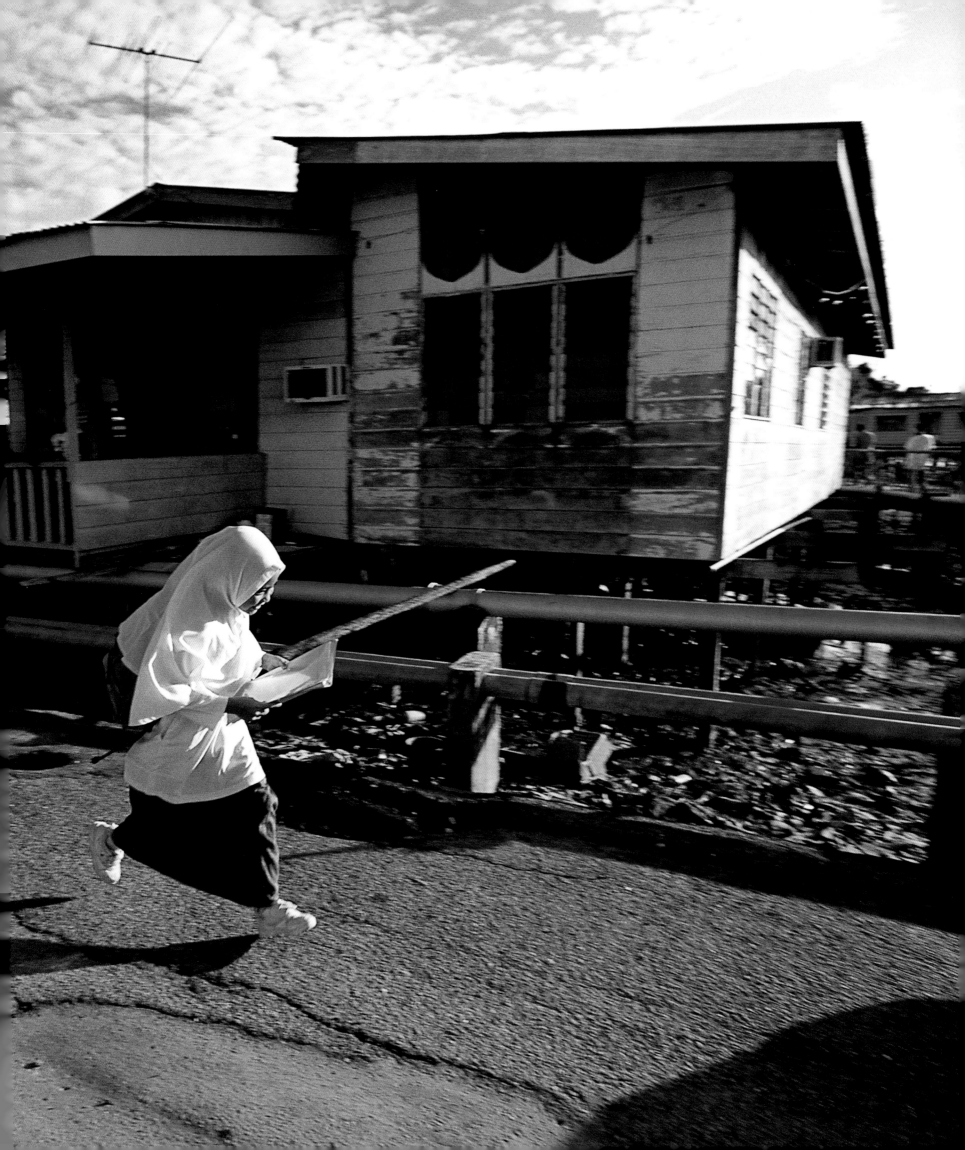

THE VILLAGE
TRADITION AND TRANSITION

Perhaps as many as half the Muslims of Southeast Asia live in villages of a few thousand people or less, according to studies by the United Nations, the World Bank, and other international development agencies. Life in the *kampong*, as villages are often called, can feel eternal, predictable, and generally unhurried. But reality is a bit more complicated. Many Southeast Asian Muslims are increasingly caught up in a complex pattern of urbanization that is changing the character of life and faith in the kampong.

Villages that once relied exclusively on rice growing or fishing for their livelihood now have new neighbors — golf courses, industrial parks, and squatter encampments. And while some of these new neighbors bring the promise of more money and a higher standard of living, they also have made life in the kampong a bit more like life in the city. Along with more job choices and higher incomes, development — and what Westerners call suburban sprawl — has brought more crime and economic insecurity. For example, some four million Indonesians living in the capital Jakarta were forced to return to their villages when their jobs vanished during the Asian economic crisis of the late 1990s.

Increasingly, villagers are becoming a pool of cheap labor, especially in Malaysia, Indonesia, and the Philippines. On buses and the backs of motorbikes, they shuttle between their kampong and new jobs that are usually found at the edges of Southeast Asia's ever-expanding cities. Villagers are cogs in an economic engine that demographers call "extended metropolitan regions." Some of these EMRs are so big and so complex that they cross international borders, as in the case of Singapore — an affluent city-state — and the adjacent regions of Johore in Malaysia and the Riau Archipelago in Indonesia.

Even Cambodia, one of the poorest countries in Asia and the world, is caught up in this urban-rural web. At dawn most mornings, ethnic Cham Muslims leave their kampong to ply the muddy Tonlé Sap River and faster-moving Mekong, bringing fish, meat, and produce to Phnom Penh, once the loveliest of the French-built cities of Indochina. Without the Cham, say residents of Cambodia's capital city, they wouldn't eat.

The Cham, it turns out, are working hard to rebuild traditional kampong life. A tiny band of Muslims who trace their lineage to an ancient empire in central Vietnam called the Kingdom of Champa, the Cham today live in villages full of noisy children, palm-shaded gardens, and houses built on stilts, the better to withstand monsoon floods that can turn the lush tropical landscape into a sea of red mud. But like too many kampong in Cambodia, theirs have a terrifying past. The Cham once lived among the "killing fields" of Pol Pot and his genocidal Khmer Rouge army, which murdered an estimated 1.7 million Cambodians as they sought to turn the country into an agrarian utopia in the 1970s. When Phnom Penh fell to the Khmer Rouge in April 1975, the country was home to an estimated 800,000 Cham. A decade later, three of every four Cham were dead, a war crime so enormous that many in the West called it genocide.

Survivors tell of executions and mosque desecrations. "The Khmer Rouge burned our Korans or made us use them for toilet paper," recalls Hussein bin Omar, a fish merchant

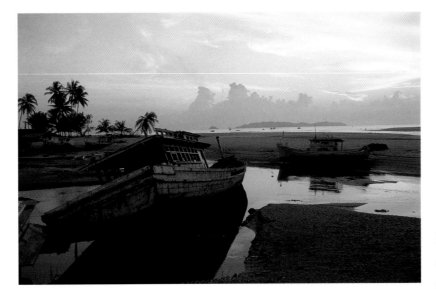

The Malaysian village of Marang wakes up to a new day as dawn breaks over the South China Sea.

who survived Pol Pot's reign of terror. "They kept pigs in our mosques and even used them as prisons."

Today Cham kampong are interspersed with Buddhists and Christian enclaves, moving in a sort of harmony that is sometimes difficult to find in other parts of Southeast Asia. Along with their fellow Cham in Vietnam, they are silk weavers, fishermen, and butchers — the latter trade because the prevailing Theravada Buddhism of Cambodia forbids the Khmer to slaughter animals. Several hundred Cham annually make the once-in-a-lifetime pilgrimage to Mecca — the *hajj* — courtesy of Saudi Arabia, which has used some of its oil wealth to help revive a semblance of Muslim life in Cambodia. Younger Muslims dream of attending high school or university in neighboring Malaysia, and some will, thanks to scholarships that promise a new beginning from what Pol Pot called "Year Zero."

For all their tragic history, the Cham live by a clock that is not so much slow as it is timeless. And they are by no means the exception in rural areas of Southeast Asia. It matters little whether the kampong is in Cambodia, southern Thailand, Malaysia, Brunei, or somewhere in the vast, anchor-shaped Indonesian archipelago. Muslims rise for early morning prayers called *fajar*, go to work or attend school at an early hour, pray several times more during the day, laze on the veranda toward late afternoon, perhaps watch a bit of TV or play some sports, and pray before going to bed — five times a day in all. What every kampong seems to have in common, besides a mosque, is a level of comfort between neighbors, despite being densely packed in clusters of unpretentious houses usually made of teak. In the kampong, Muslims speak of shared values and a common ancestry — something unimaginable in Asia's congested and convulsed cities.

Today it is fashionable for Muslim city dwellers and intellectuals to criticize rituals that may have their origin in ancient Hindu or animist traditions — practices that predate the arrival of Islam in Southeast Asia. But Muslims of the kampong have long adhered to these traditions. In Malaysia, for example, villagers loudly applaud shadow puppets shows called *wayang kulit*. And they cheer newly married couples sitting on a colorful dais for all to admire — a custom called *bersanding* that anthropologists think is derived from Hindu court traditions. Malay villagers also talk of a palpable natural force called *semangat*, along with a host of lesser and usually invisible spirits. Some believe this animist magic can affect everything from the yield of this season's rice crop to the number of children that will bless a family.

For the most orthodox Muslims, of course, these beliefs come close to heresy. Islam is, after all, a faith in one God, a pure monotheism. But like it or not, the kampong remains a curious mix of shared customs and beliefs, some more ancient than others. Births and deaths, circumcisions and weddings, dry season and monsoon rains — all come and go like the tides of the South China Sea, whose proximity links the Muslim world of Southeast Asia.

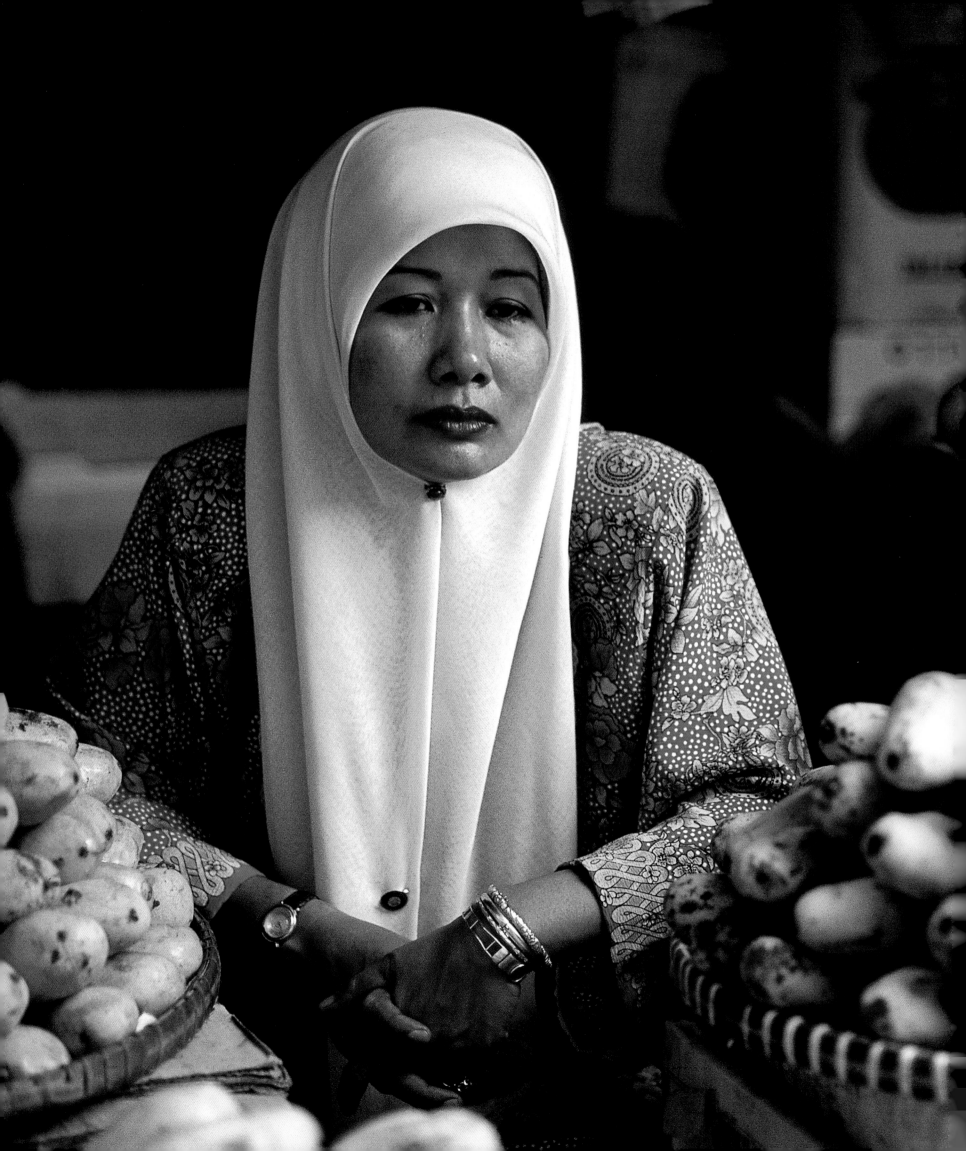

Bounty of the Malay Peninsula, village-grown tropical fruits fill a foodstall on a busy north-south highway near Kota Bharu. Connoisseurs from cities like Singapore and Kuala Lumpur drive hours to find just the right well-stocked stand, where they pinch, smell, and buy fruits like durian – considered the "king of fruit" by Malays – as well as pineapple, papaya, hairy red rambutan, golden and white mangoes, passion and star fruits, mangosteen, guava, and bananas.

Clouds gather over the Bukit Barisan Mountains on the northwest tip of Sumatra, where a lone cyclist peddles through the village of Kutalaseumana in remote Aceh Province. Traditionally the Indonesian archipelago's first point of contact with outside influences, Aceh welcomed many faiths over the centuries, including Hinduism, Buddhism, and Islam, which arrived with Arab and Indian traders between the ninth and 13th centuries.

For easygoing villagers of Kelantan State, coffee shops are an institution — a place to catch up on news, exchange gossip, and enjoy something to drink, which on Malaysia's conservative east coast means sweet tea and soft drinks. Kelantan is considered a rustic bastion of Muslim Malay culture, in part because it largely did not experience the influx of Chinese and Indian immigrants who came to British Malaya to work the tin mines and rubber plantations.

Reverent in the presence of royalty, a caretaker (right) tends the graves of Acehnese royalty in a small kampong near Banda Aceh. Under Sultan Iskandar Muda, Aceh became a major 17th-century Southeast Asian trading post with its own currency and international trade agreements.

Far to the south on Penyengat Island (above), considered the cultural capital of the Malay world during the 19th century, villagers tie yellow cloth — the traditional color of royalty — on the headstones of notables and wish for miracles.

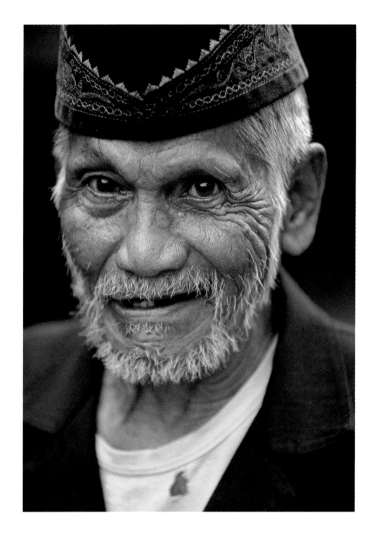

A grandmother cares for children (left) on tiny Penyengat Island, where the relaxed and aristocratic villagers trace their ancestry to Bugis and Malay nobility. The island sits astride the sea-lanes off Singapore, but is part of Indonesia's Riau Islands. Septuagenarian Muhammad Yusuf (above) served as an Indonesian Marine commando before retiring to a fishing village along the Indian Ocean coast in Aceh Province.

Sunset Beach lives up to its name along the windblown Indian Ocean coast of Sumatra in northern Aceh Province, where Arab, Indian, Portuguese traders first made landfall in Southeast Asia. A former Islamic kingdom with its own proud past, oil-and-gas-rich Aceh led the battle against Dutch colonial rule. After Indonesia achieved independence in 1949, the country's first president, Sukarno, promised to make Aceh a special autonomous region but never followed through.

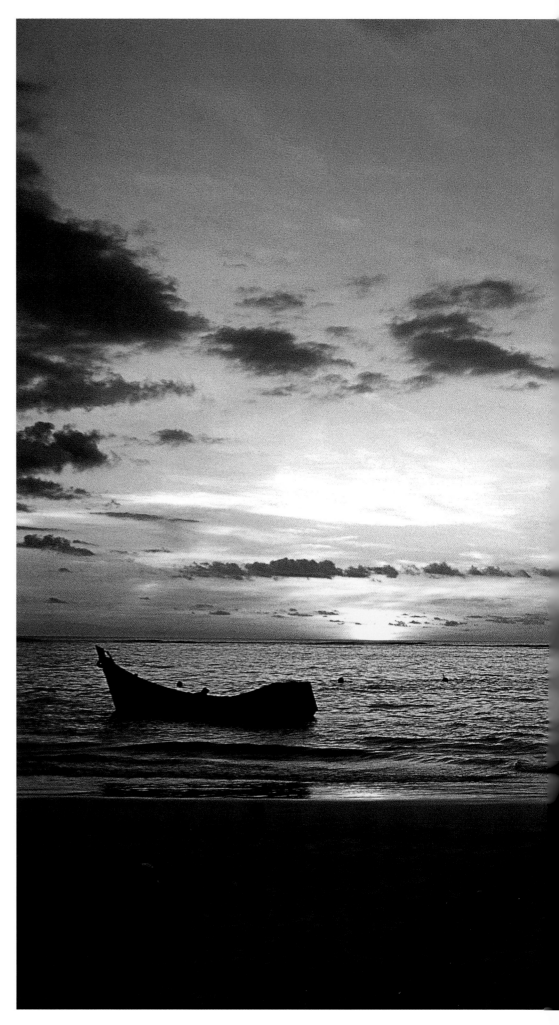

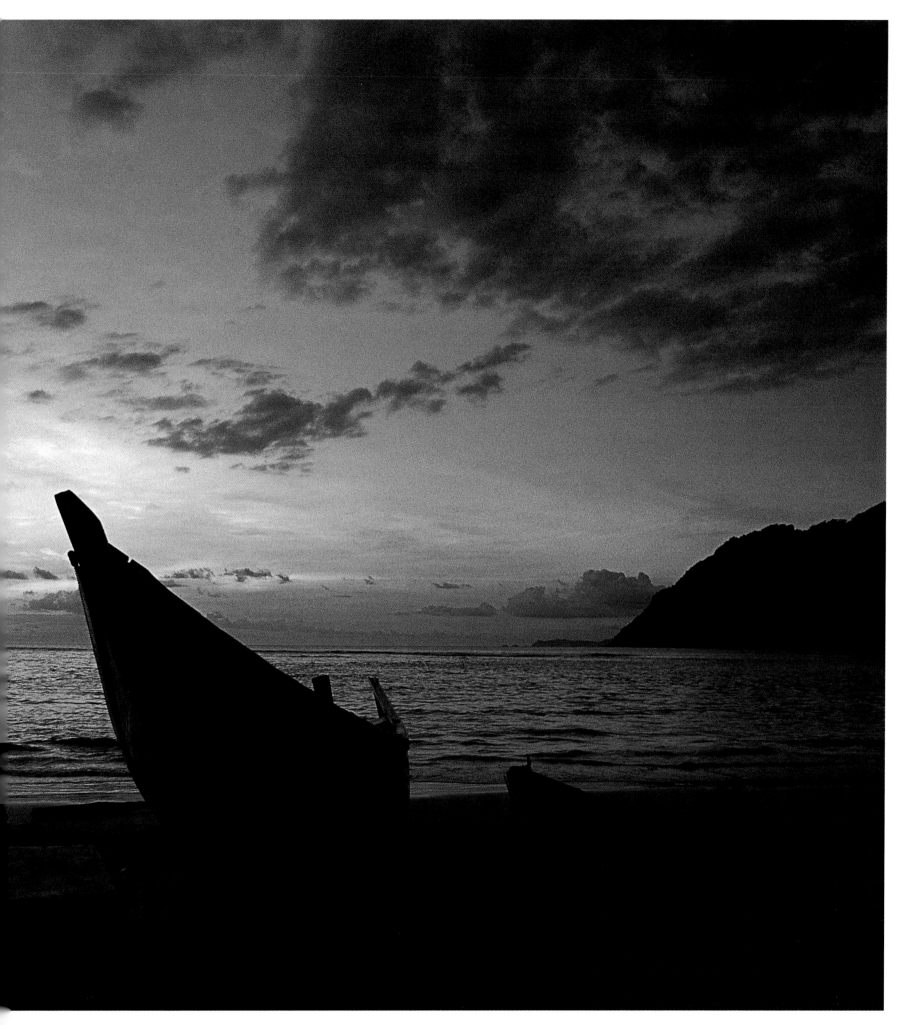

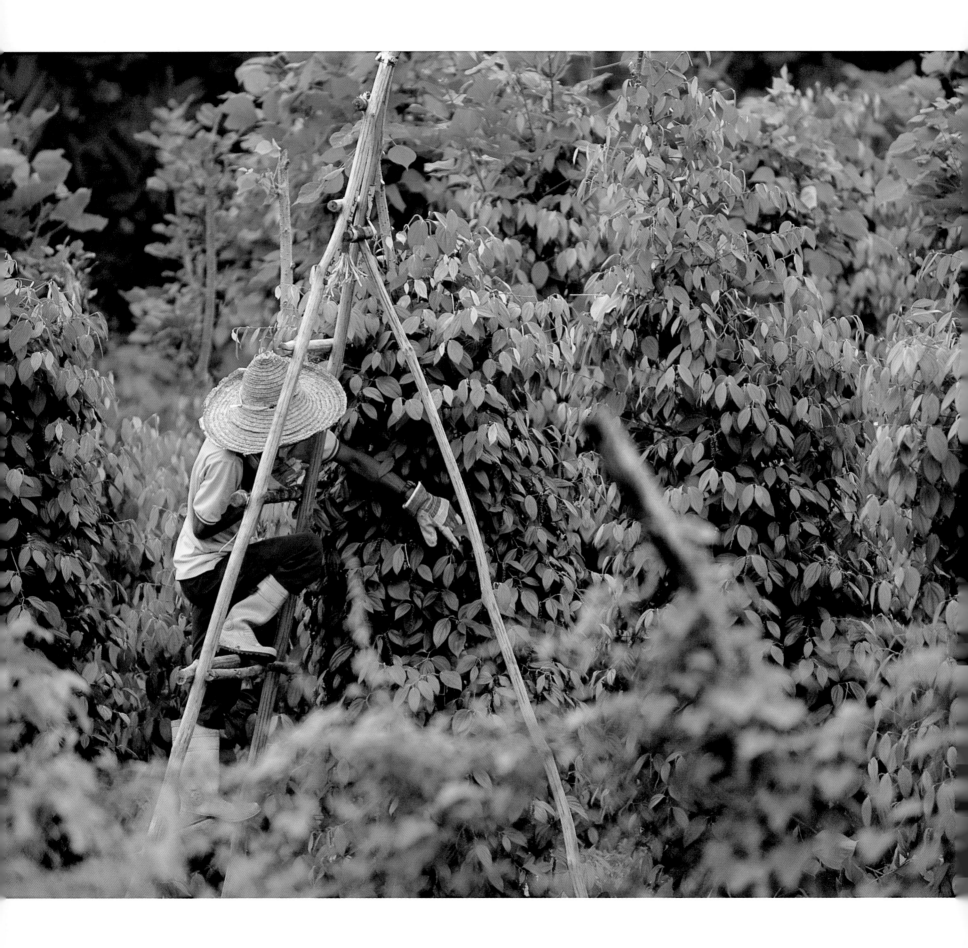

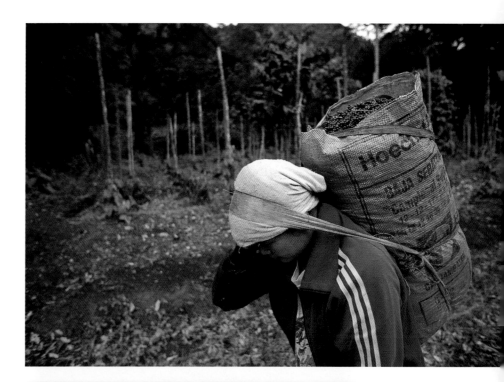

Pepper is king in Sarawak on the island of Borneo, where thick vines (left) thrive in the hills near Serian. Muslim spice merchants from Arabia and India brought Islam to coastal trading ports of Borneo and the Indonesian archipelago, returning home with pepper, cinnamon, cassia, nutmeg, cloves, ginger, and turmeric. Green pepper berries (lower right) are picked, hauled to collection points (upper right), then sun-dried until their skins become black and wrinkled. Today, Sarawak black and ivory white pepper is exported to more than 40 countries.

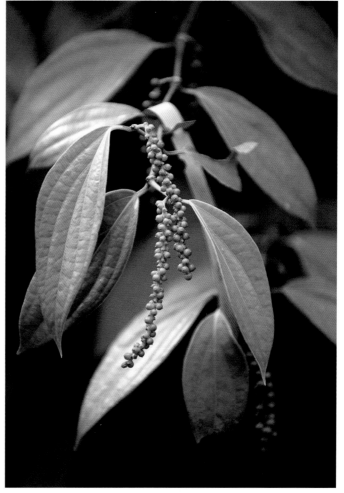

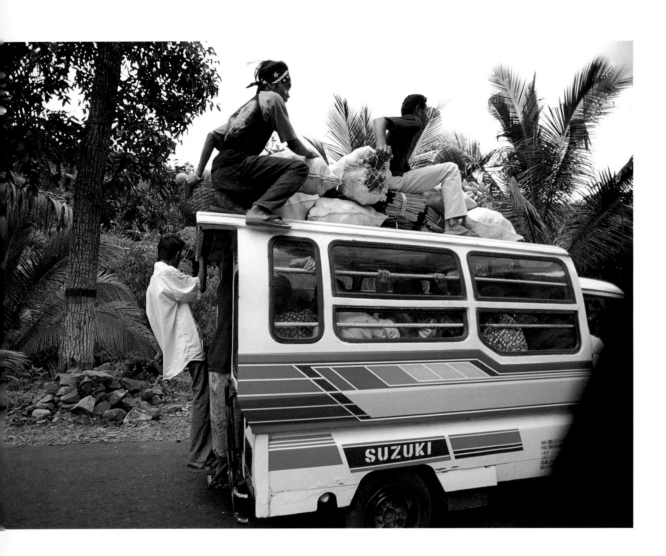

Loaded with villagers and their crops, a pickup-turned-taxi (above) hurtles down the slopes of 3,800-meter (12,300-foot) Gunung Rinjani, second highest peak in Indonesia, on remote Lombok Island. Famous for rugged scenery, white beaches, and an easygoing Islamic lifestyle, Lombok has little arable land.

Children help with the harvest on Lombok Island (right), where hardscrabble Muslim Sasak farmers have turned rice terraces into tobacco plantations. Most of the island's population lives on a narrow 25-kilometer (16-mile) strip of land between high mountains and the surrounding Indian Ocean, the Bali Sea, and the Lombok Strait.

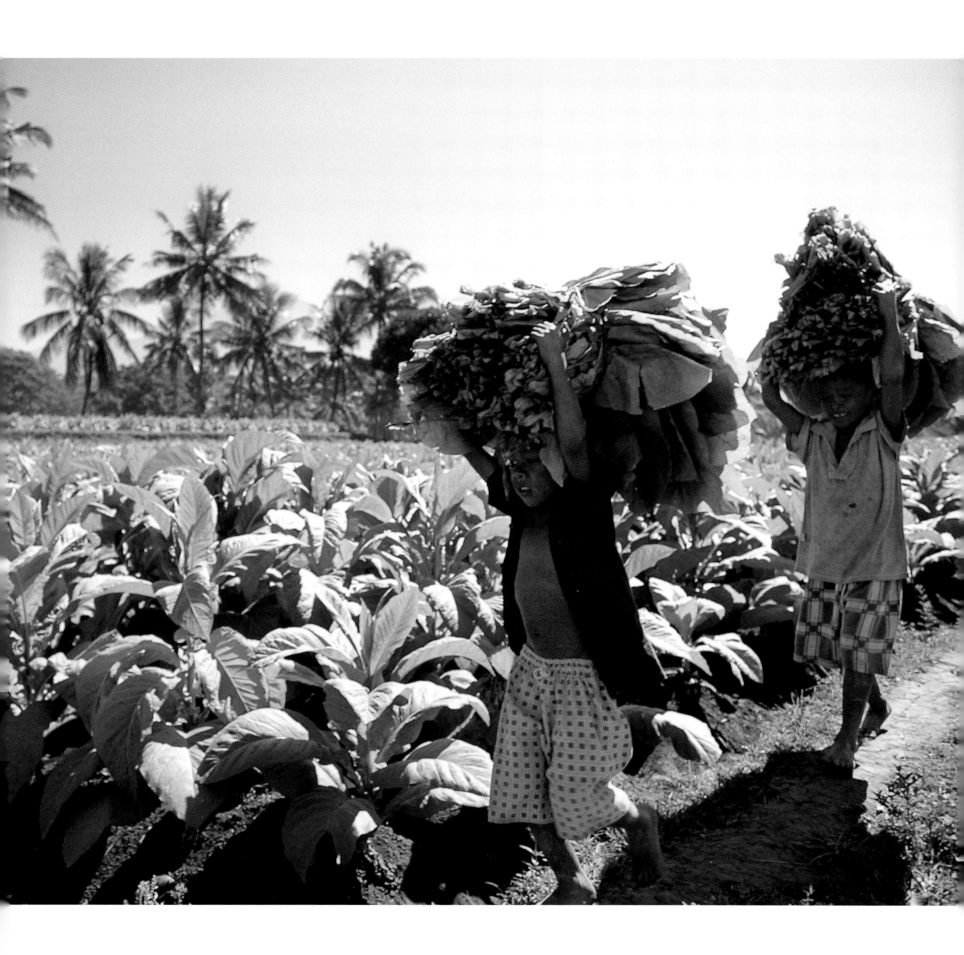

At sunrise, fishermen from the staunchly Muslim village of Marang, on Malaysia's east coast, net their quarry at low tide. Few coastal vistas can compare with the view across the Marang River estuary, where fishing boats come and go with the South China Sea tides. The ocean brought Muslim traders to Southeast Asia, where coastal villages and ports were the first to convert to Islam.

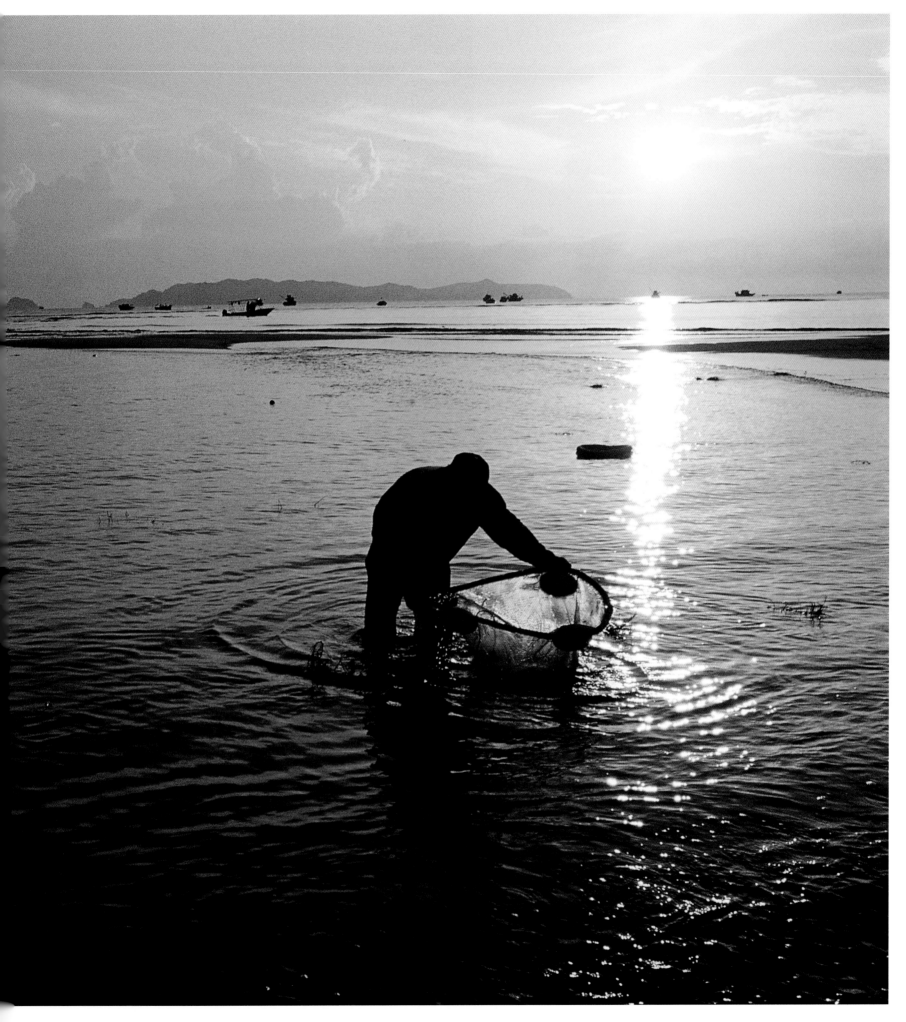

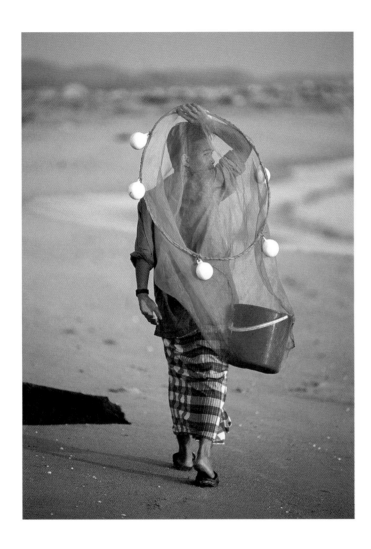

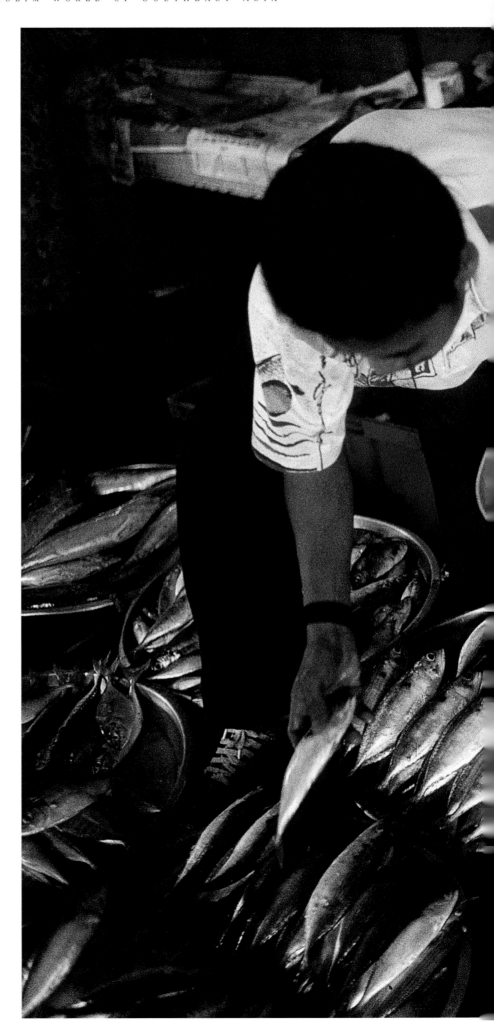

A fisherman (above) sets off to harvest the Marang River estuary. The day's catch — mullet, snapper, tuna, mackerel, pike, and perch — is on display at the Central Market in Kota Bharu, capital of Kelantan State and sultanate. The eight-sided building has its so-called "wet" side for fish and meat, and other sections for fruits, vegetables, and spices, all testimony to Malaysia's abundance.

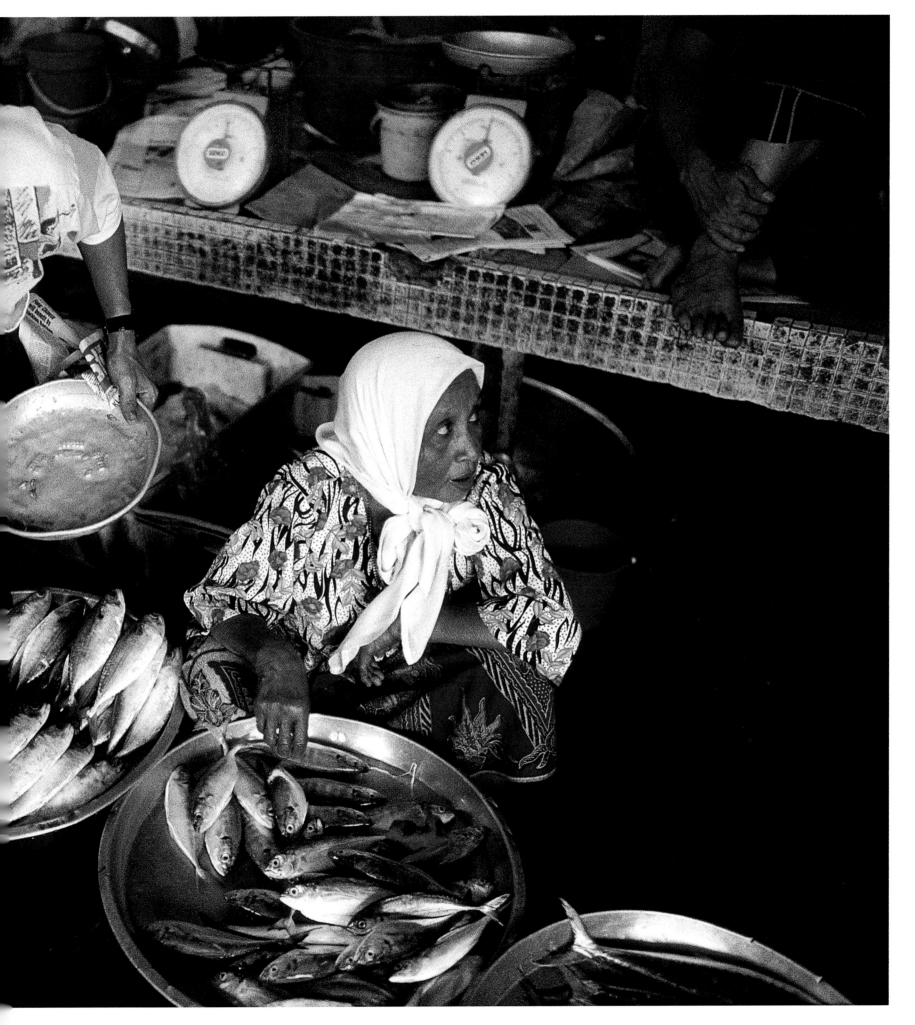

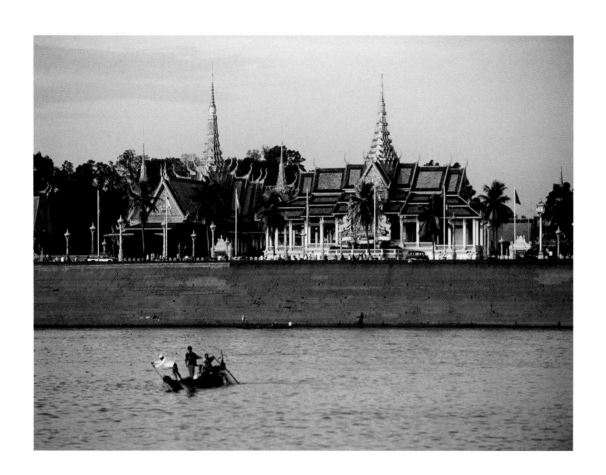

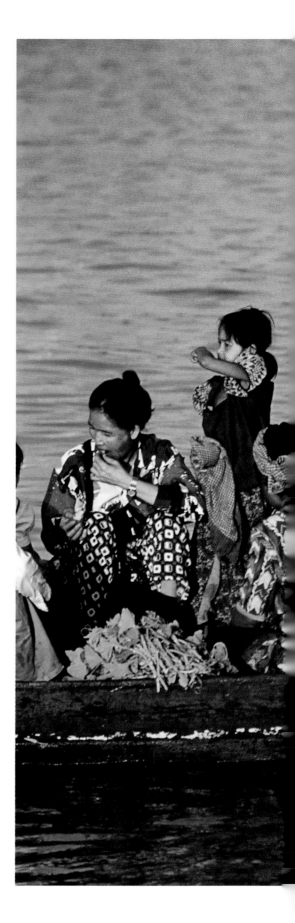

Cham Muslim fishermen ply the Tonlé Sap River in front of Phnom Penh's Royal Palace and Silver Pagoda (above), two of Cambodia's most revered shrines and home to King Norodom Sihanouk. In a twist of geography and faith, the spiritual center of Cham Muslims is a spit of land opposite the capital of the overwhelmingly Buddhist country.

A low-slung boat packed with Cham Muslim traders crosses a tributary of the fabled Mekong River, bringing produce, meat, and fish to Phnom Penh, capital of Cambodia. Because the prevailing Theravada Buddhism forbids Khmers from slaughtering animals, the Cham — Cambodia's largest minority group — also are the country's butchers.

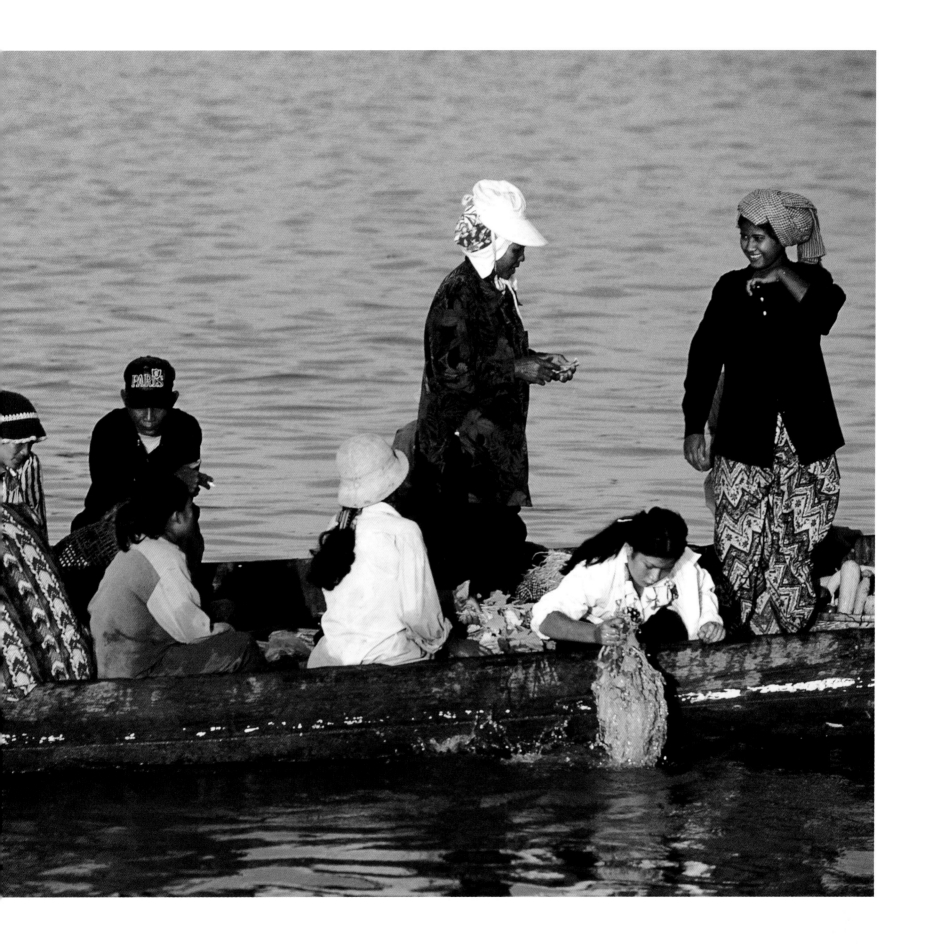

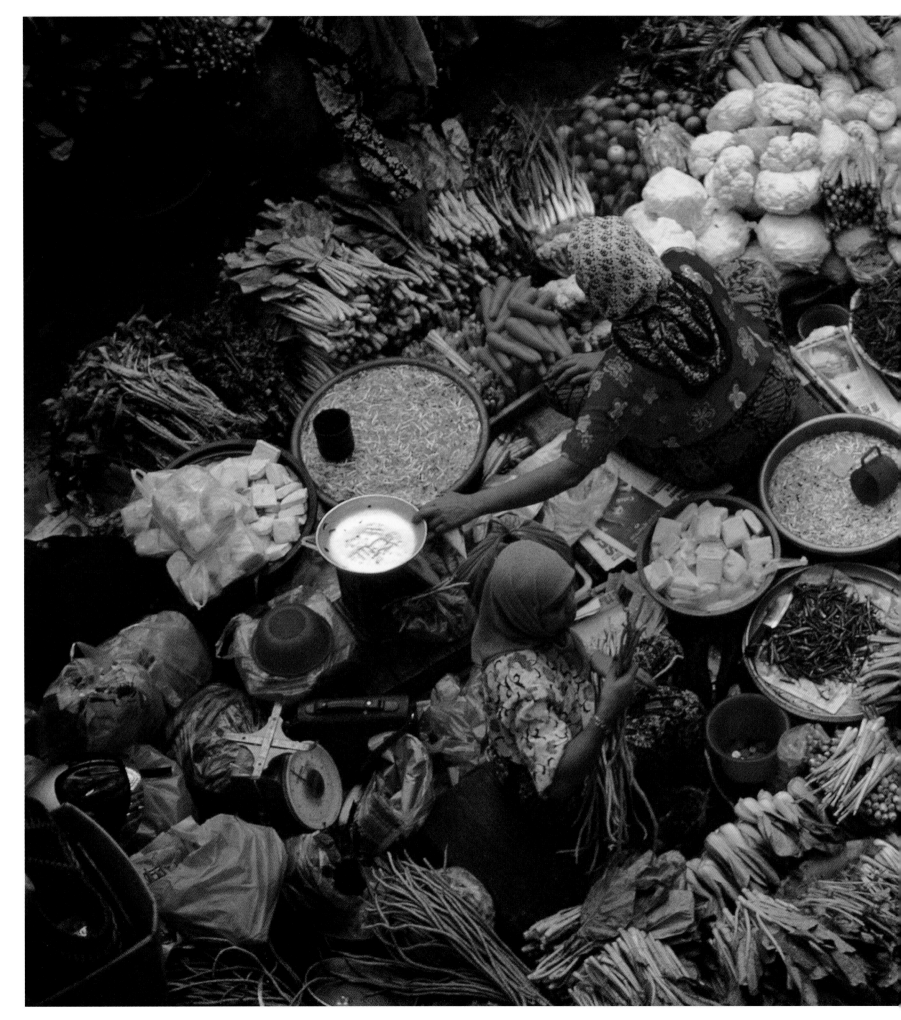

One of the most colorful markets in Southeast Asia, the octagonal Central Market in Kota Bharu overflows with the ingredients for Malay curry puffs, spring rolls, vegetable salads, and barbecue sauces. The market's translucent roof filters sunlight so that it casts a soft yellow glow on the produce, which comes from nearby kampong on Malaysia's east coast.

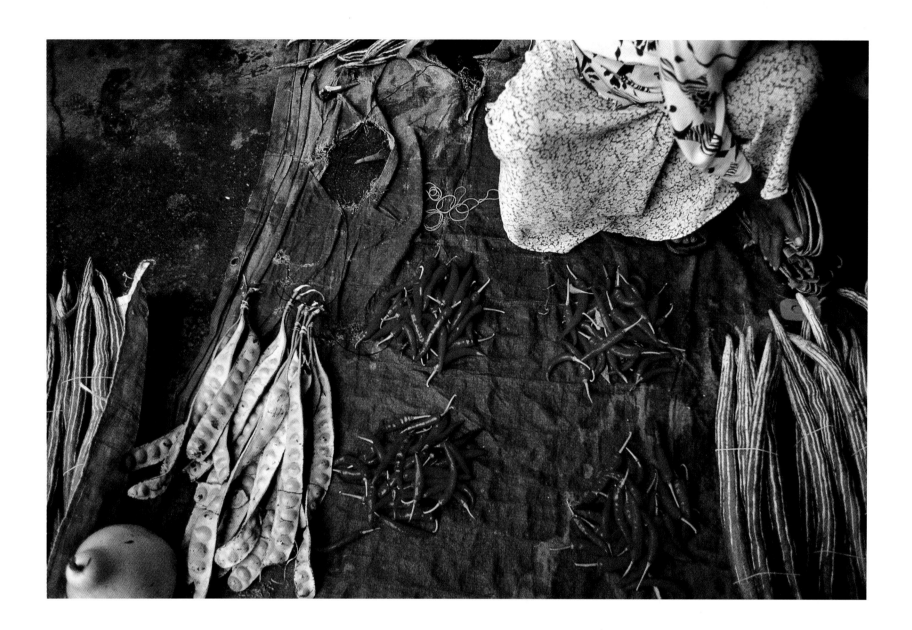

Malaysians like their food spiced with red chilli peppers (above), which are a staple in produce markets like this one in Kuala Terengganu. Peppers are an essential ingredient in the ubiquitous Malay curries and a fiery dish called beef *rending*, in which the spicy meat is cooked dry so it can be kept without refrigeration — a boon for traders generations ago. Complementing the red chillies is a pungent green bean called *petai* by Malaysians and Indonesians.

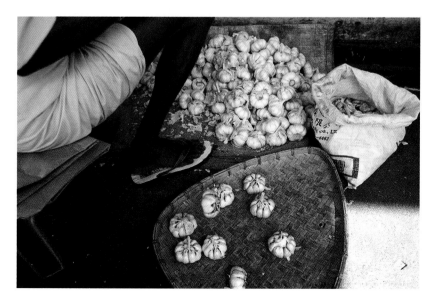

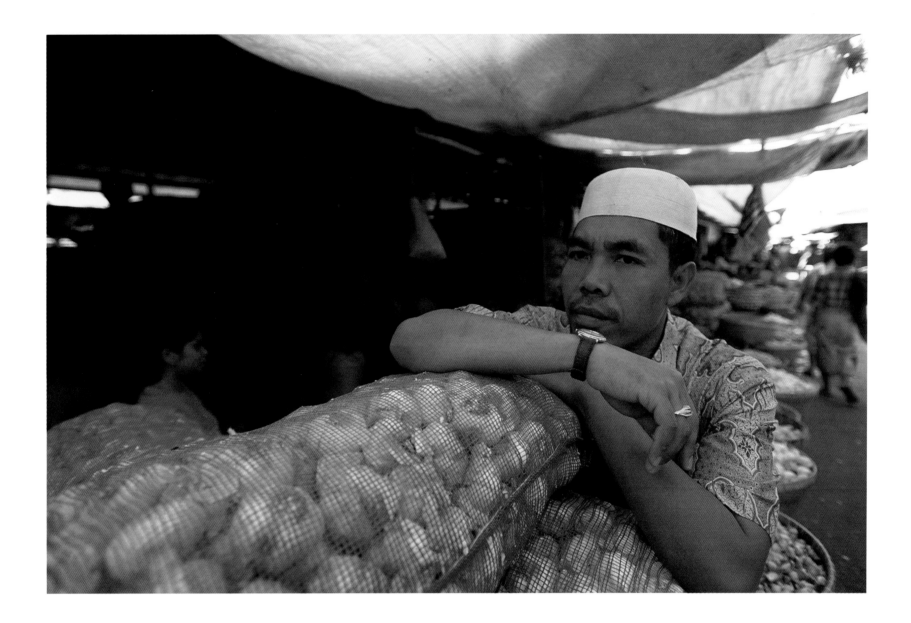

Garlic imported from China fills markets in the Malaysian port of Malacca (left) and in Lombok (above), where a spice merchant strikes a reflective pose. A staple in kitchens throughout Southeast Asia, garlic enlivens curries, steamed dishes, battered fish, and Thai sauces. While the cuisines of Indonesia vary from island to island and region to region, garlic remains a constant — and is thought to help lower blood pressure and reduce cholesterol levels.

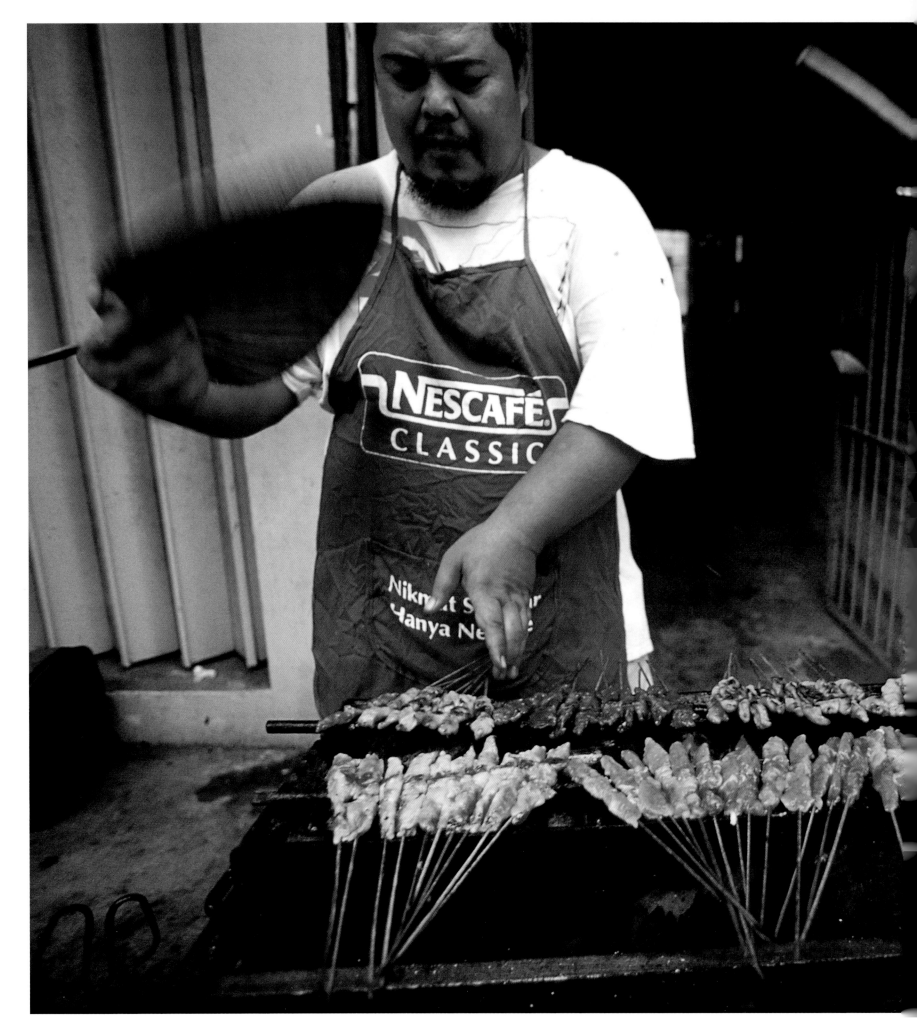

Fanning the fires of a charcoal burner, a Malay street hawker grills chicken and beef kebabs called *satay*, tidbits of meat skewered on thin bamboo sticks and then barbecued and dipped in sauces. Satay are thought to have originated on the island of Java, but also have become mainstays in the cuisines of Malaysia and Thailand.

Wearing a heavy-metal band T-shirt, a Malay Muslim offers a traditional Islamic greeting — hand placed over the heart — while his companion prefers the traditional Western handshake. In the Malaysian state of Kelantan, men often wear Batik sarongs and wrap their heads in turban style. But Western clothing, especially the ubiquitous denim jeans and T-shirts, is increasingly common in villages that are embracing the modern world of mobile phones, television, and city jobs in high-tech manufacturing plants.

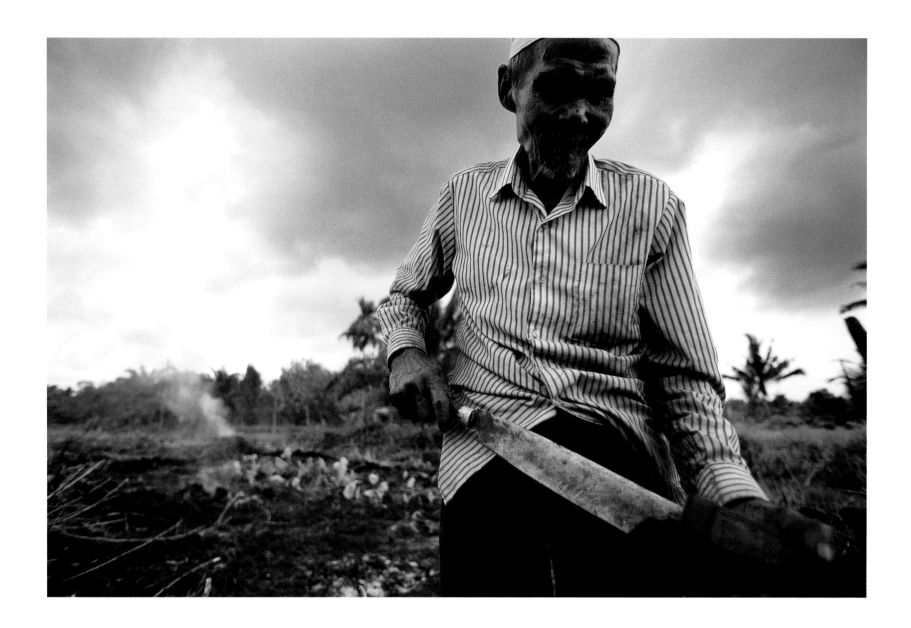

Unsheathing a large knife used for
farm work, 90-year-old Hajji Bali
bin Muhammad is a village leader,
called *penghulu* in Malay, of a small
kampong outside Johor Bharu at the
southern tip of the Malay Peninsula.
He also is a *bumiputra*, literally a
"son of the soil," a title now widely
used for all Malays whether they live
in villages, the suburbs, or cities.

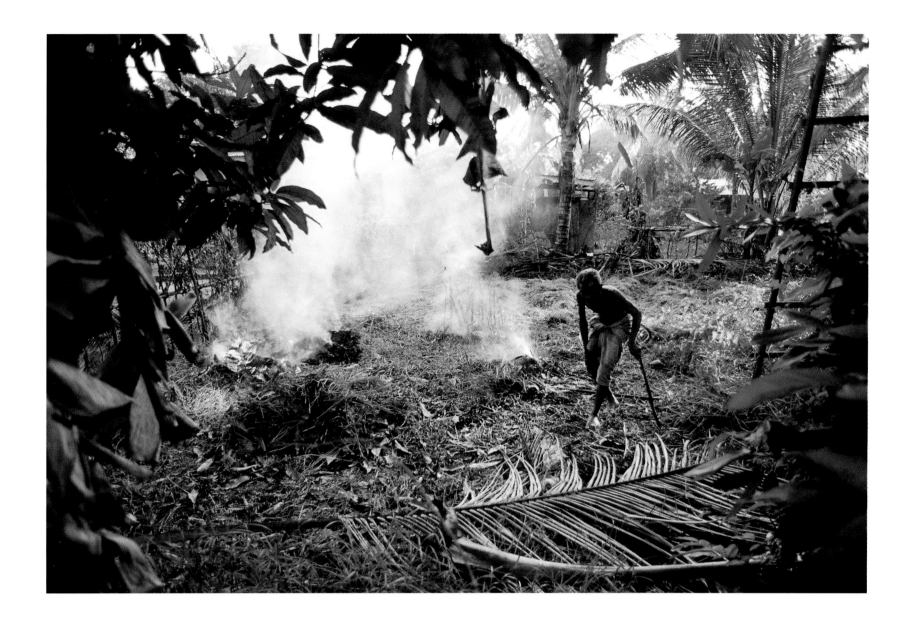

An elderly Malay resident of a kampong in Malaysia's Kelantan state burns rubbish, a traditional way to dispose of everything from garbage to underbrush. Traditionally, villages operate under a strict code of behavior, called *adat* in Malay, that emphasizes collective rather than individual responsibility. Adat maintains harmony in social relations, especially inside families, and is still practiced in kampong and suburbs.

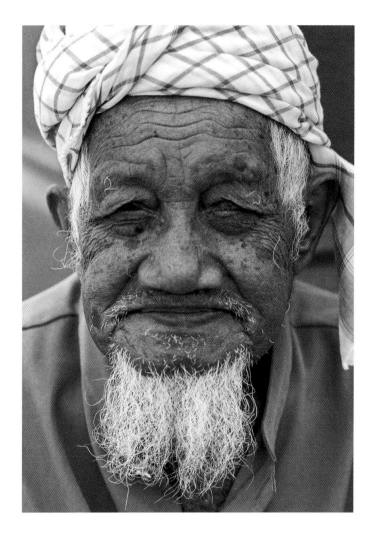

Dates and sweetened milk symbolically mark the breaking of the month-long Ramadan fast — the fourth pillar of Muslim faith — in a town square on Malaysia's east coast (left). In kampong across Southeast Asia, Ramadan is considered a unifying experience with families fasting together from dawn to dusk in affirmation of their obedience to God. Muslim elders (above) insist that family members discipline their passions and their appetites during Ramadan and show compassion for the hungry and the thirsty.

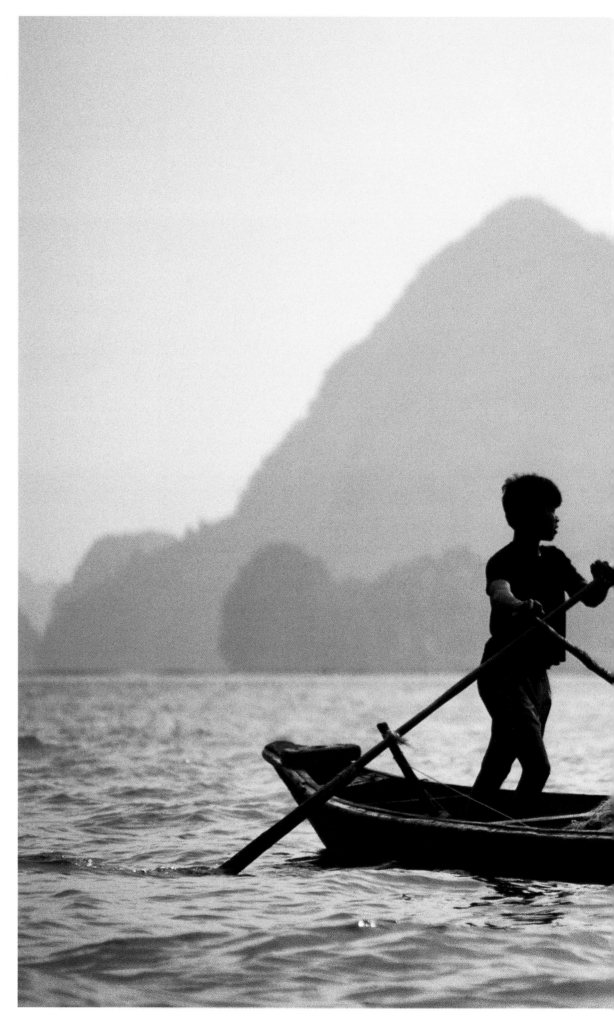

Like fanciful shapes in a dream, the limestone peaks of Phangnga Bay rise behind Muslim fishermen who ply the Andaman Sea on Thailand's west coast. The craggy karsts are the work of erosion over millennia and provide shelter for villages of nomadic "sea gypsies" and ethnic Malays who hold Thai citizenship and speak Jawi, an Arabic form of the Malay and Indonesian tongues.

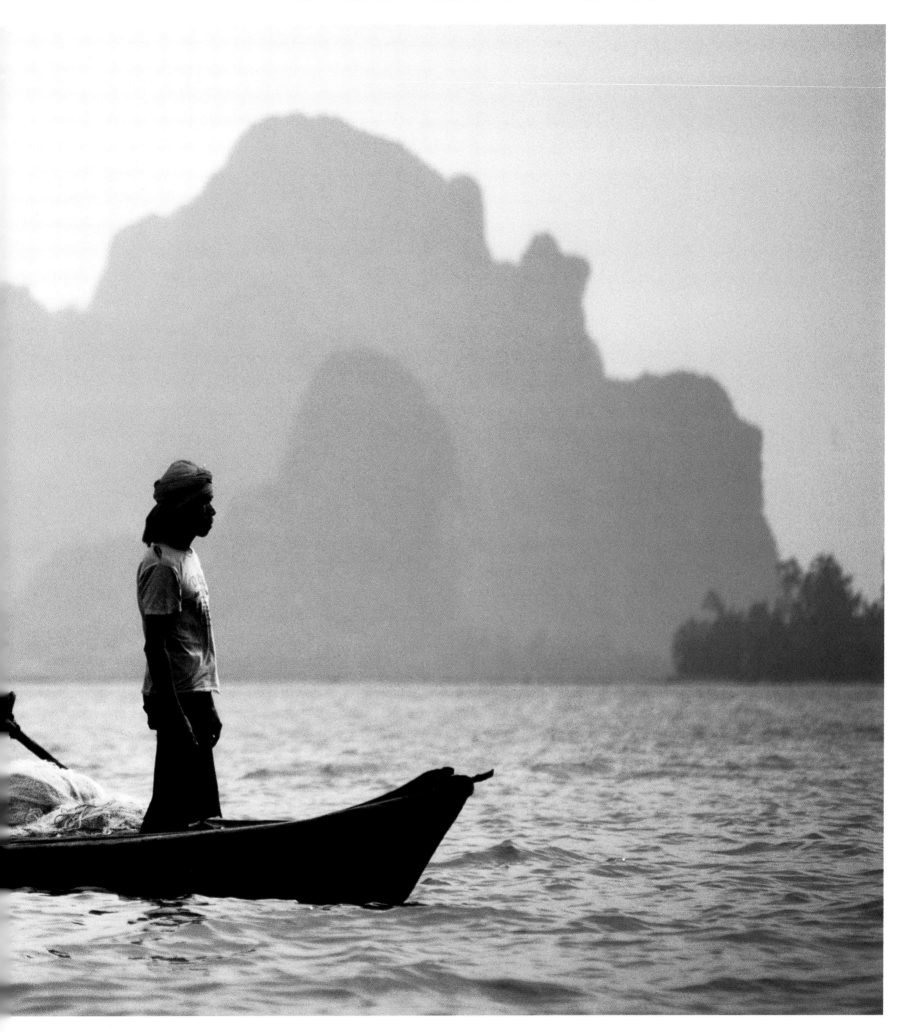

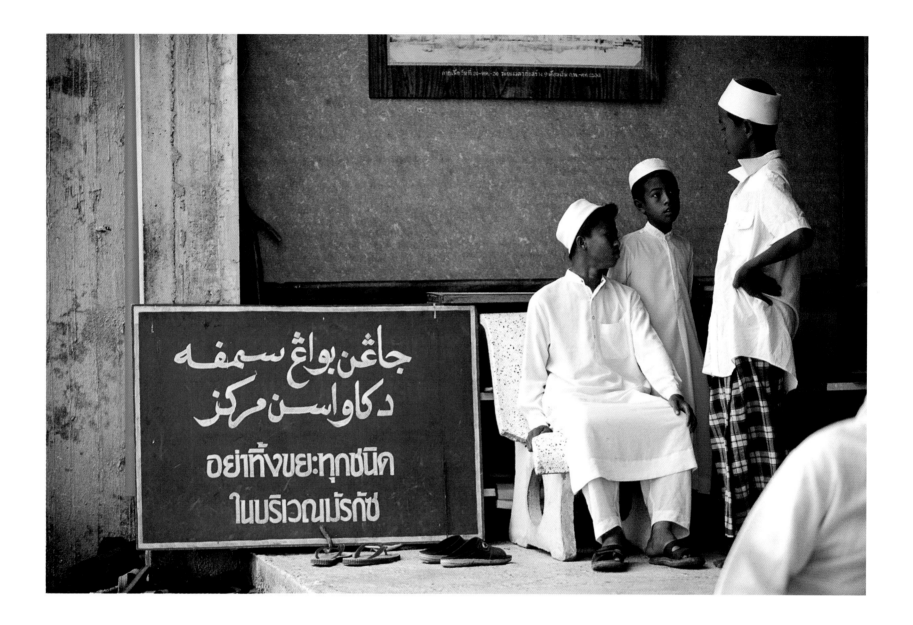

Thai Muslims, some three million strong and concentrated in the country's southern provinces near the Malaysian border, observe Friday prayers with the same reverence as their counterparts elsewhere in the Islamic world. In the provincial city of Yala, a sign in Thai and Jawi (above) cautions worshippers to dispose of their trash before they enter a nearly completed mosque, a gift of Saudi Arabia.

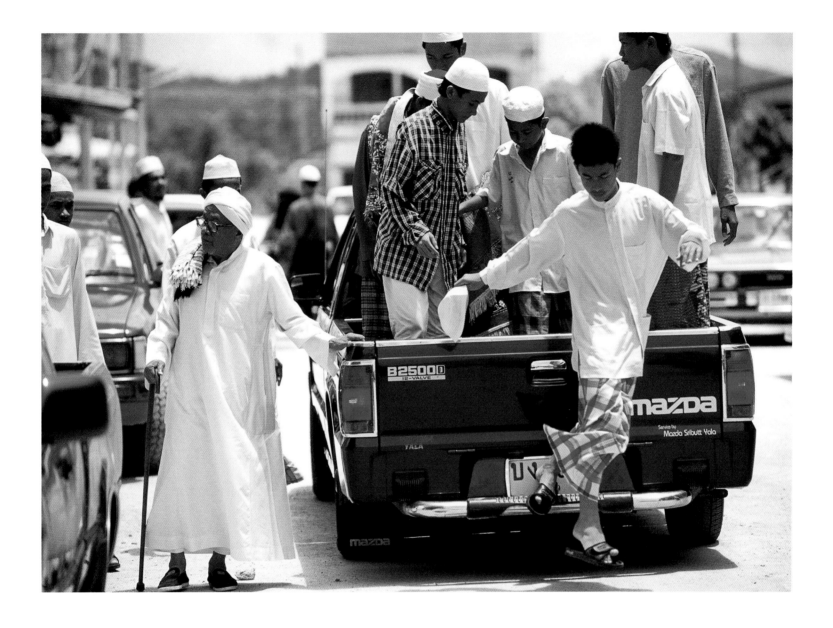

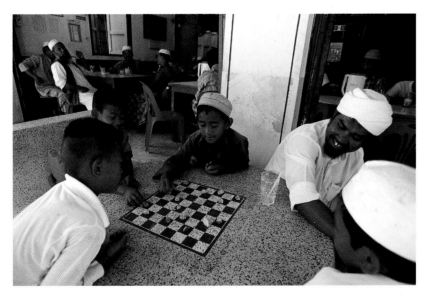

Worshippers dressed in robes and sarongs (above) arrive for Friday prayers in the back of a pickup truck, a ubiquitous feature of rural Thailand. Muslim coffee shops (left) have the feel of teahouses in the Middle East, with men dressed in turbans and children playing a form of checkers. Relations between the government in Bangkok and Muslims have improved in recent years, but an on-and-off insurgency continues around Patani, an important 17th-century center of Islamic scholarship.

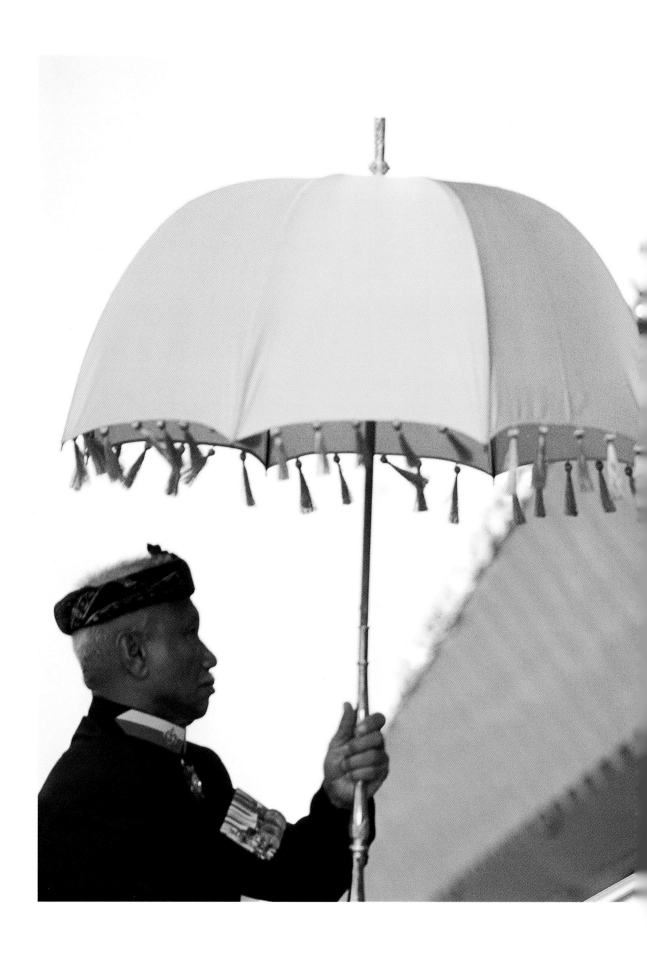

Sultan Hassanal Bolkiah, Brunei's multibillionaire monarch, descends a reviewing stand after military ceremonies marking his birthday. Universally called "His Majesty" by admiring subjects, the sultan has enforced economic discipline on this conservative Muslim enclave on Borneo's north coast after years of lavish spending by the royal family. The monarch wants to wean Brunei from its dependence on oil and government largesse, which trickles down to the smallest kampong, and to lure tourists and investors to his tiny sultanate.

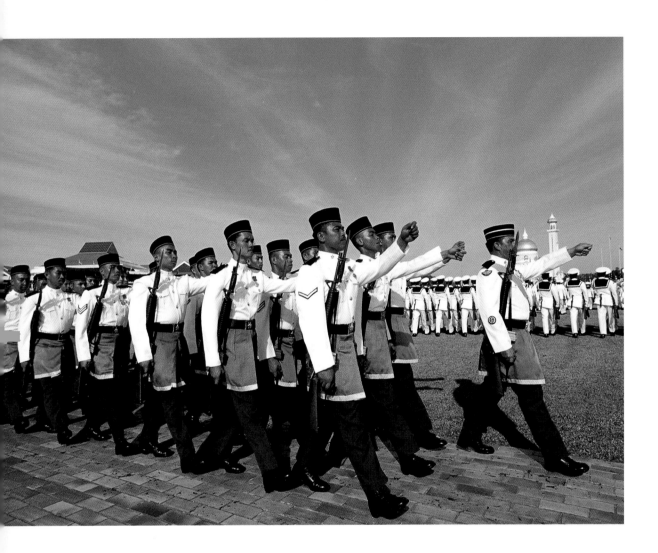

Brunei's air force shows off its airmen (above) and its might — a flight of helicopters and transports (right) — to Sultan Hassanal Bolkiah, the country's monarch, as well as its minister of defense and supreme commander. The sultan is a graduate of the British Royal Military Academy at Sandhurst. A former British protectorate, Brunei has a defense agreement with the United Kingdom under which a battalion of British Army Ghurkas is stationed in remote Seria, near the center of Brunei's oil industry. Brunei also conducts training with the armed forces of neighboring Asian countries and the United States.

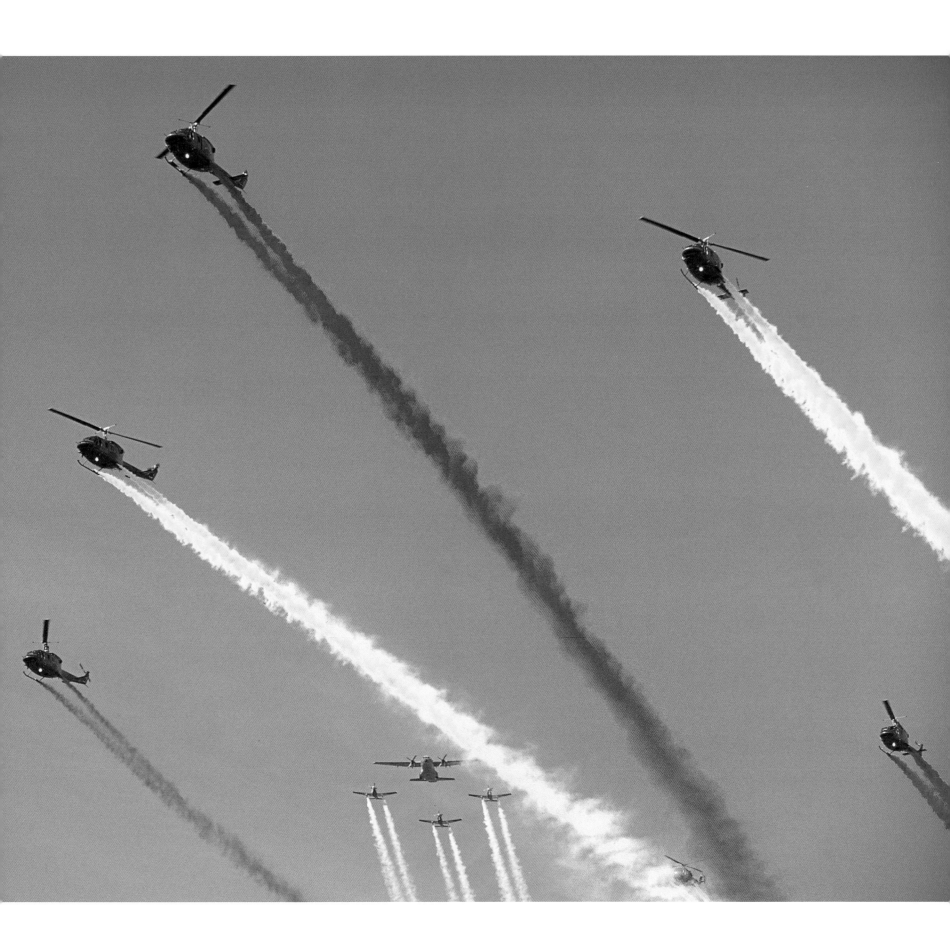

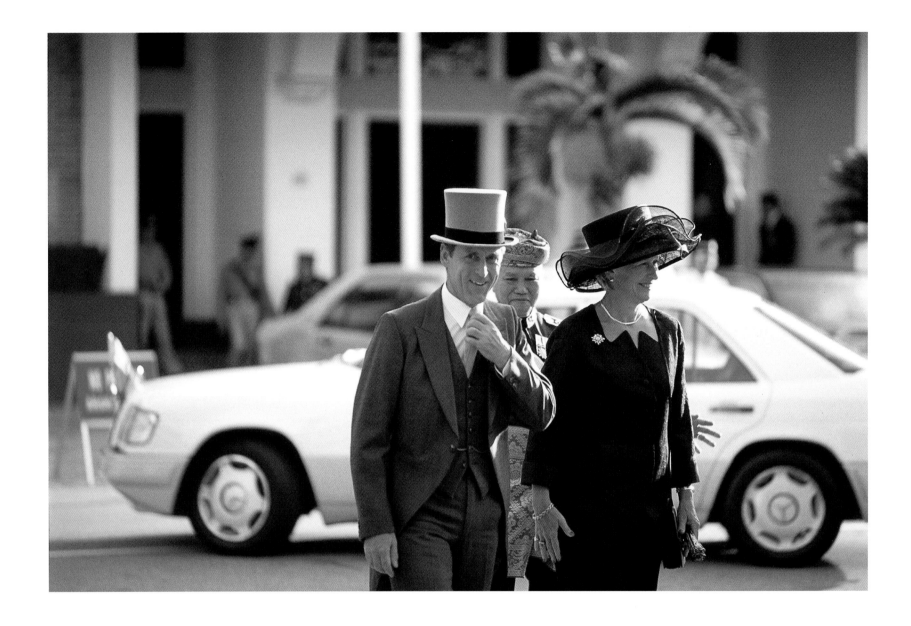

Wearing top hat and tails, a British diplomat and his wife arrive for a birthday celebration honoring the Sultan Hassanal Bolkiah of Brunei. The monarch's family has been ruling parts of north Borneo for six centuries, coming under British protection between 1888 and 1984 and eventually ceding much of its territory to what is now Malaysia.

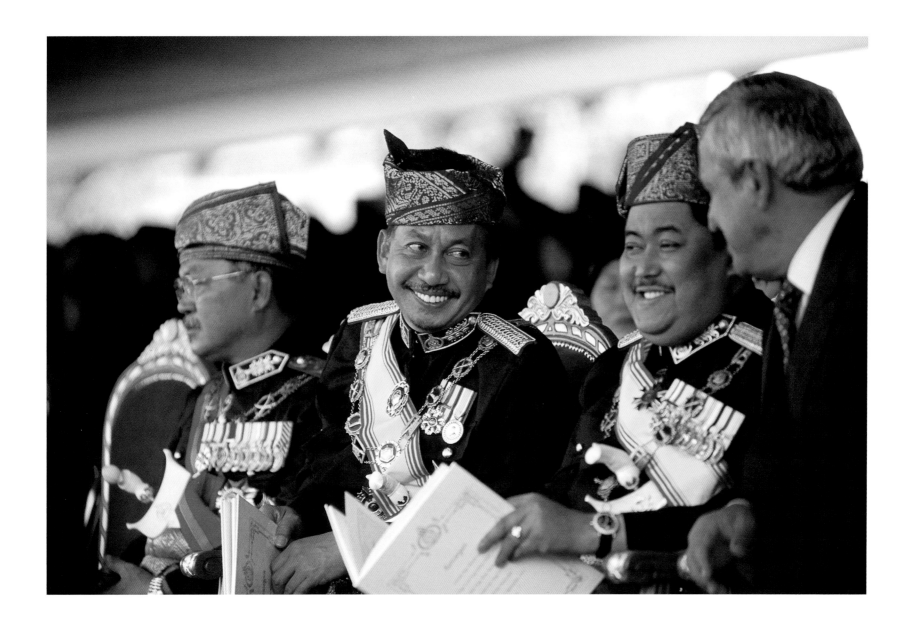

Brunei's government consists largely of the royal family, whose members turn out in sumptuous uniforms for state ceremonies. Since 1962, when the last sultan quelled a revolt, the country has officially been in a state of emergency. The last parliamentary elections were in 1968, and there is no real opposition party, largely because citizens are so comfortable that few see any need for change.

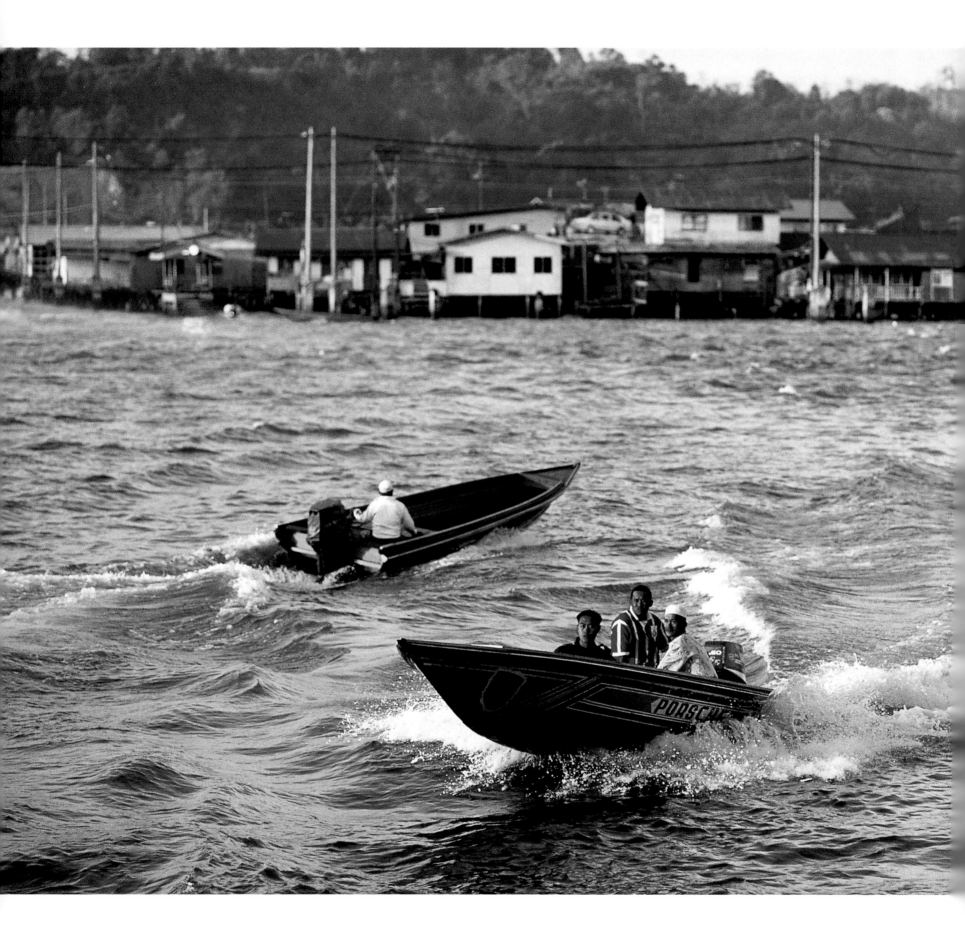

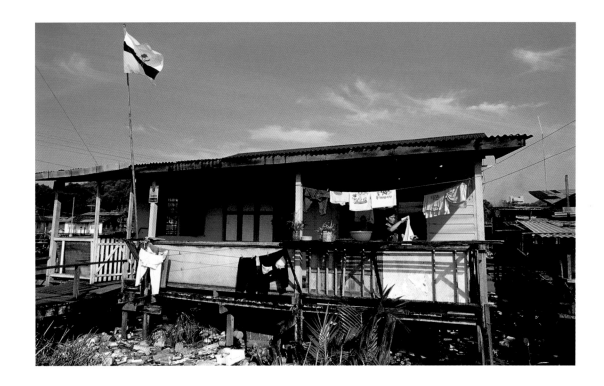

Fast water taxis (left) shuttle between Kampong Ayer, a collection of some 28 villages built on stilts, and Bandar Seri Begawan, capital of Brunei. First described in 1521 by an aide to the explorer Magellan, the kampong are a diverse mix of ancient and modern, with schools, shops, mosques, satellite dishes, and a water-born fire department.

A typical wooden home in Kampong Ayer (above) flies the Brunei flag. In Brunei, health care, local telephone service, and education are free — largesse that is known as "Shellfare," a reference to Royal Dutch/Shell Group, the giant petroleum corporation that pumps crude from Brunei's offshore oil fields and cash into the government's coffers.

A young couple steals a private moment outside a shopping complex in Bandar Seri Begawan, Brunei's quaint capital, where most women cover their heads with the tudung Muslim scarf, buildings rise no higher than the central mosque, and alcohol is banned. In the last decade, Brunei has sought to counter modernization and Western values with a national ideology called Melayu Islam Beraja that stresses Malay culture, the monarchy, and Islam.

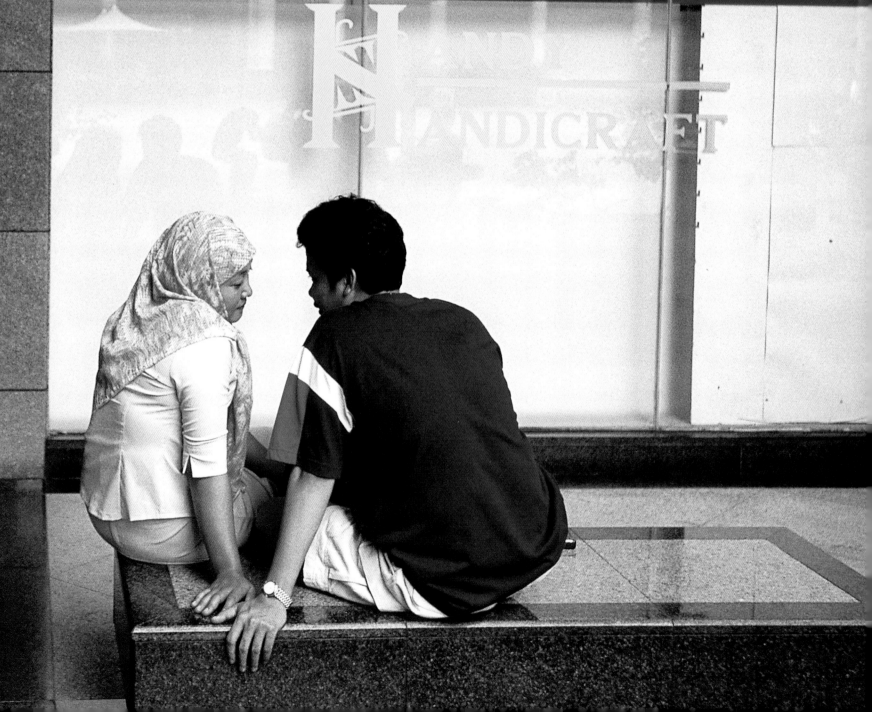

THE CITIES
ISLAM MEETS THE INTERNET

Everyone in Asia seems to have an opinion about Singapore. To some it's Manhattan with palm trees, clean air, and good manners. To others it's a rigid city-state whose Confucian elders bristle at criticism, especially from foreigners and journalists. Statistically, Singapore has the highest gross national product in Southeast Asia and regularly is voted the most competitive country in the new global economy. Delightfully green, safe, and efficient, it's viewed by almost everyone as an oasis in an unsettled part of the world, and an impressive tribute to urban planning and immigrant pluck.

But comparatively few people know Kampong Glam, the heart of Singapore's Muslim community, which numbers some half million Malays and descendants of Indian and Arab traders. Just a short walk from the flashy department stores and fast-food restaurants at the Bugis MRT subway station, Kampong Glam is low-rise while the rest of Singapore reaches for the sky. Except for the occasional shop flying the red-and-white national flag or sporting Chinese calligraphy, it could be a neighborhood straight out an Arabian kingdom.

Crammed into 23 hectares (57 acres) are four mosques, several markets, an Arabic school, a dilapidated palace once used by Malay royalty, and a Muslim cemetery where the tombs of Malay princes rest beneath frangipani trees. Bearded men in skullcaps and long robes sit in teahouses along Muscat, Baghdad, and Kandahar Streets, names that reflect the quarter's beginnings as an Arab trading center almost two centuries ago. Shaded from the morning sun, several portly retirees sip cups of sweet milky tea. They murmur of Islamic life in Singapore, where Muslims make up about 14 percent of the island's 4.1 million citizens. "In the West, Islam means revolution and *jihad* (holy war)," says one of the tea drinkers. "But here we just want to pray and live quietly."

"And they want to make money," observes Mohamed Abdullah Rahman, a retired Singapore schoolteacher out on his morning stroll. Rahman ambles along Arab Street, a thoroughfare where sidewalks are heaped with textiles, baskets, carpets, brass pots, and displays of gems. He passes women wrapped head-to-toe in lavender, saffron, and cinnamon-colored scarves and robes, and open-air stores full of Chinese silks, Javanese batiks, Malaysian sarongs, and hand-blended, alcohol-free perfumes made of sandalwood, jasmine, and other fragrances. Rahman pauses at 20 and 22 Arab Street, the most photographed shop exteriors in Singapore — a city known for its liberal application of the wrecking ball in other handsome colonial-era districts. "History has been kind to Kampong Glam," says Rahman, "because the government of Singapore has spent money to make this a preservation zone."

This includes Sultan Mosque, the largest and most famous of Singapore's 80-plus mosques. Its imposing mustard-yellow domes and fanciful white minarets stand in stark contrast to bustling neighboring shops. Inside the mosque's austere main prayer hall, where the only concession to the 21st century is a pair of digital clocks, several men recite passages from the Koran or snooze beneath ancient ceiling fans that barely stir the oppressive midday heat and humidity.

This quaint Arab Quarter stands in sharp relief to Jakarta and Kuala Lumpur, capitals with Muslim majorities

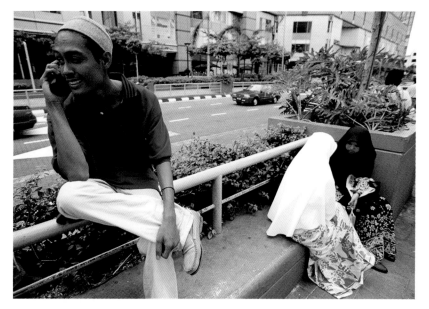

that have been whipsawed by the global crosscurrents of money, markets, democracy, the Internet, and Western popular culture. Jakarta, in particular, seems like a city on the edge of a nervous breakdown ever since angry street mobs drove former President Suharto and his military government from power in 1998. What worries many Jakarta residents is that newfound political freedoms are being used by radical Muslim groups to promote a conservative Islamic agenda and heightened tensions between Christians and Muslims.

Few women bother to wear the Muslim headscarf on Jakarta's sleek boulevards or in the shantytowns that line the sewage-laden canals built by Dutch colonialists who called their capital Batavia. As the faithful are called to mosques for evening prayers, many young people in Jakarta head for bars, discos, or cyber cafés, where they chat with the opposite sex on the Internet. Indonesia, in fact, gives no constitutional preference to Islam, though 85 percent of the country's 225 million people are Muslim. Other religions are openly practiced in keeping with a government policy of tolerance and inclusiveness. But lately militant Muslim groups in Jakarta have attacked discos, pubs, and restaurants that they considered sinful. Armed with sticks and swords, the groups have roughed up patrons and vandalized the establishments in an effort to close them. More deadly have been bombs planted outside churches on holy days such as Christmas Eve.

Kuala Lumpur has been spared most of Jakarta's turmoil, in part because of Malaysia's vastly higher standard of living and because of an affirmative action program that seeks to bring the majority Malay Muslims into the economic mainstream. "Malaysia's stronger institutions are better able to withstand a resurgence in Islamic fundamentalism," says a Western scholar who has studied the country's Muslim revival for many years.

A government-fueled building boom had transformed sleepy British colonial towns like Kuala Lumpur, Penang, Malacca, and Johor Bahru into modern cities, creating an urban middle class that has adapted to the ways of the global economy without giving up much of its Muslim identity. In Kuala Lumpur, Malaysia's congested commercial hub, architecturally stunning skyscrapers, many of Muslim design or origin, house armies of workers fresh from the *kampong*, as Malay villages are called, or universities that ring the Klang Valley. Prayer rooms are strategically placed in factories, banks, and subways. And consumers patronize Muslim banks that offer loans and credit cards that conform to the tenets of the Koran. All this, say scholars, adds strength to the fabric of urban life in Malaysia.

Even a compliant mass media plays a role. Newspapers operate under strict government licensing and national security laws that compel journalists to minimize controversy. Advocates of social and political change usually find their voice on the Internet, which is widely available in Malaysian cities in offices, cyber kiosks, cafés, and homes. "We learn to read between the lines in the press," says a Kuala Lumpur housewife, " but the Internet fills in the blanks."

Western fashion meets Muslim tradition in the chic Suria KLCC Shopping Centre at the base of the world's tallest building, the Petronas Twin Towers in Kuala Lumpur. Like much of the developing world, Malaysia embraces American popular culture. But the government, like a stern parent, reviews every movie, television show, book, and performance, deleting violence and sex, and guarding against perceived violations of Islamic values.

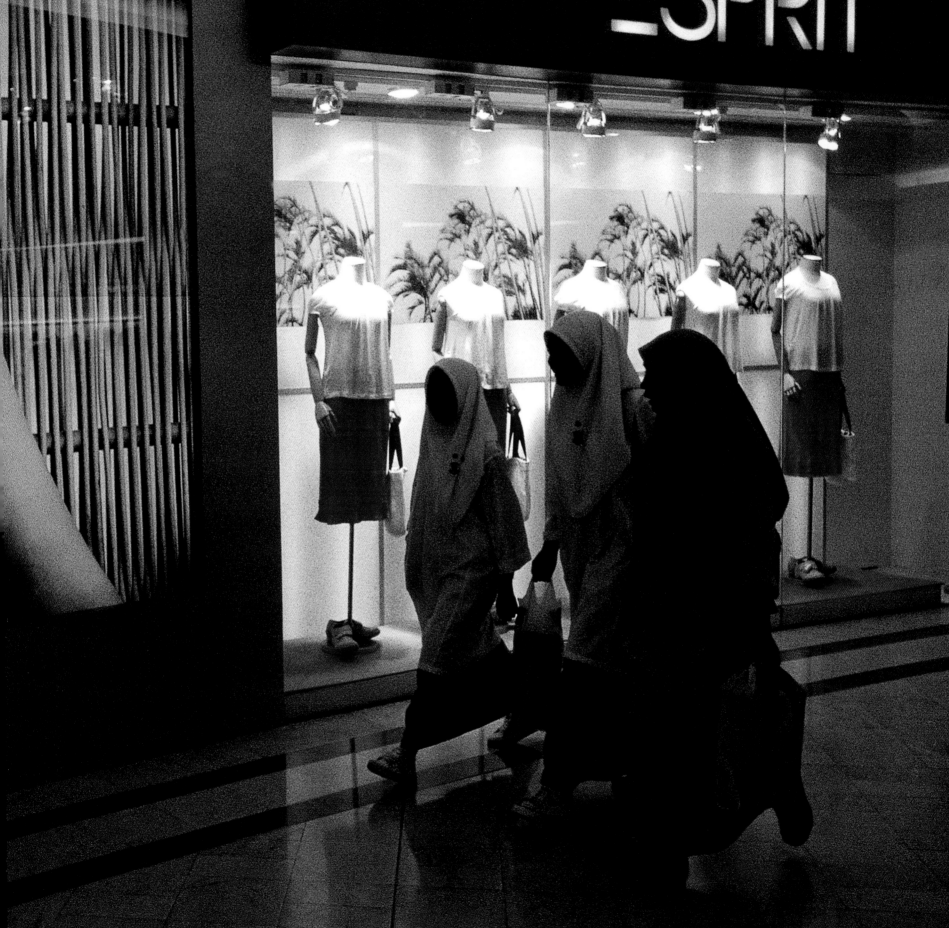

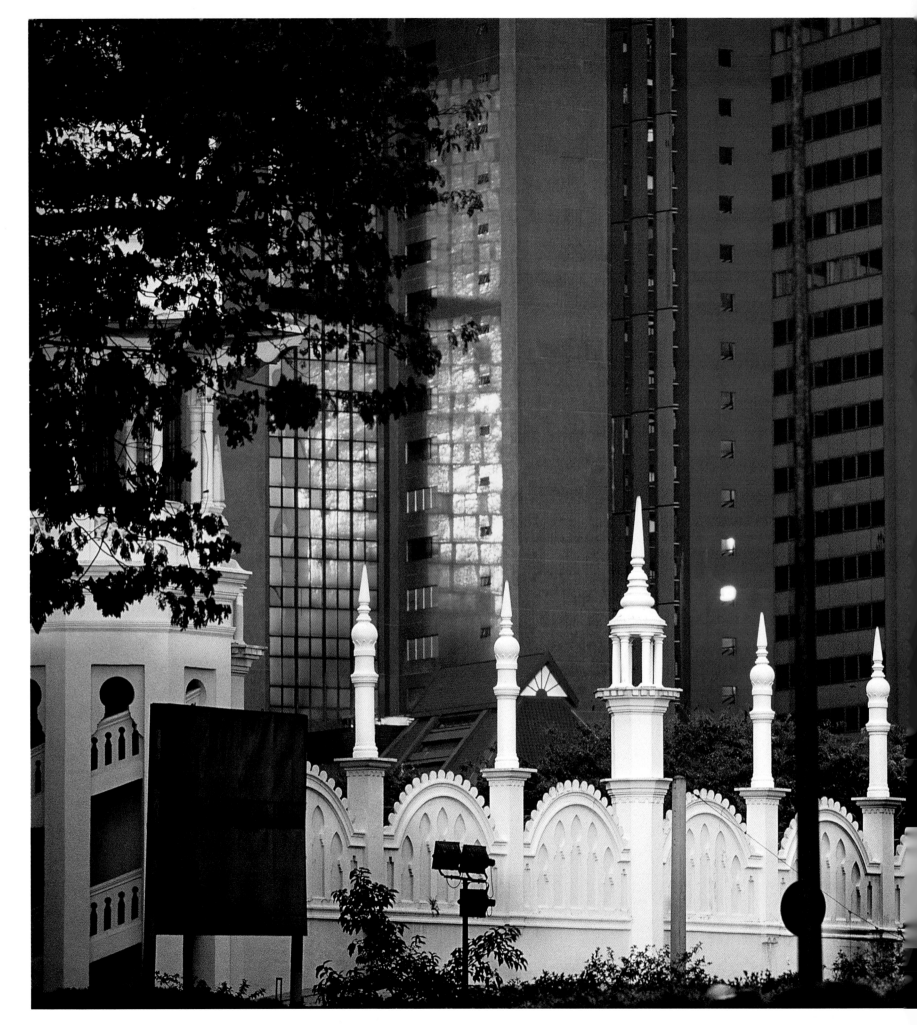

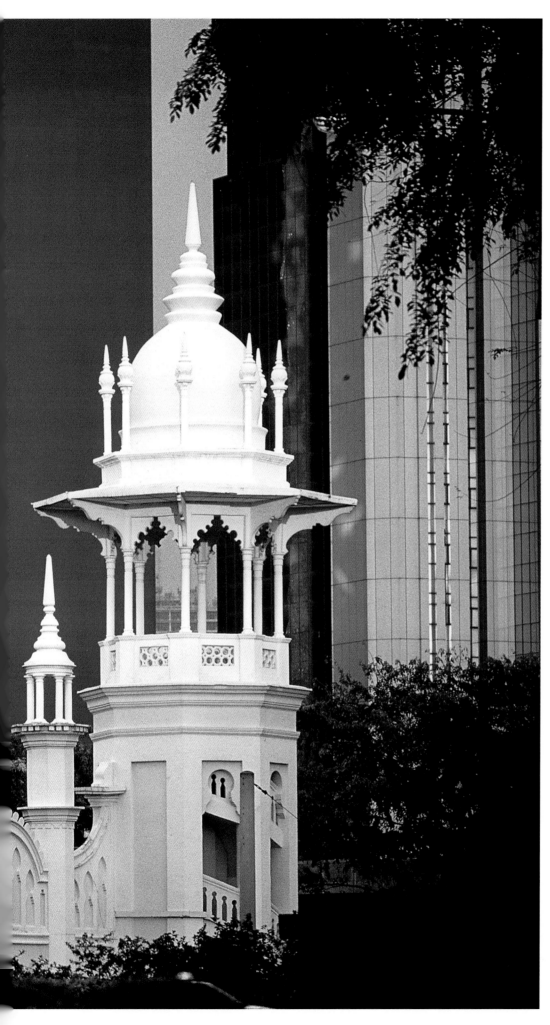

The fanciful spires, domes, cupolas, and archways of the Kuala Lumpur Railway Station contrast with the sleek skyline of Malaysia's capital, where a two-decades-long building boom has spawned a forest of modern skyscrapers — part of a government plan to make Malaysia a fully developed First World country by the year 2020.

Barometer of stocks approved by the Muslim clergy, the *Syariah*, or Islamic index of the Kuala Lumpur Stock Exchange, flashes across the screen at a gallery in RHB Bank. Stocks deemed unsuitable for Muslim investors or incompatible with Islamic law include companies that deal in alcohol, pork-related products, conventional financial services like banking and insurance, and entertainment, such as hotels, casinos, cinemas, pornography, and music. Islamic scholars also advise against investments in tobacco or weapons manufacturers.

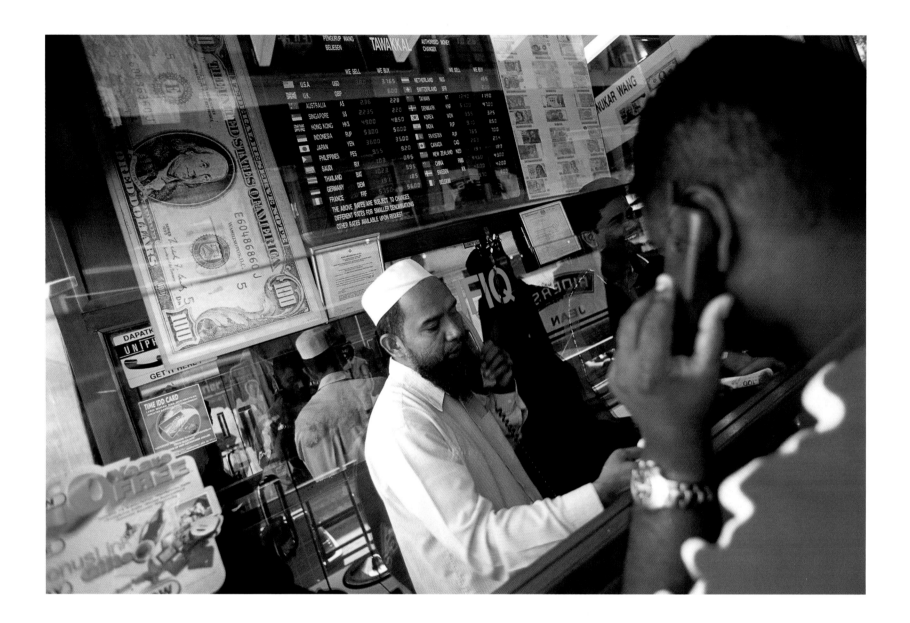

Moneychangers in a small Kuala Lumpur kiosk talk with their customers by closed-circuit telephone beneath an oversize photocopy of a U.S. one hundred dollar bill. Foreign exchange trading is considered a traditional — and honorable — occupation for Muslims of Indian origin in much of the Islamic world of Southeast Asia.

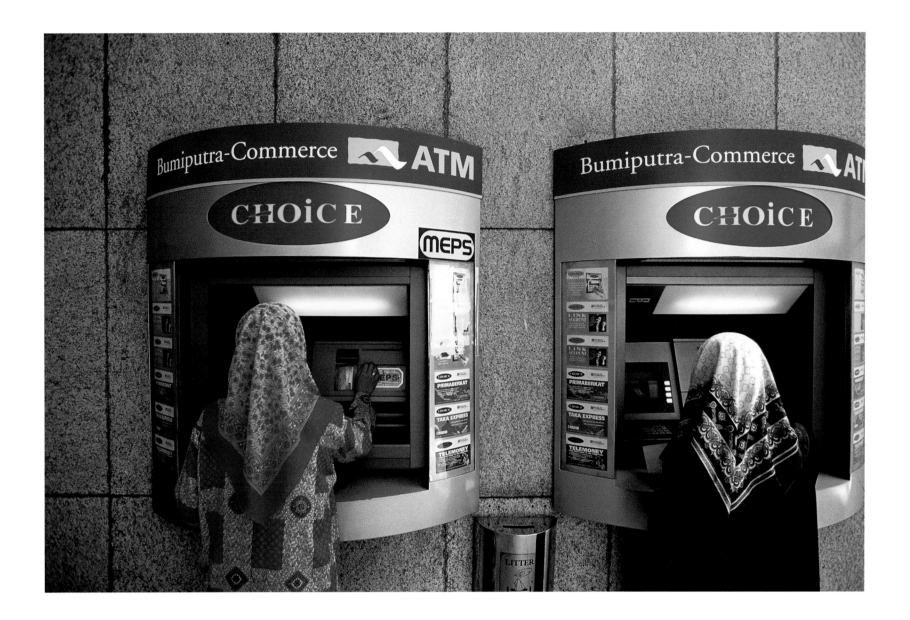

Automatic teller machines like these in Kuala Lumpur are a fixture of urban life in Asia. Islamic banking is catching on in Malaysia, Brunei, and Indonesia, where Muslim-backed banks operate according to the tenets of the Koran and Sharia law, which prohibit charging interest on loans or paying interest on deposits.

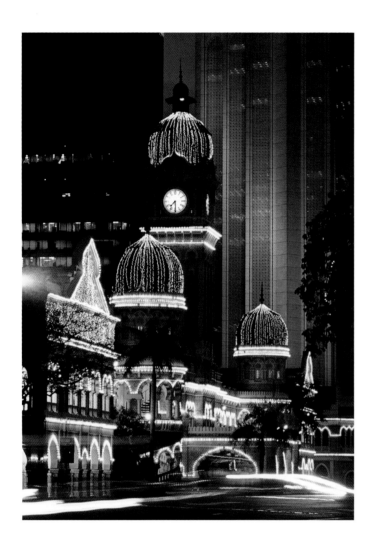

Grandest building of its time, the Bangunan Sultan Abdul Samad (above), with its 40.5-meter (133-foot) clock tower, was completed in 1897 when Kuala Lumpur was a small colonial enclave of shophouses and bungalows. The building was named after the then-Sultan of Selangor State and served as headquarters of the Federated Malay States. Built in classic Mogul style with copper-covered onion domes and arched colonnades, the Sultan Abdul Samad Building (right) now houses Malaysia's Supreme Court, on Merdeka (Freedom) Square.

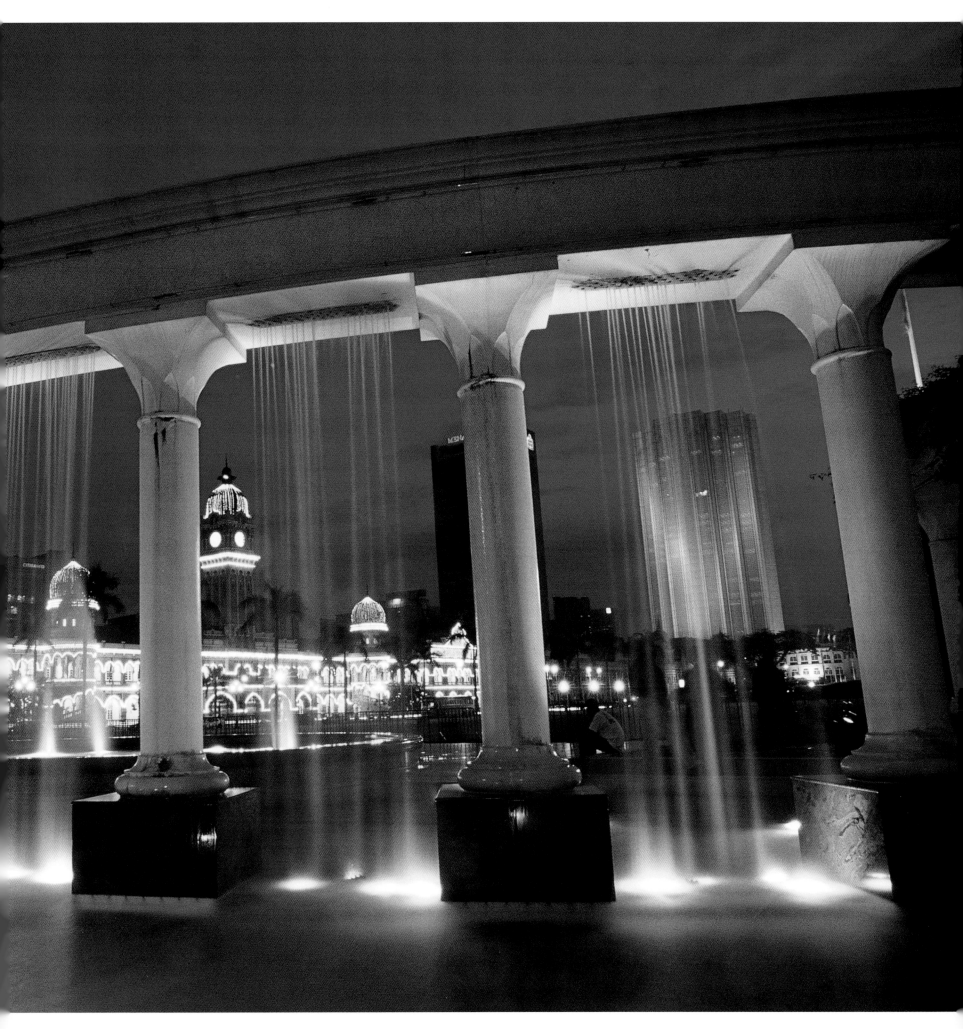

While Islamic law forbids gambling, patrons at the Kuala Lumpur Turf Club (above) watch the ponies cross the finish line on closed-circuit television. Muslims are discouraged from frequenting racetracks and casinos, which are allowed for non-Muslims in pluralistic Malaysia and Indonesia. Global banking giant Standard Chartered Bank (upper right) has its name transliterated into Jawi — Malay in Arabic script — at a branch in Kota Bharu on Malaysia's east coast.

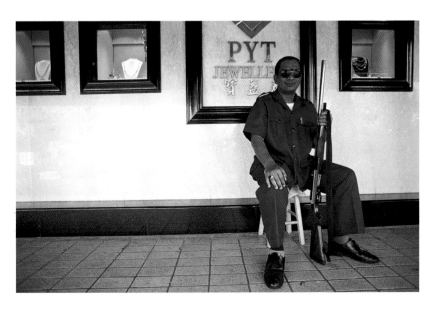

A security guard (left) sits with shotgun at the ready outside a jewelry store in Bangsar Bharu, an upscale Kuala Lumpur suburb. In the past decade, thousands of rural residents have moved to the cities, dazzled by the new malls and cineplexes and looking for a place to belong. With urbanization has come social ills familiar to Westerners — rises in the rates of divorce, crime, out-of-wedlock pregnancy, drug abuse, and HIV infection.

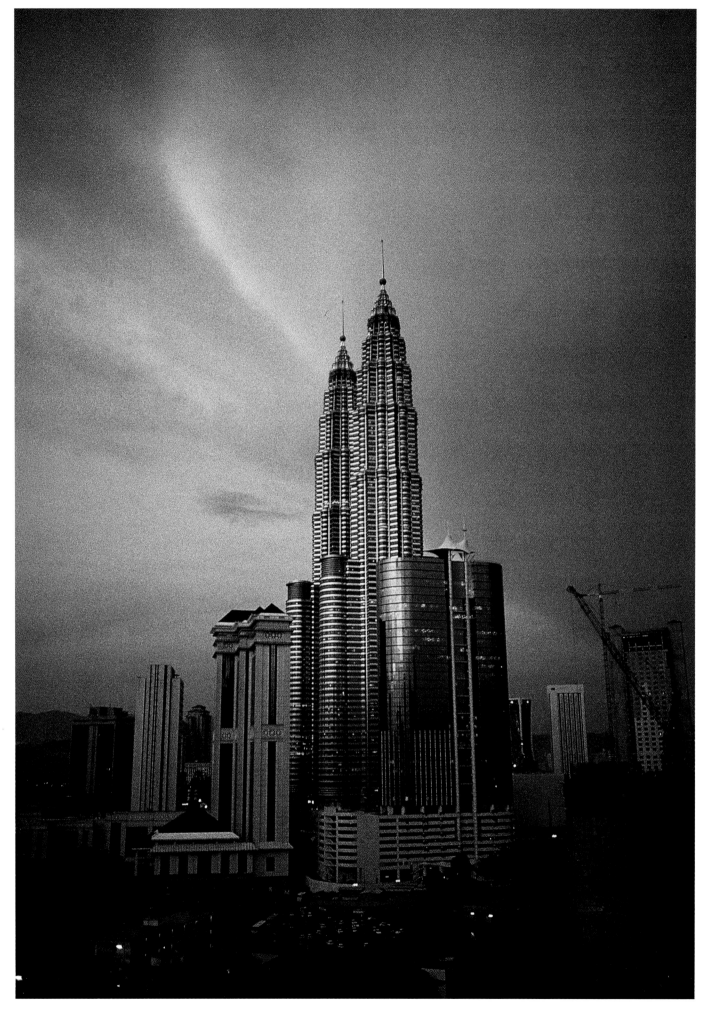

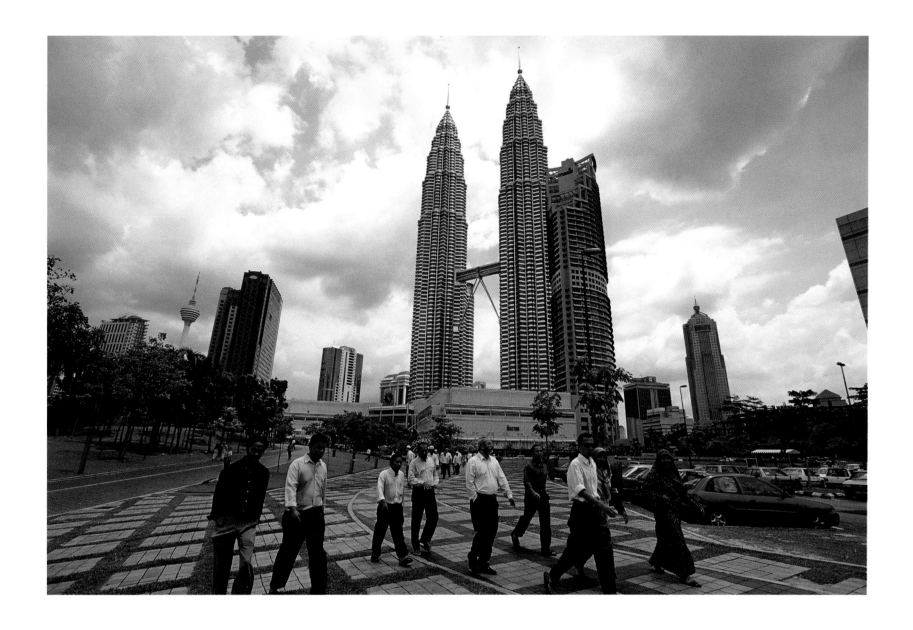

Until another Asian skyscraper beats them to the sky, the Petronas Twin Towers hold the title of tallest building in the world at 452 meters (1,483 feet). The towers are wrapped in some 85,000 square meters (280,000 square feet) of European stainless steel and are the focal point of a commercial development called Kuala Lumpur City Centre. Malaysians consider the towers not only an architectural feat, but also testimony to the country's status as a global player able to attract foreign capital, expertise, and materials to show that *Malaysia Boleh* — or Malaysia can do it!

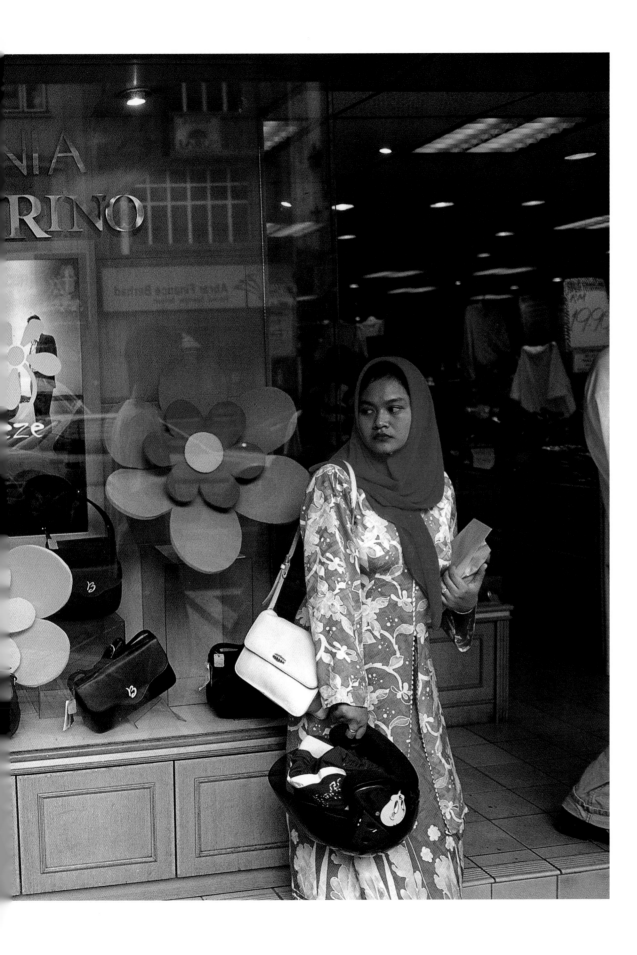

In a subtle standoff, a Muslim woman averts the gaze of a bearded man in a Kuala Lumpur market. Confrontation is rare in multiethnic Malaysia, where Malays are a bare majority in their own country, and the constitution guarantees freedom of worship to all faiths. Malaysia is a parliamentary democracy with a constitutional monarch and not an Islamic state based on Sharia law, but it has an official religion — Islam — and gives the faith considerable financial and moral support.

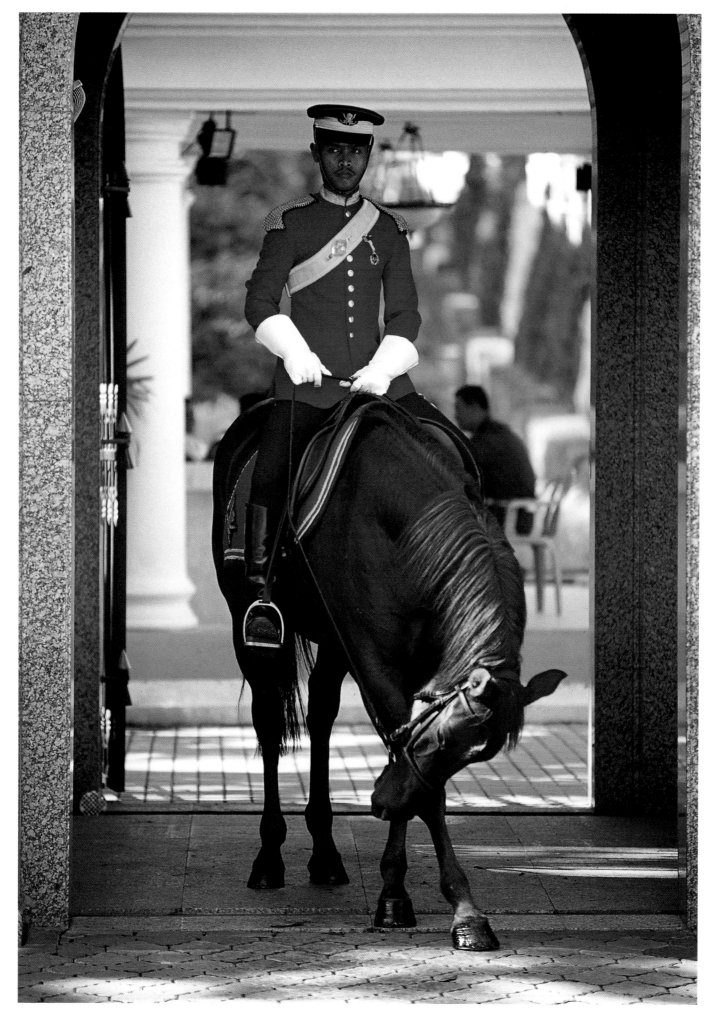

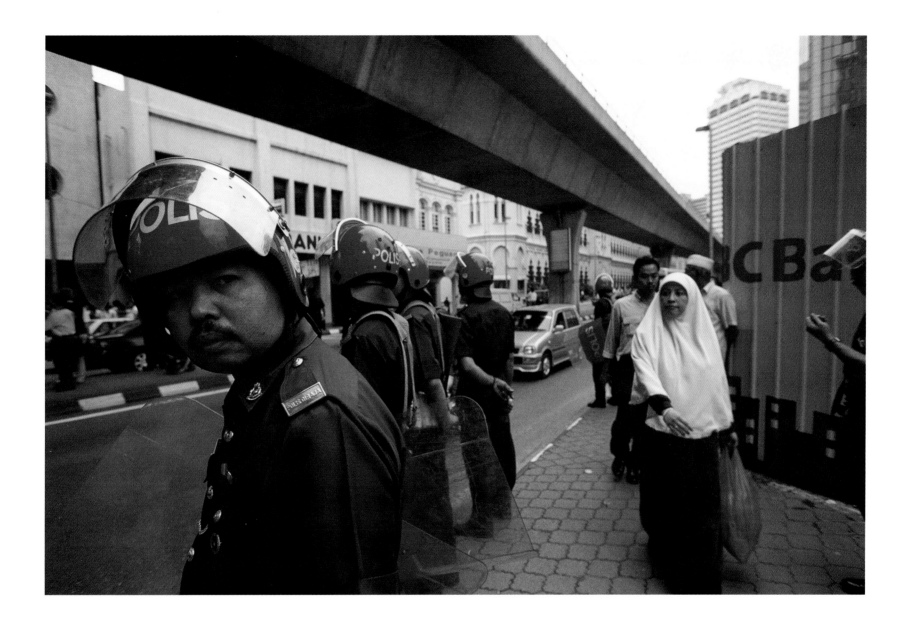

The horse of a guard at the *Istana Negara* (left), or National Palace, bows to tourists in Kuala Lumpur. The palace is the official residence of Malaysia's head of state, the *Yang di-Pertuan Agong*, or paramount ruler, customarily referred to as the king. Kings are elected for five-year terms from among the nine sultans of the peninsular Malaysian states. The king is also the leader of the Islamic faith in Malaysia.

Order is the ideal expression of democracy, a credo that is sometimes put to the test on the streets of Kuala Lumpur, where antigovernment demonstrations have become more common. Police have used the tough Internal Security Act, introduced in the early 1960s to stem a communist insurgency, to detain protestors indefinitely without trial. Increasingly, say officials, Islam is becoming a powerful force in the street politics of both Malaysia and Indonesia.

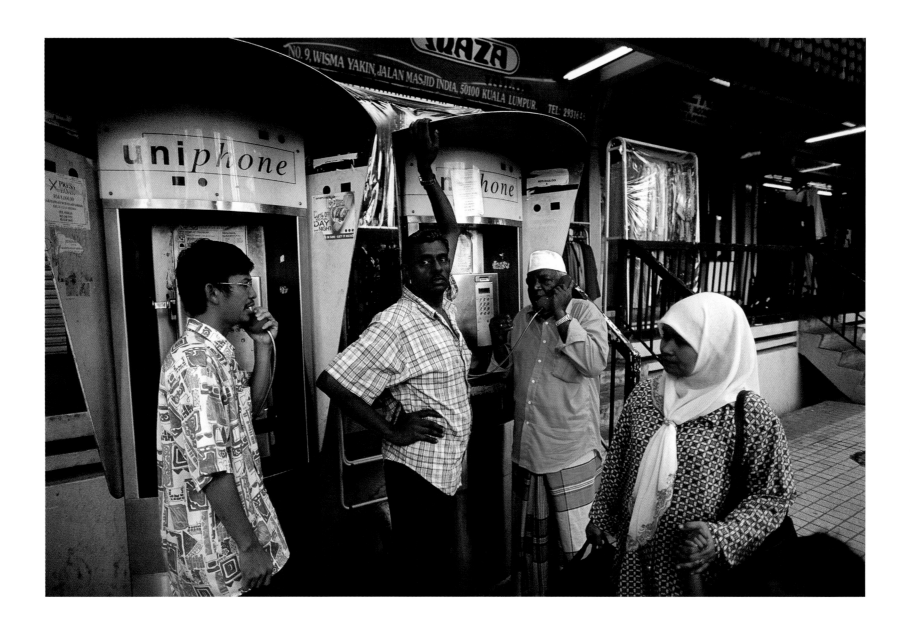

Jalan Masjid India, or Indian Mosque Street, in Kuala Lumpur's Little India district, sometimes has the feel of a pedestrian mall, as Malaysians of every hue — Chinese, Indian, and Malay — jostle for bargains in crammed shops and restaurants. Silk, perfume, batik, and Muslim religious objects are some of the most sought after good buys.

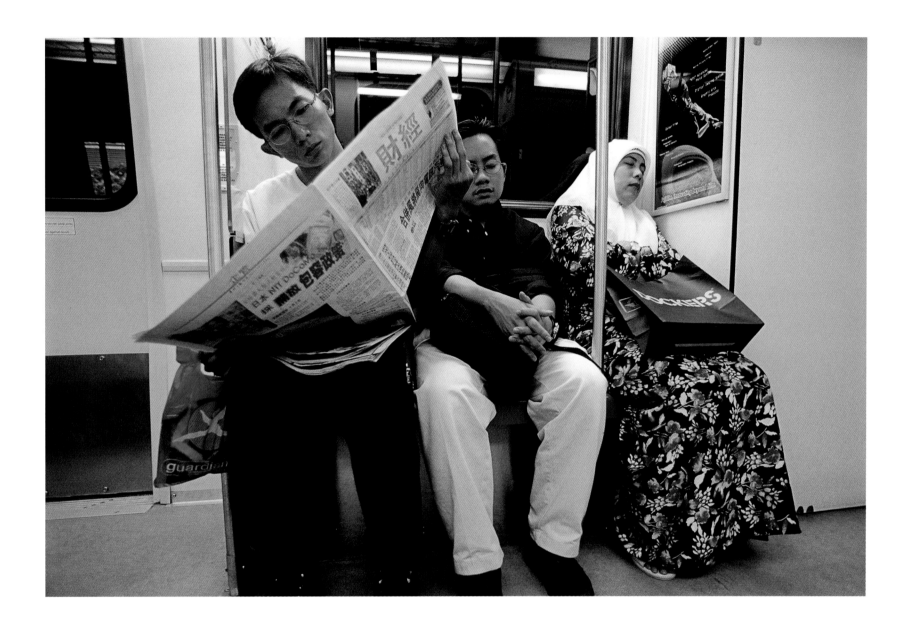

Chinese and Muslim commuters share seats on a high-speed monorail train, which has helped turned Kuala Lumpur's once slow and chaotic public transport system into a model of urban efficiency. Malay Muslims are some of the newest immigrants to Malaysia's crowded cities, which were dominated by Chinese and Indian merchants and professionals until independence in 1957.

With a taste for fast food, Malaysians love Kentucky Friend Chicken (above), which comes flavored with local spices. But like many Southeast Asian countries, Malaysia's love affair with American popular culture is full of ambivalence and confusion. The government worries that sex and violence in imported television shows, movies, and music will erode traditional Islamic values.

At fast food emporiums like McDonald's (right) in Kota Bharu, it is common to see women in Islamic dress logging on to the Internet at the MacCyber Café. But in youthful Malaysia, where 50 percent of the population is under 25, elders fear that respect for authority is eroding. Authorities have cracked downed on some forms of imported Western entertainment, including video arcades.

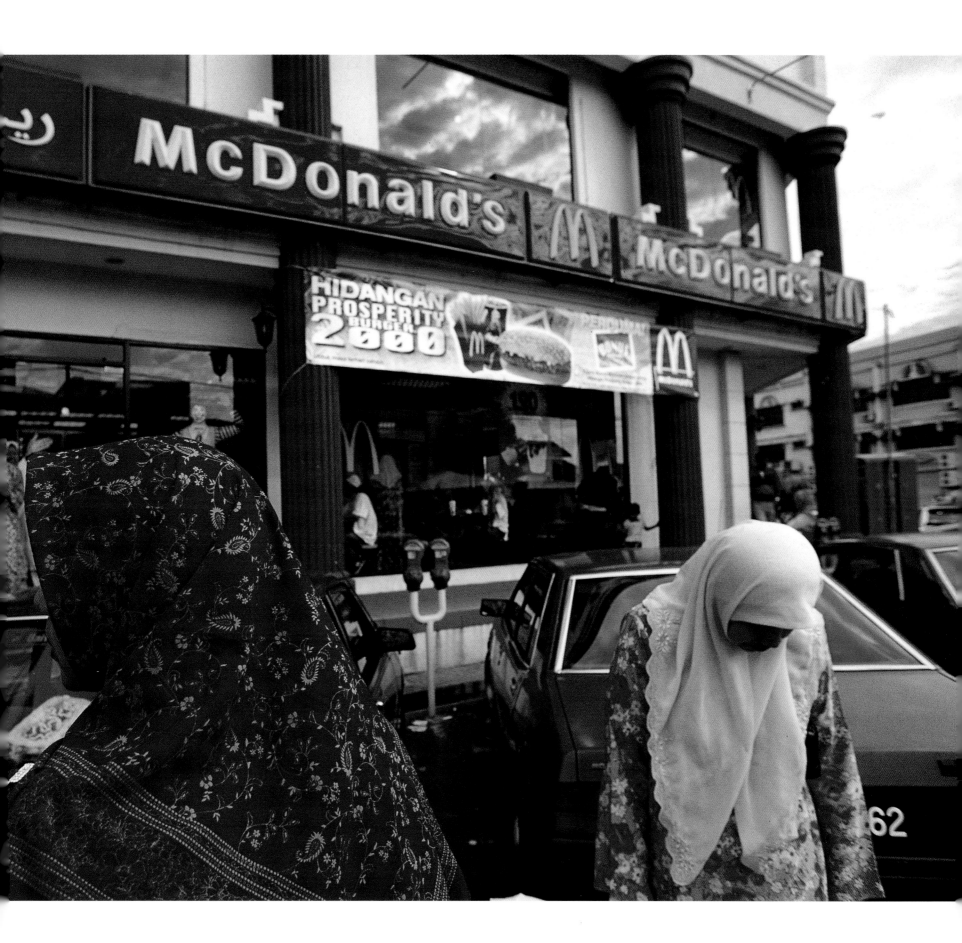

A Muslim couple, disregarding law and custom called *khalwat*, share an affectionate moment at Merdeka Square in the heart of the old colonial quarter of Kuala Lumpur. In Malaysia, Islamic religious police patrol beaches, shopping malls, and public parks, looking for unmarried Muslim couples in compromising positions, while vigilantes have closed down pubs and discos in Indonesia.

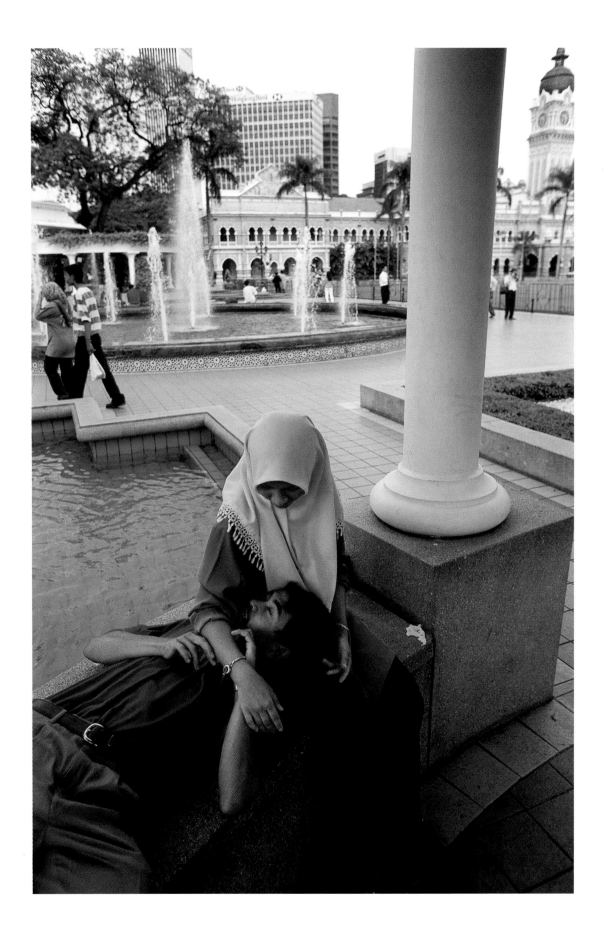

A sign posted on a hilltop overlooking Kuala Lumpur is emphatic in its injunction against public displays of affection, as are signs in some Islamic schools and offices that caution against "mixing of gender." While Sharia law applies only to Muslims, countries like Malaysia, Brunei, and Indonesia have tightened laws on alcohol, beauty pageants, and beach attire for everyone.

Delivering a soothing foot massage is an art, say masseuses on Jalan Masjid India in Kuala Lumpur's Little India quarter. Foot massage is also an honored occupation for Indian Muslims in Malaysia, many of whom are descendants of immigrants who worked on plantations, tin mines, and ports during British colonial times.

Newspapers in Malaysia (above) come in Jawi — Malay in Arabic script — as well as English, Chinese, and Bhasa Malaysia, the national language. The news media of Thailand and Indonesia tend to be free and unfettered, but elsewhere journalists are more circumspect — and circumscribed — especially on the sensitive subject of religion.

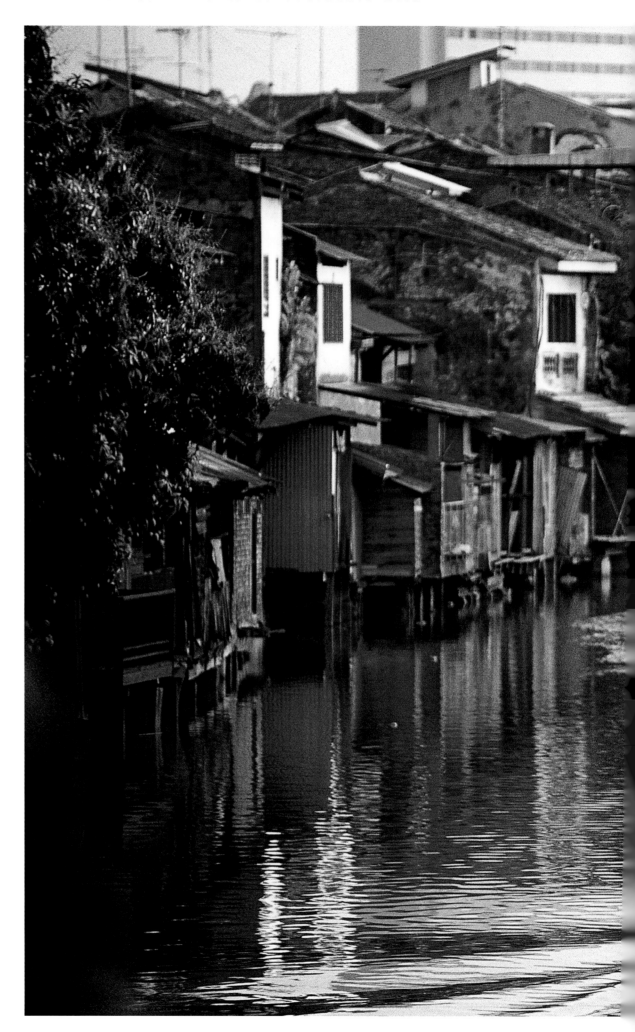

City with a glorious past, Malacca is the fabled entrepôt through which Islam arrived on the west coast of the Malay Peninsula in the 15th century, perhaps earlier if new archaeological evidence is accurate. Situated on the Malacca River, the city attracted Muslim merchants plying the Indian Ocean and South China Sea. Before the arrival of Portuguese colonists in 1509, the Malacca Sultanate was an important center of Islamic scholarship and established Malay as the language of trade in Southeast Asia.

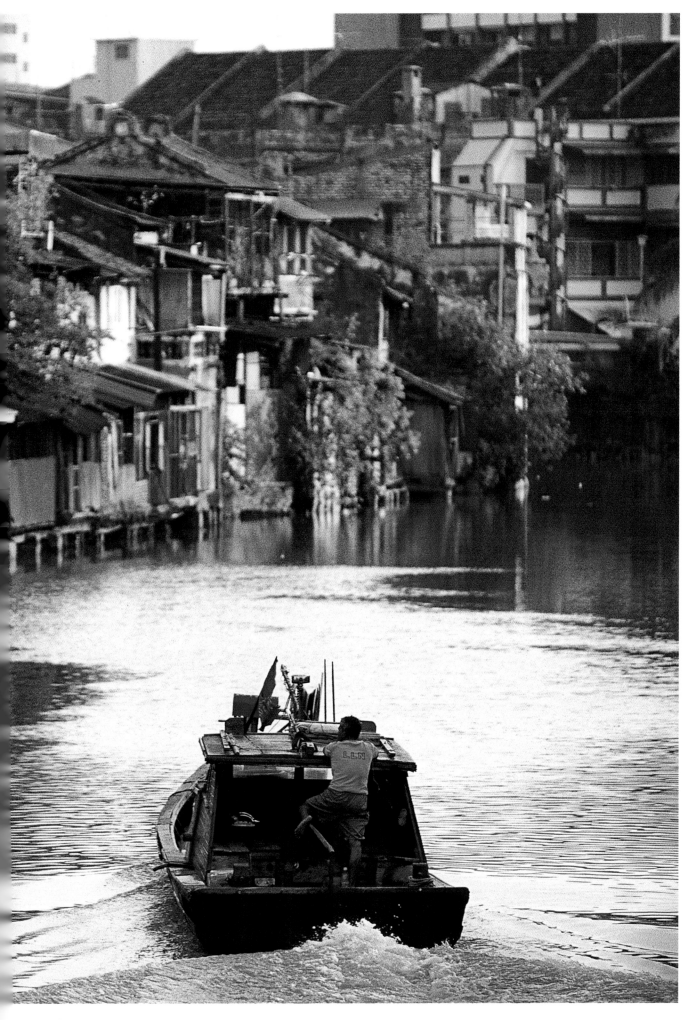

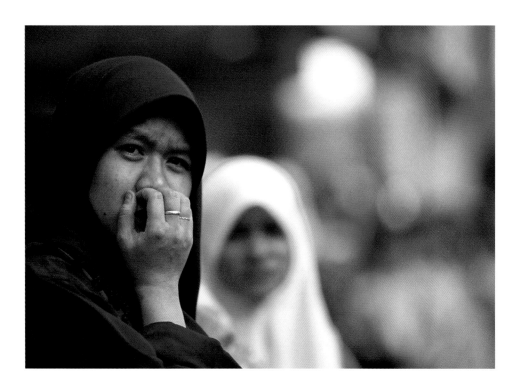

A pensive Malay woman (above) is emblematic of the shifting status of women in parts of Malaysia and Indonesia, where local political parties have cracked down on Muslim girls wearing miniskirts and women holding political office. The region's Islamic resurgence has been marked by a controversial increase in the number of women being compelled to cover so-called "naked areas" of their bodies, a practice called *aurat* in Arabic, and by restrictions on women working with men.

Despite efforts to clean it up, the sex trade in Kuala Lumpur is centered on the Chow Kit area (right), where prostitutes and transvestites lurk in doorways. A major source of concern is a practice called *bohsia*, literally "without a word" in Malay, a reference to girls who exchange sex — though not necessarily intercourse — for money or favors. Governments in Kuala Lumpur and Jakarta blame social problems like these on rapid urbanization and the consequent erosion of family and community controls.

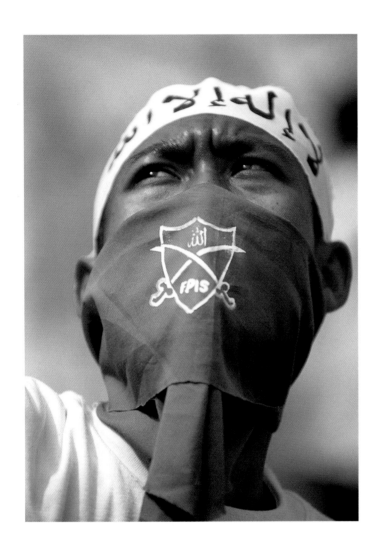

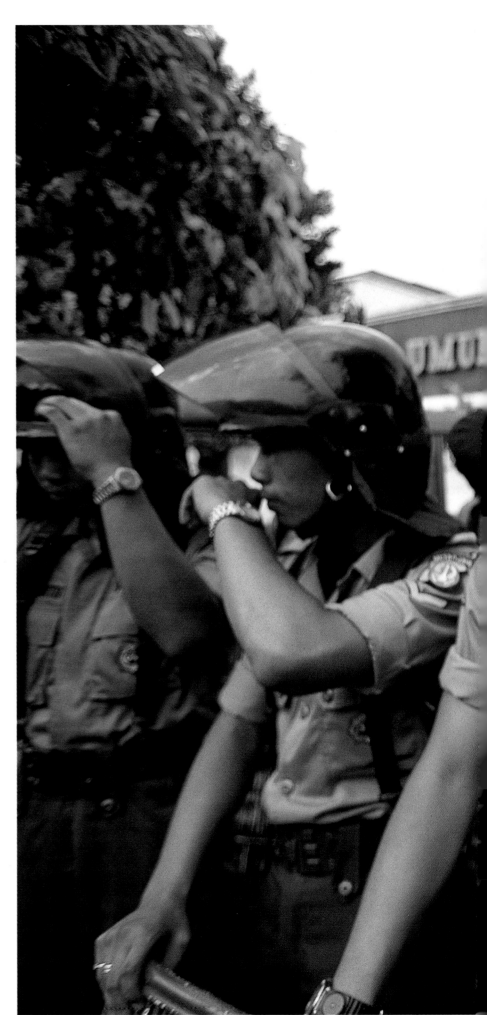

Muslim against Muslim is often the rule in the streets of Jakarta, where riot police (right) suit up to protect government offices, businesses, embassies, and private residences against crowds of angry demonstrators, many with an Islamic bent. Muslim protestors (above) take to the streets to demand *jihad*, or holy war, against government corruption, Christians in the Maluku or Spice Islands, and opposition parties.

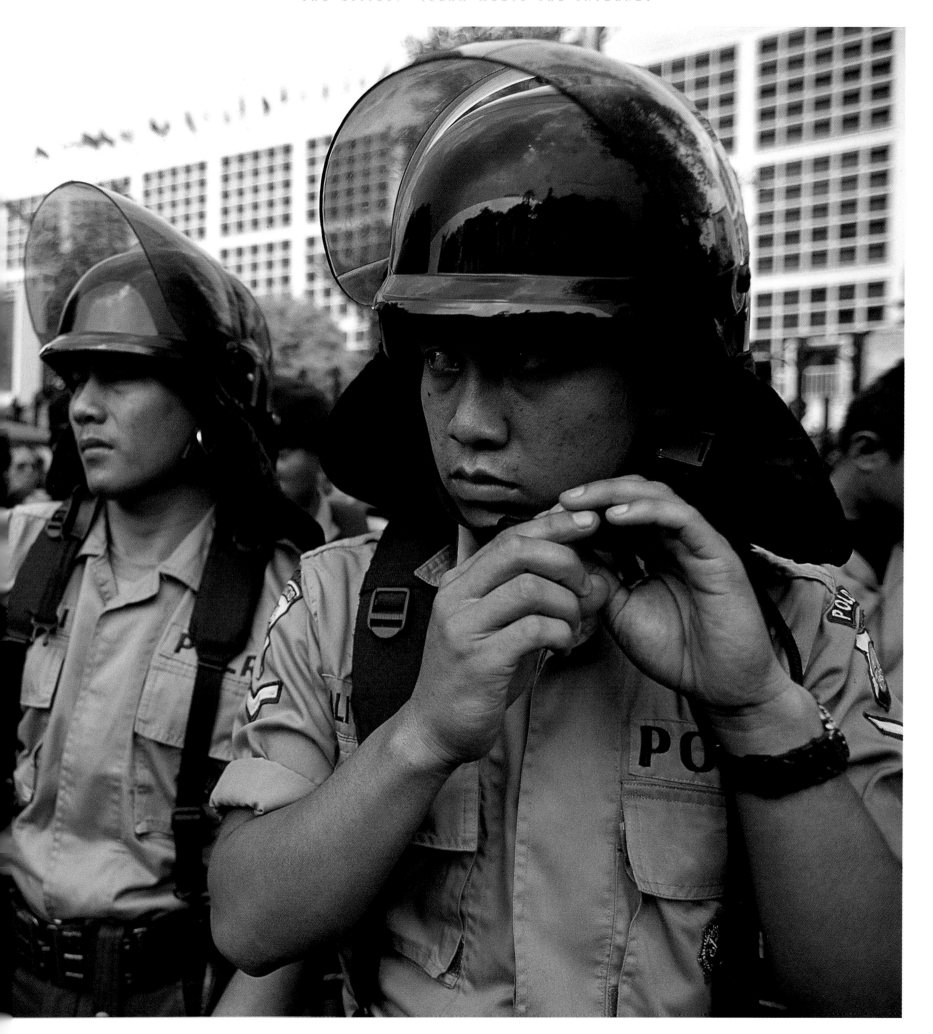

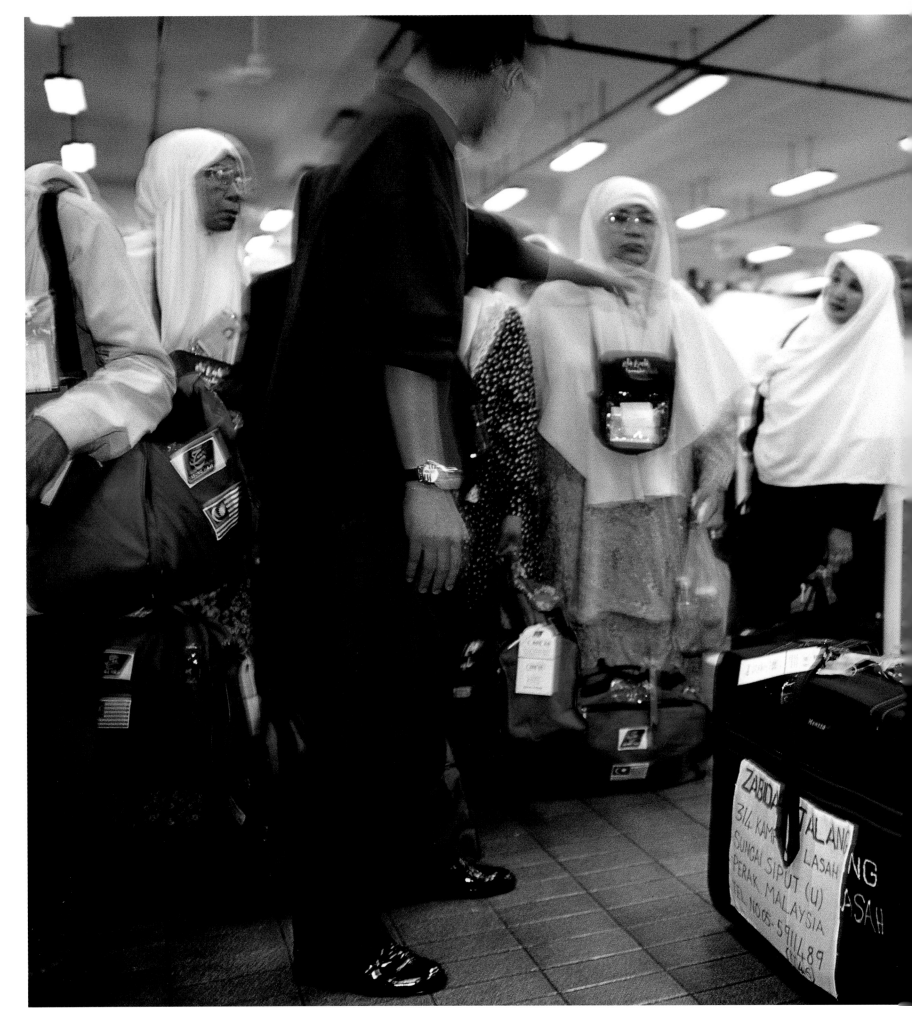

Urban processing centers, like this one in Kuala Lumpur, handle tens of thousands of Saudi Arabia-bound hajj pilgrims. For many, it is their first international journey and their first time on an airliner. In many Southeast Asian countries, government-sponsored agencies provide one-stop help with travel documents, transportation, and lodging in Mecca and Medina.

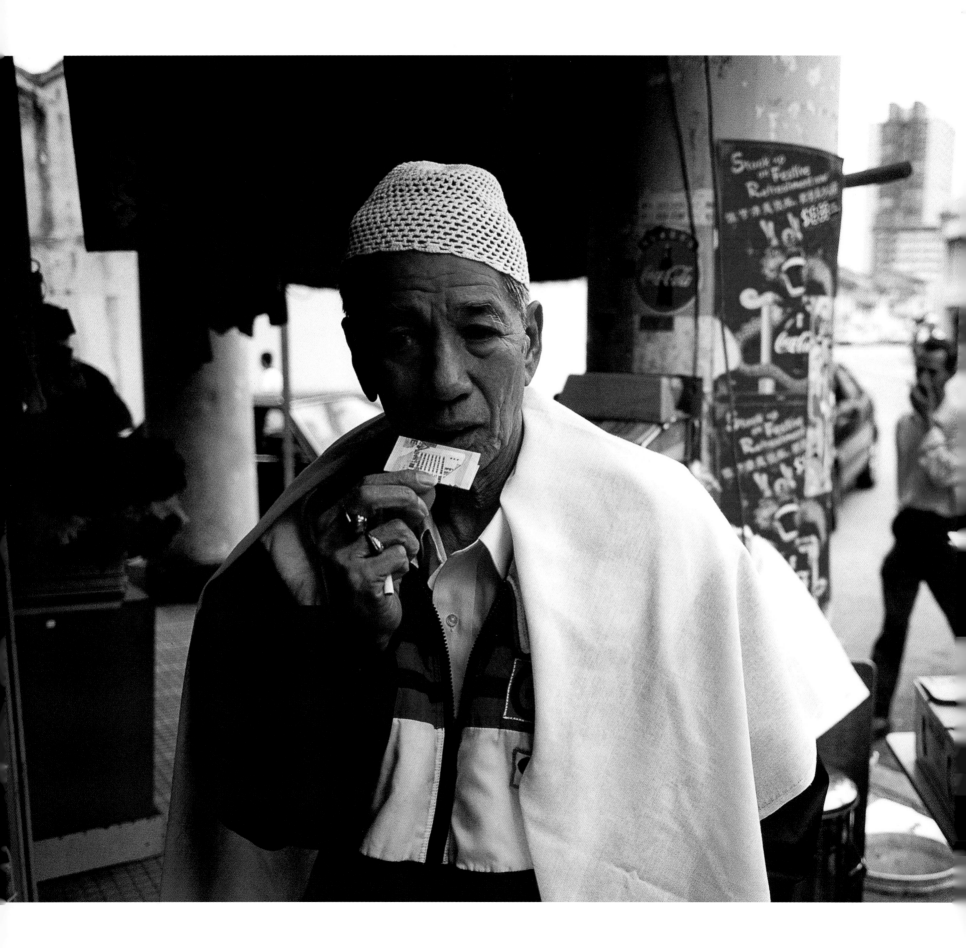

Literally tasting his money, a Muslim puts Singapore currency to his lips (left) in the Arab Street quarter of Singapore, an enclave with the feel of a North African kasbah or Persian Gulf kingdom. The district feeds, clothes, and ministers to many of Singapore's Muslims, who make up about 14 percent of the island city-state's 4.1 million inhabitants.

Signs in the Arab Street quarter (above) are lettered in English and Chinese — two of Singapore's four national languages along with Malay and Tamil. Many of the district's names — Muscat, Baghdad, and Kandahar Streets — reflect the quarter's roots as an Arab trading center established almost two centuries ago by Singapore's founder, the British colonial administrator Sir Stamford Raffles.

Setting out spools of cloth from India, China, and Indonesia, a merchant along Arab Street in Singapore begins his morning routine. Many of the district's shopkeepers are Muslims of Indian descent who, unlike salespersons in the highbrow department stores along Orchard Road, are happy to bargain for a "discount" over a cup of tea that is customarily offered shoppers.

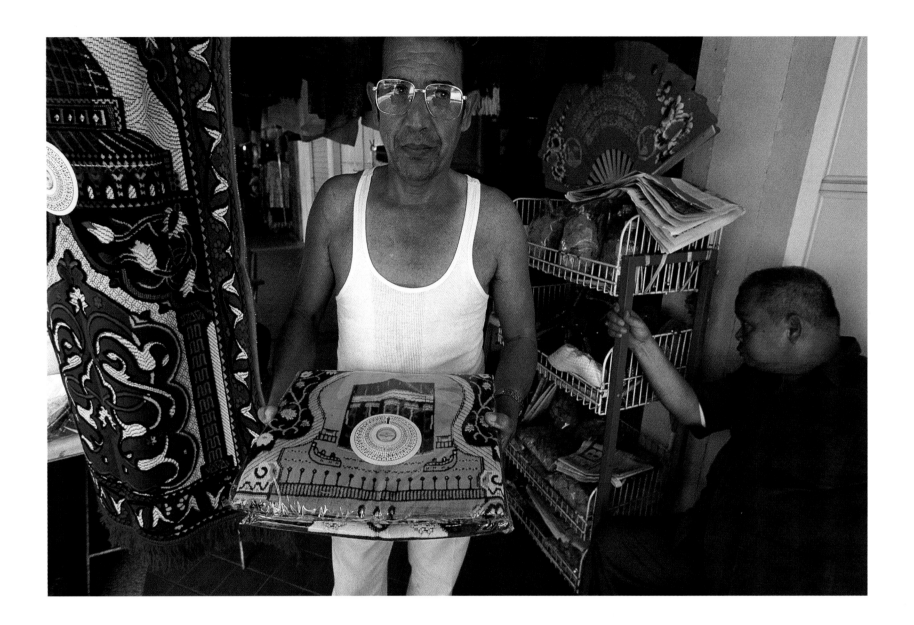

Novelties abound beneath the colonnaded arches of Arab Street. An enterprising Singapore shopkeeper (above) sells a prayer rug fitted with a compass that points in the direction of Mecca, toward which a Muslim must face to pray. Other shops sell carpets and brassware from the Middle East.

An Arab Street basket and rattanware emporium (upper right) claims to be one of the most photographed shops in Singapore, a city known for its liberal use of the wrecking ball in other colonial-era districts. But the city's Muslim quarter has been declared a historic preservation zone.

Embroidered prayer caps (left), called *songkoks* in Malay and *kopiah* in Indonesian, are piled high at a store near Singapore's Sultan Mosque. A $3,000 donation from the British East Indiana Company helped build the first mosque in Kampong Glam in 1826.

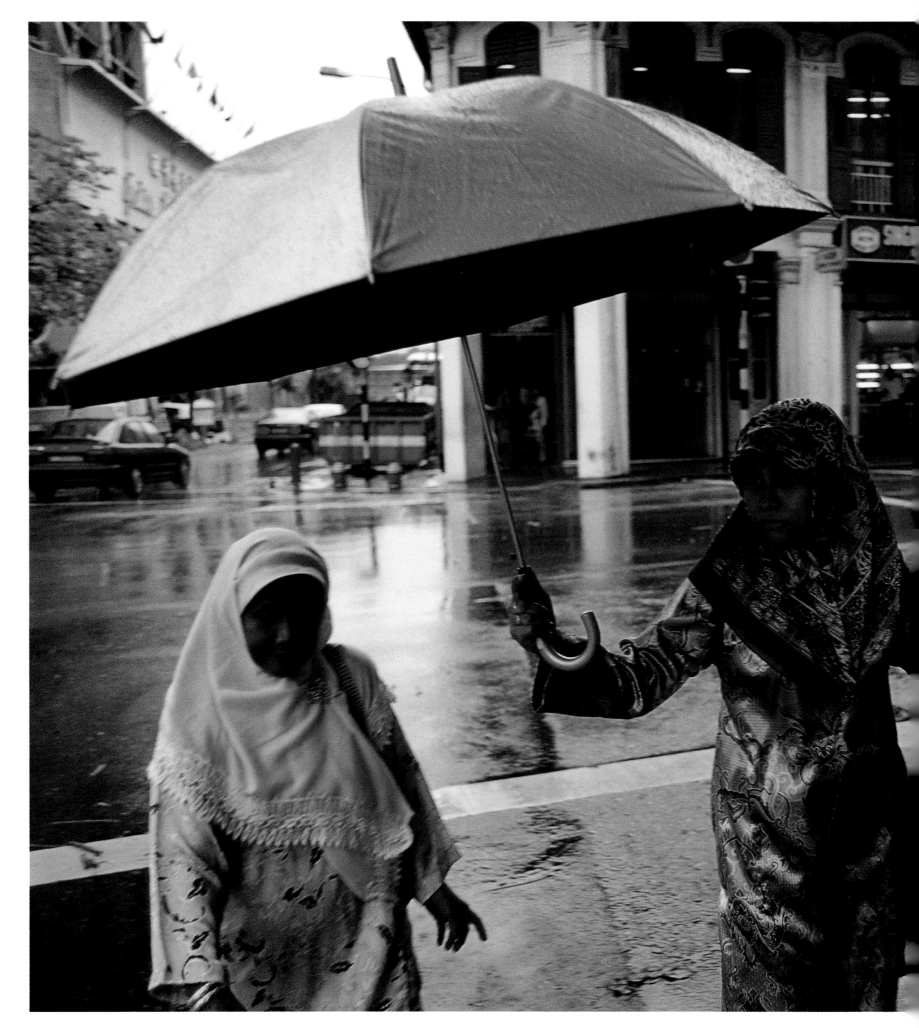

Muslim women cross busy North Bridge Road and Arab Street, where Singapore Muslims — about a half million Malays and descendants of Indian, Arab, and Bugis traders — come to shop and eat. Many women buy hand-mixed perfumes that include the essences of rose, jasmine, sandalwood, basil oil, and honeysuckle.

Singapore Muslims gather most mornings in the tea shops along North Bridge Road (right) to catch up on the overnight news. Sheikh Abdullah Bakar, far right with beard, traces his ancestry to Malay sultans who once ruled the island of *Singapura*, then part of the empire of nearby Johor in Malaysia. Hectic Singapore moves to the 24-hour-a-day rhythm of the global economy, necessitating most businessmen and women, including this Muslim at an Arab Street tea shop (above), to carry a mobile phone.

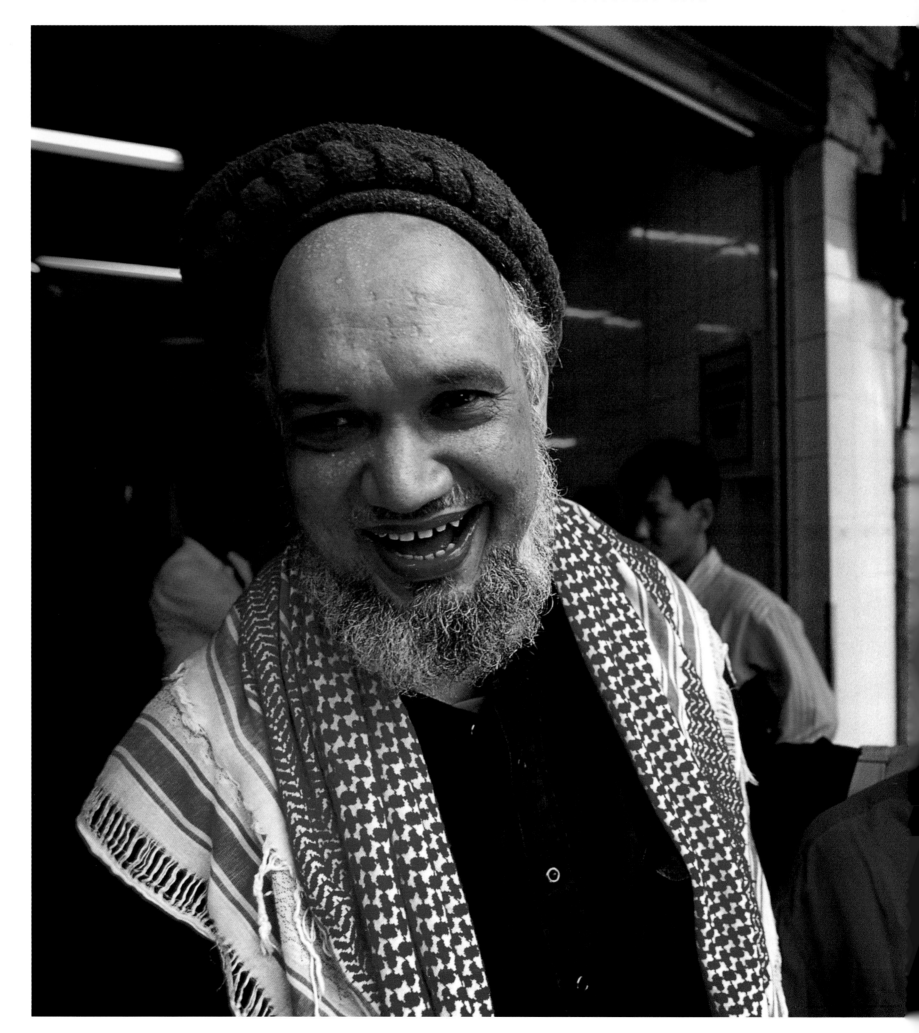

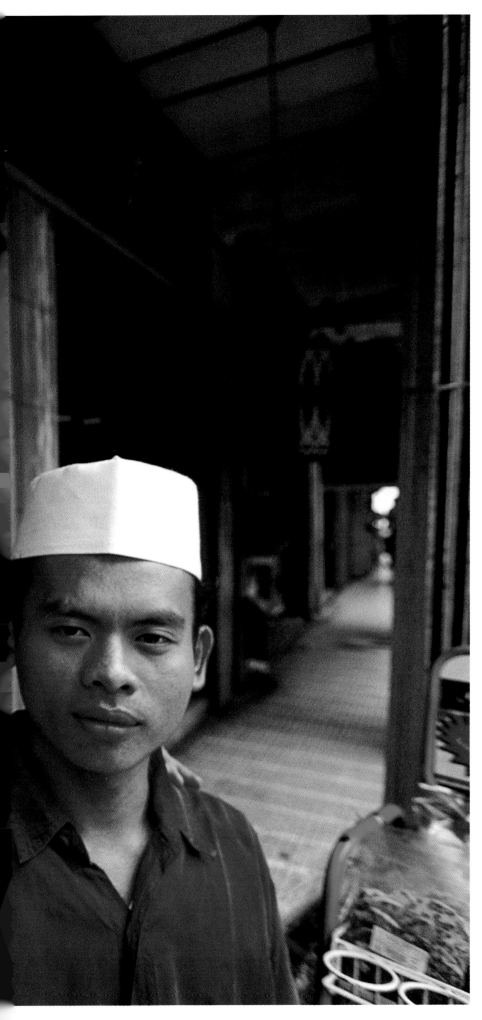

A devout Muslim and one of his disciples greet a passerby on the covered streets of Kampong Glam, a compact enclave filled with mosques, markets, an Arabic girls' school, a palace once used by descendents of Malay royalty, and a Muslim cemetery. An Arab Street shop (above) flies the Singapore flag on the country's Independence Day — August 9.

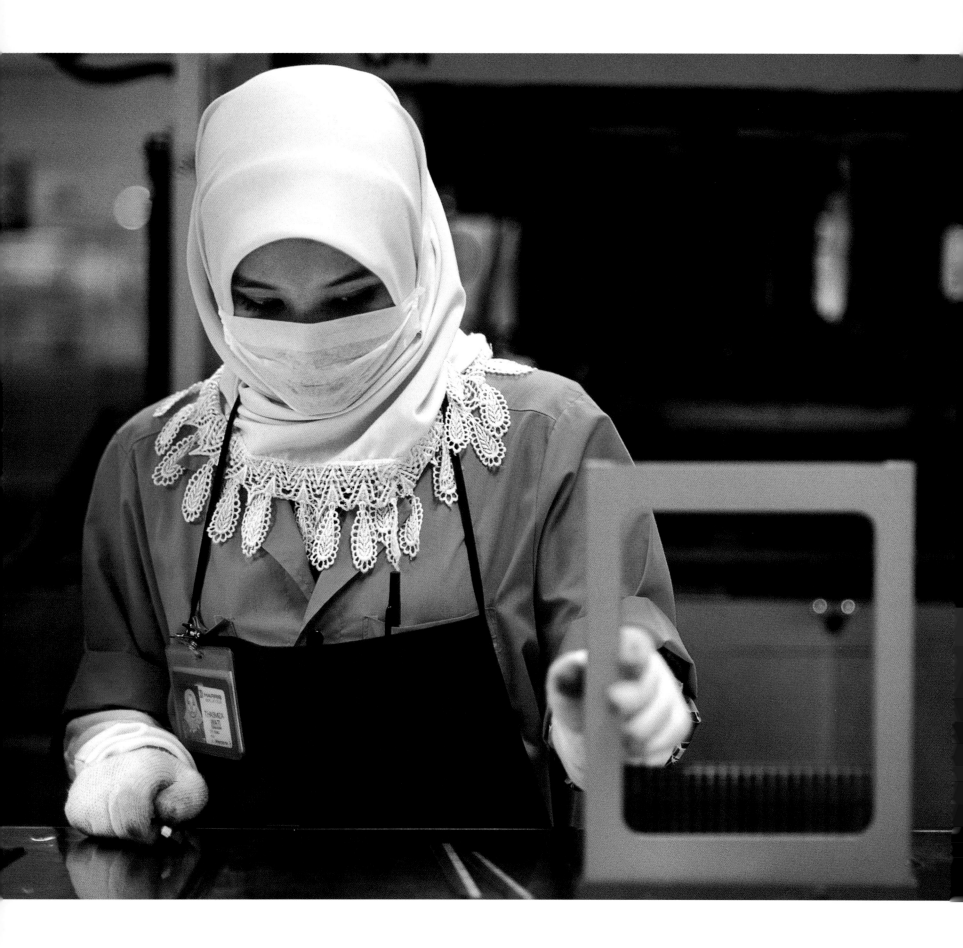

For a country that two decades ago was primarily a producer of tea, rubber, tin, and cooking oil, Malaysia is now one of the world's largest exporters of semiconductors and disk drives. At Intersil Technology (left), Muslim workers are allowed to wear the Islamic head scarf and given time off the assembly line for prayers.

Islam has gone on line in Malaysia (above) with this URL plastered on the side of the National Islamic Center in Kuala Lumpur. Governments throughout Southeast Asia use the Internet to explain themselves, as do Muslim political parties, schools, universities, banks, and opposition groups.

A Muslim chef tosses *murtabak*, a thick pancake stuffed with meat, fried onion, and egg, that is loved by Asians of all faiths at a food stall in the Arab Street quarter of Singapore. Islamic restaurants along Singapore's North Bridge Road draw clientele from across the island, serving up specialities like *roti Mariam*, a flat wheat pancake flavored with tangy Malay spices, and baked tunafish called *ikan bakar*.

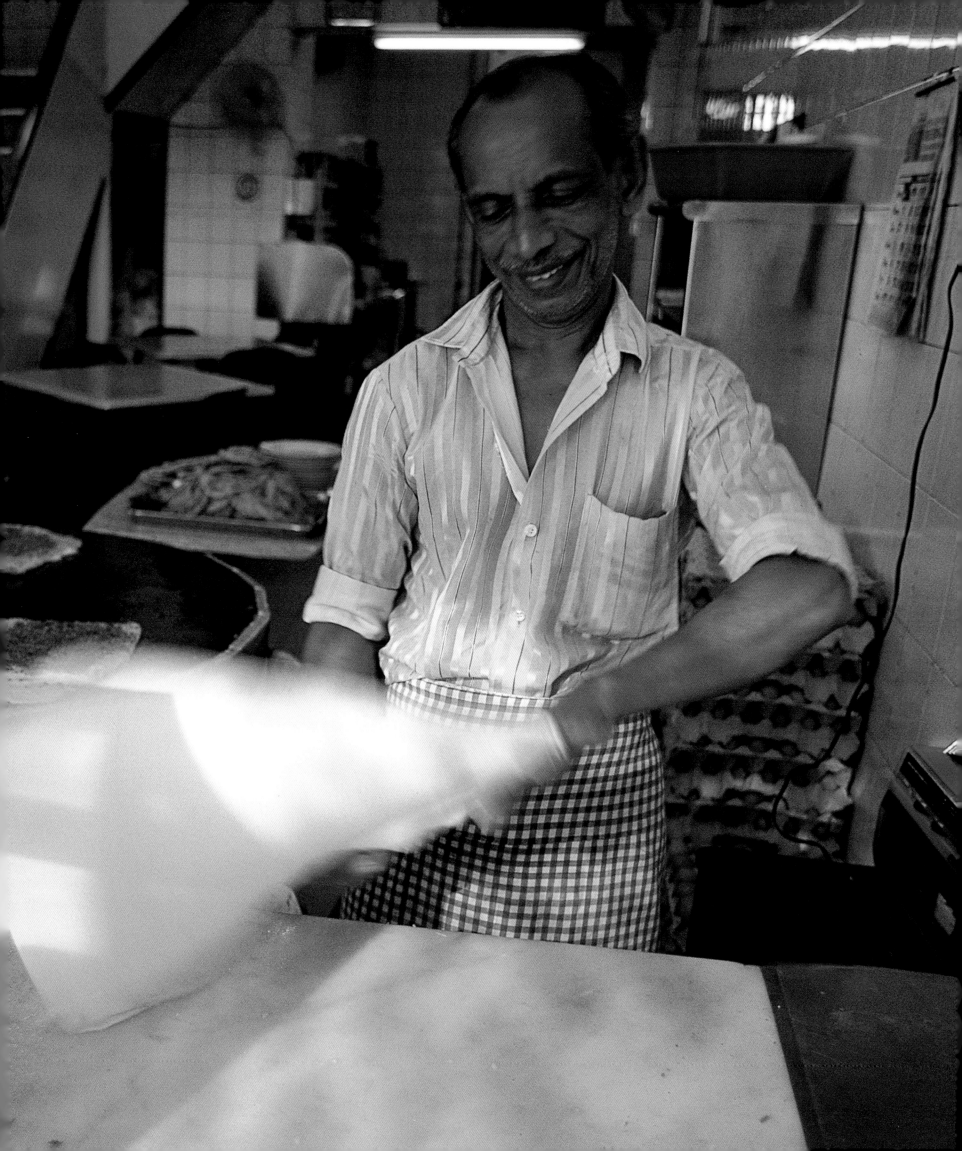

MAINSTAY OF FAITH

THE MUSLIM FAMILY

Television stations across Malaysia reported the Keeper of the Ruler's Seal declared an end to Ramadan, the Muslim month of dawn-to-dusk fasting and penance, noting that 12 observatories had sighted a new moon. But the ruling was partially ceremonial, a nod to tradition in a country rushing to join the front ranks of the developed world by the year 2020. Months before, the religious elite called the *ulama* had agreed when Ramadan would begin and end, allowing families to plan a moveable feast called *Hari Raya Aidilfitri*.

And so on the first morning after Ramadan, Abdullah Juhaidi packed his wife, Zainab, and their three children into the family's Toyota minivan and drove off to pray at a local mosque in his hometown of Kota Bharu. But the main event of *Hari Raya Aidilfitri* is always a succession of festive open-house visits that officially last three days, sometimes longer.

Juhaidi and his family wore luxurious Malay costumes. Zainab and her daughters were outfitted in the ubiquitous *baju kurung* — a knee-length blouse of silk printed in bold colors and lively geometric patterns. And Juhaidi, a worldly extrovert who has studied journalism and politics in the United States and Japan, donned the traditional *baju melayu* — the black prayer cap, silk shirt of batik print, and a gold sash called a *songket* tied around his waist.

Over the next few days, they called on parents, relatives, in-laws, business associates, friends, and local politicians, who entertained thousands of constituents at a time. At each stop they savored curries both hot and sweet, tiny grilled kebabs of chicken and mutton called *satay*, a fiery curried meat in coconut marinade called *rendang*, plus desserts of cakes, dates, and tropical fruits. They sang Malay ballads and Western rock on karaoke machines, and caught up on family gossip — a reward in itself after traveling 13 hours on crowded freeways and mountainous roads to be home for *Hari Raya Aidilfitri*. In houses connected to satellite television, Juhaidi's stepchildren watched MTV-Asia, which guaranteed a week of "partying *Hari Raya* style" for the young attuned to a globalized world.

Meet the Muslim family of the 21st century.

Yet beneath the easygoing informality of *Hari Raya* lie significant changes in the Muslim family and society. Muslim men, for example, are marrying more often, partly because many are prosperous enough to support more than one wife. In Malaysia, Muslim marriages have steadily increased over the past decade. One reason is population growth. Malays are having more children and now account for 55 per cent of Malaysia's 23.5 million citizens. And more Malay men are legally taking second wives, though often these unions are performed in secret to spare the feelings of the other spouse. The Koran, the Islamic holy book, allows men to have as many as four wives at a time, as long as all wives receive equal emotional and material support. For example, Sultan Hassanal Bolkiah of Brunei, one of the world's richest men thanks to his country's oil wealth, often appears in public with both of his wives. Their photographs hang side-by-side in public buildings, and they work together to host foreign dignitaries, including former President Bill Clinton of the United States.

A popular misconception is that Muslims can quickly

and painlessly end unhappy marriages by declaring "I divorce you." They can't. "Of all the permitted things," said the Prophet, "divorce is the most abominable with God." In Malaysia, for example, divorces are steadily declining. This may be the result of better mandatory premarital counseling or, more darkly, because unhappy couples cannot reach a divorce settlement due to business or legal constraints. Interviews with family court judges and sometimes sensational newspaper articles support both suppositions.

Despite the decline in the divorce rate, scholars say attitudes toward divorce appear to be changing throughout Muslim Southeast Asia, with more women taking the lead to end unhappy marriages. In Malaysia, women make up the majority of the plaintiffs before the Sharia courts where divorce, child custody, and inheritance are settled for most Muslims. Women appearing before these courts often cite domestic abuse as their reason for wanting to leave a marriage. Once a taboo subject, domestic violence is becoming a much-talked-about issue in newspapers, on university campuses, and inside some legislative chambers.

One of Southeast Asia's most prominent groups to lobby against domestic abuse is called Sisters of Islam in Malaysia. Over the years, it has published books titled *Are Muslim Men Allowed to Beat Their Wives?* and *Are Men and Women Equal Before Allah?* "We need to change the way society looks at women's roles," says Marina Mahathir, a social activist and daughter of Malaysian Prime Minister Mahathir Mohamad. "It is

often a case of two steps forward, one step back. We are the first Asian country to have a Domestic Violence Act, but women who report their violent husbands are still being told to go home and be 'nicer' to them."

Paradoxically, this activism comes at a time when increasing numbers of Muslim women are becoming more Islamic in dress and identity. Conservative social pressures partially account for this. In some parts of Malaysia, for example, Muslim women employed by state governments must wear the *tudung* head scarf and wear loose-fitting clothing. Mothers are encouraged to stay home with their children. And in the Malaysian state of Kelantan, supermarkets must now have separate checkout lines for women and men, movie theaters must keep the lights on during films, and hotels must maintain separate swimming pools for men and women.

Even neighboring Indonesia is feeling the pressure to return to conservative Islamic family traditions. And they are being aided by some unlikely allies — young people who have grown up with MTV, shopping malls, fast food, and other trappings of Western popular culture. In Jakarta each morning, young women by the thousand set off for classes in flowing white robes and snug head covers called *jilbabs*. Many students say Islamic dress does more than satisfy the seventh-century dictates of the Koran, which requires women to cover parts of their bodies that would be considered private. Women at Asshiddiqiyah Islamic College are quick to tell visitors that Islamic dress makes them feel "more beautiful" and several admit to having convinced their mothers to wear the *jilbab*.

All smiles for the Hari Raya Aidilfitri holiday, Abdullah Juhaidi — known to his friends simply Juhaidi — and his wife, Zainab, steal a few moments during a busy round of open-house visits that mark the end of the month-long Ramadan fast. An extroverted Malaysian journalist turned government press officer, Juhaidi is a convert to Islam.

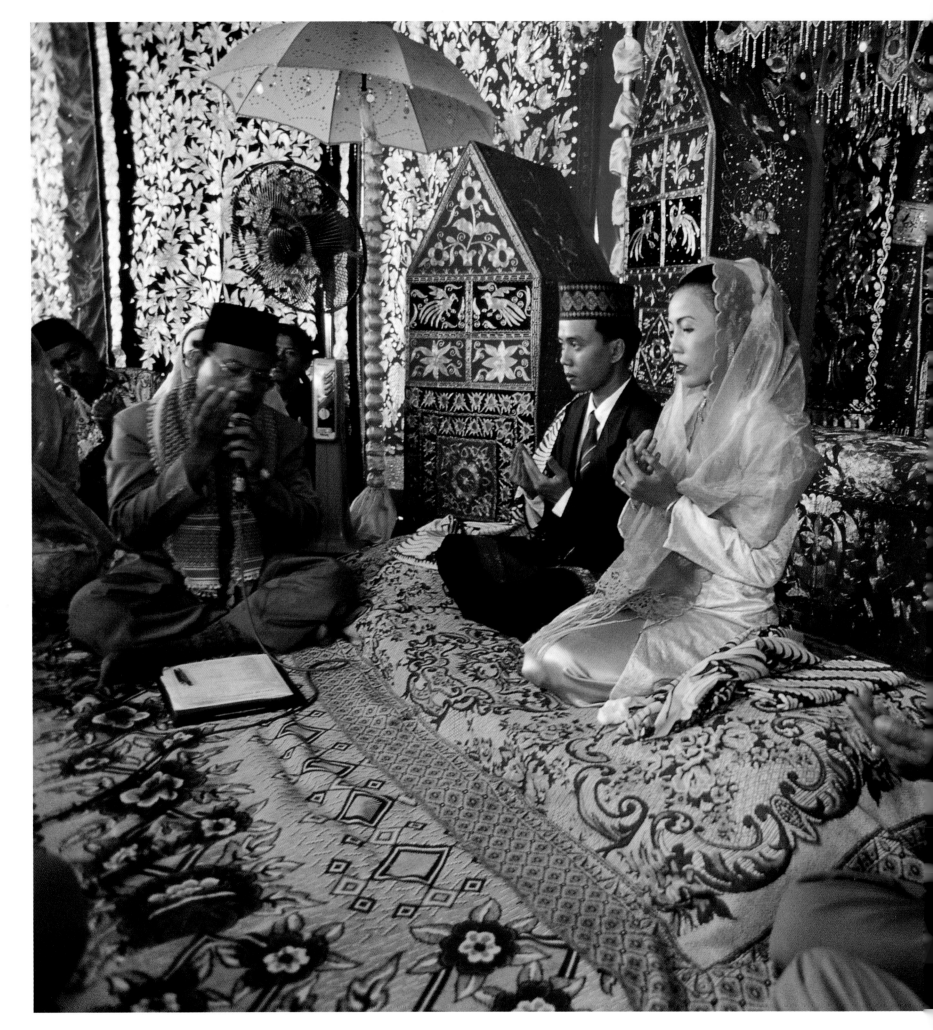

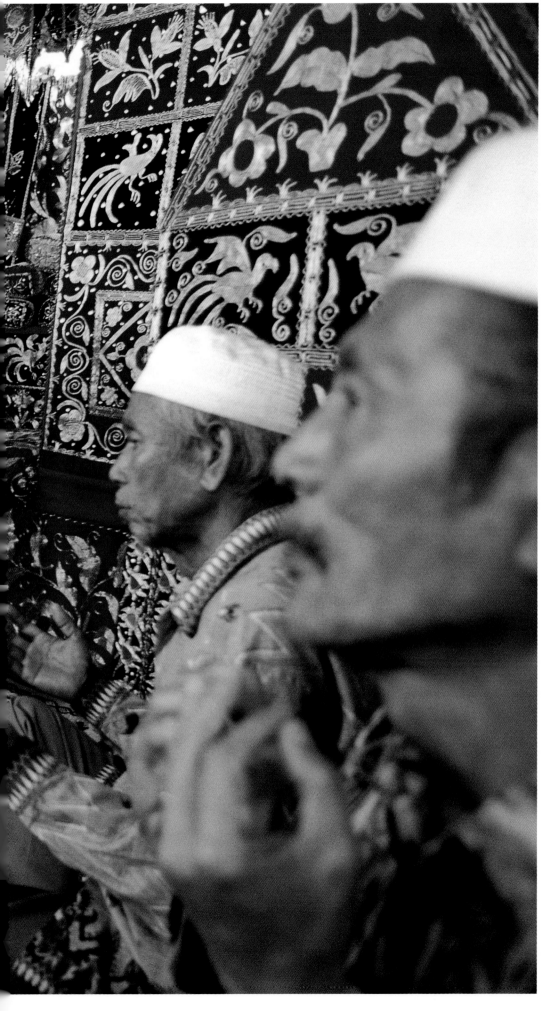

A Muslim wedding unites two colorful ethnic groups on the island of Sumatra — the Minangkabau, energetic merchants who have migrated throughout Indonesia, and the isolated Batak of the fertile volcanic highlands surrounding Lake Toba. A Muslim cleric, far left, reads from the Koran over a portable public address system, binding Ade Indriani, the bride, and Ridwan Hendrir, who sit on a dais outside the bride's home in the Sumatra capital of Medan. In Muslim tradition, marriage is a solemn contract that unites two individuals and two families, but it is not considered a sacrament — or spiritual mystery — as in the Christian faith.

Backbone of the rural family, an elderly Cham Muslim woman runs a small food stall and cares for her grandchildren in a village near Siem Reap in northwestern Cambodia. The Cham suffered horribly under the regime of the Khmer Rouge Communists, seeing their numbers decimated from about 800,000 in 1975 to some 185,000 by the mid-1980s. Today the Cham number about 203,000, roughly 2 percent of Cambodia's 11 million citizens.

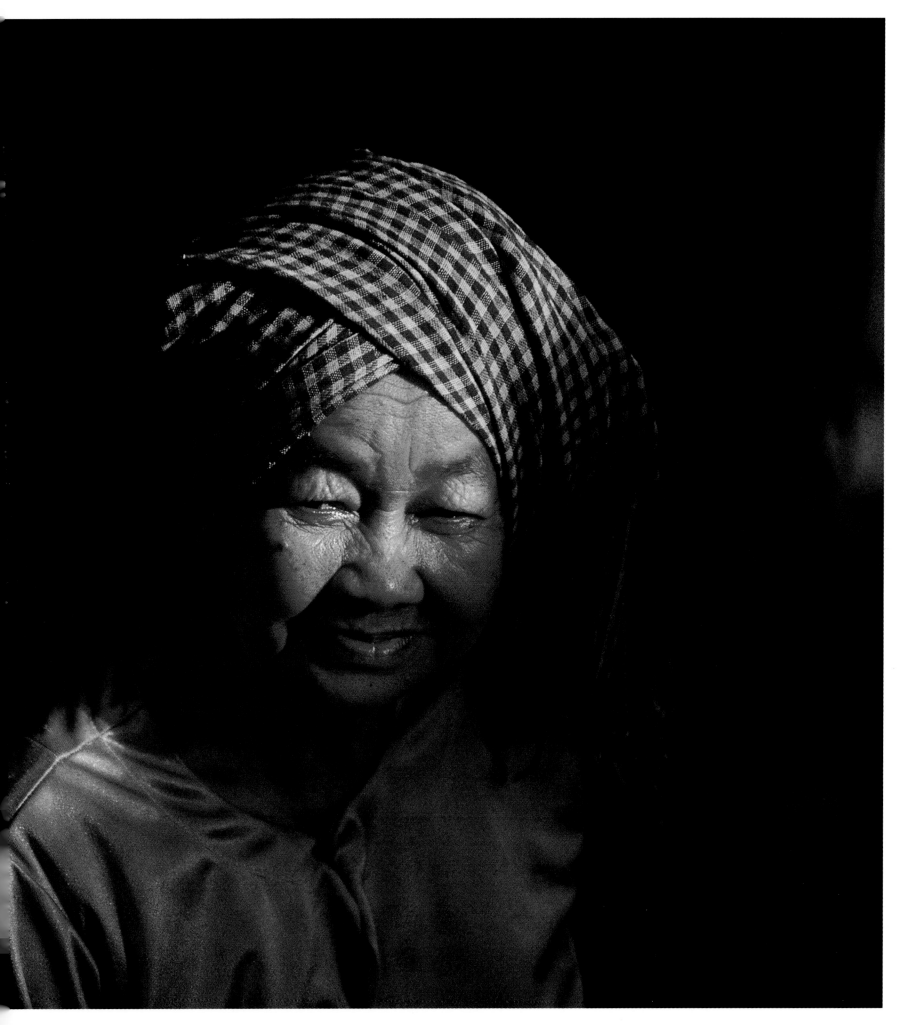

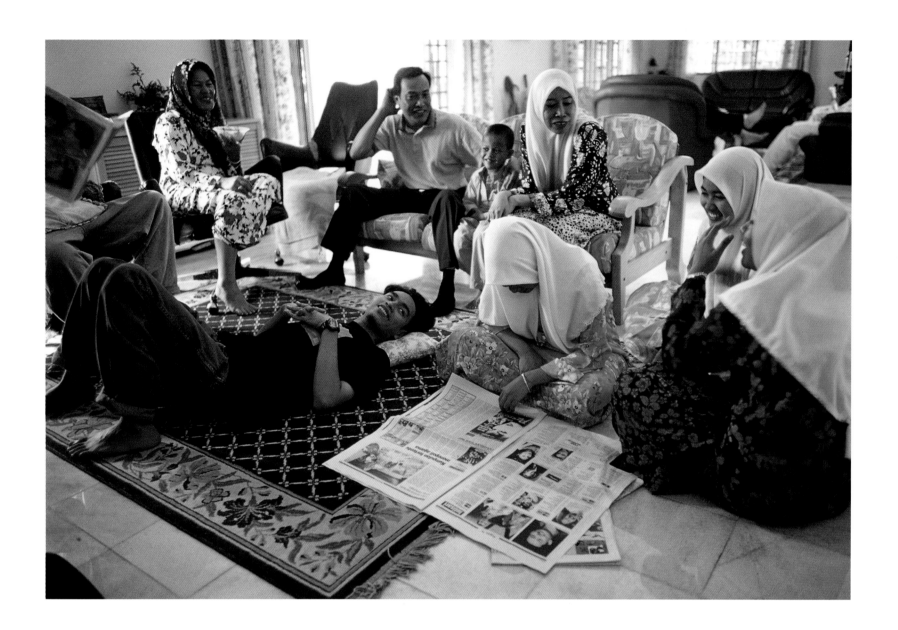

Gathered around the television and newspapers, a Muslim family in Kota Bharu quietly passes the Hari Raya Aidilfitri holiday that marks the end of the month-long Ramadan fast. It is not uncommon on Malaysia's conservative east coast to see women wearing the tudung head scarf inside their own home or in the presence of male relatives.

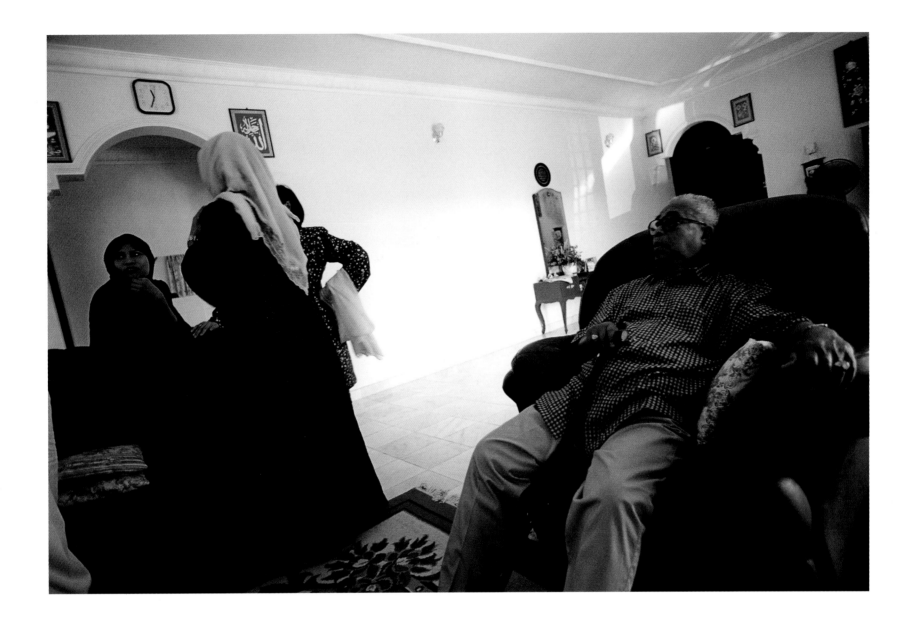

Concern for children knows no age limits inside this Muslim family in Khota Bharu, where a father keeps a paternal eye on his grown daughters. Contrary to popular misconceptions, the Koran elevates the status of women over pre-Islamic times, giving them the right to choose their mate, keep for themselves any dowry, and inherit property.

Enjoying a picnic beside a cool mountain stream, Abdullah Juhaidi and his wife, Zainab, (above) cast aside some of the modesty that dominates family life in Malaysia, Indonesia, and elsewhere in the Muslim world of Asia. Zainab is a gourmet chef who runs several Kuala Lumpur restaurants and has taught Malay cooking at Harrods, the aristocratic London department store.

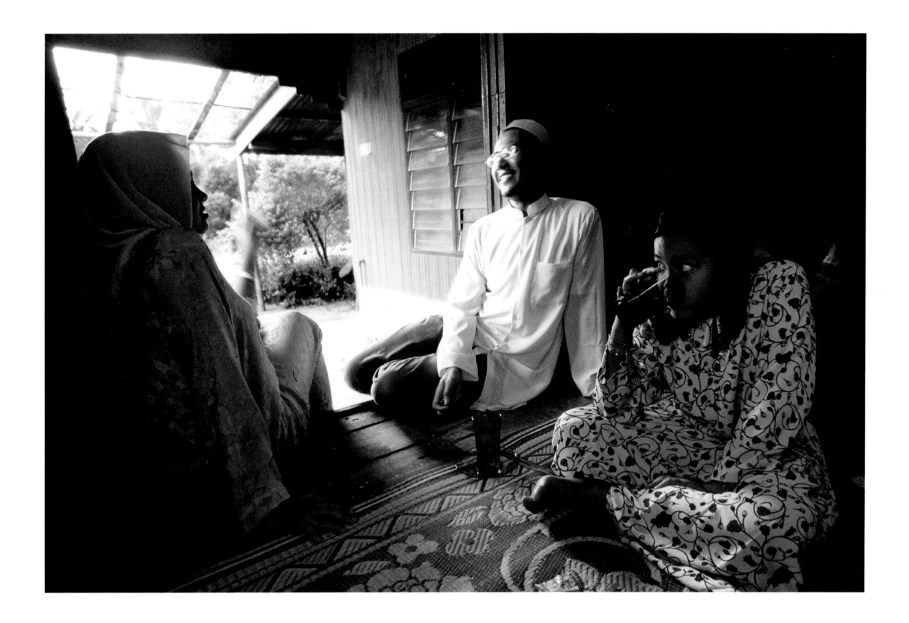

The sumptuous open houses that characterize the Hari Raya Aidilfitri holiday in Southeast Asia take days of preparation in the kitchen for even more days of feasting. A mother and daughter (left) cook rice in milk from a freshly chopped coconut inside a typical kampong kitchen. Juhaidi and Zainab's daughters (above) chat with their cousin, a student at Malaysia's International Islamic University.

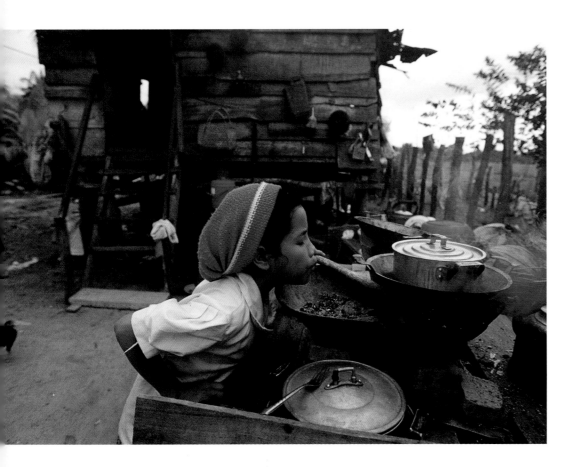

Fanning the cooking fire with a huff and a puff, a Cham Muslim girl (above) prepares dinner in a rustic kitchen outside her family's home in northwest Cambodia. In rural Cham communities, as elsewhere in Southeast Asia, children cook and clean, and boys tend and slaughter animals, the latter a practice that is anathema to the dominant Buddhist culture of Cambodia.

Most Cham families now have access to a mosque or small prayer house called a *surau*, though only a handful of the 113 Cambodian Muslim clergymen alive in 1975 are thought to have survived the murderous regime of Pol Pot. A Cham boy in prayer cap (right) playfully peaks from behind a window in a surau outside Phnom Pen, the Cambodian capital.

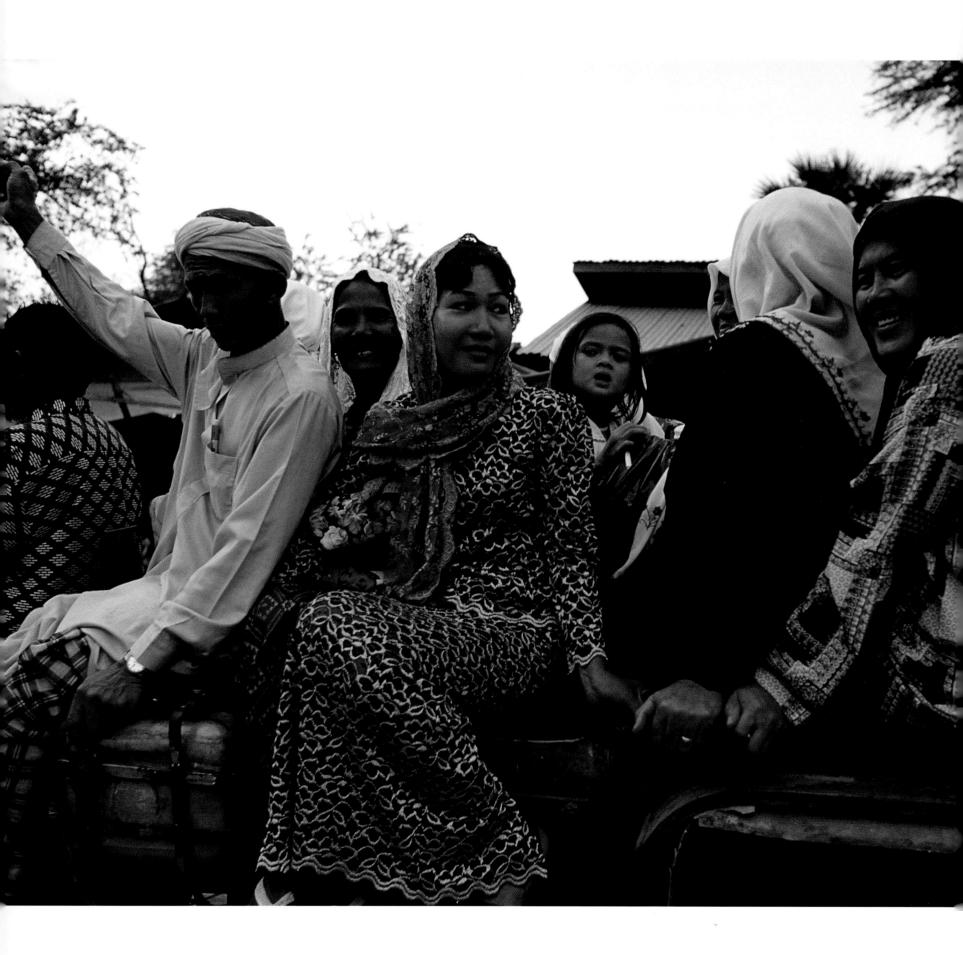

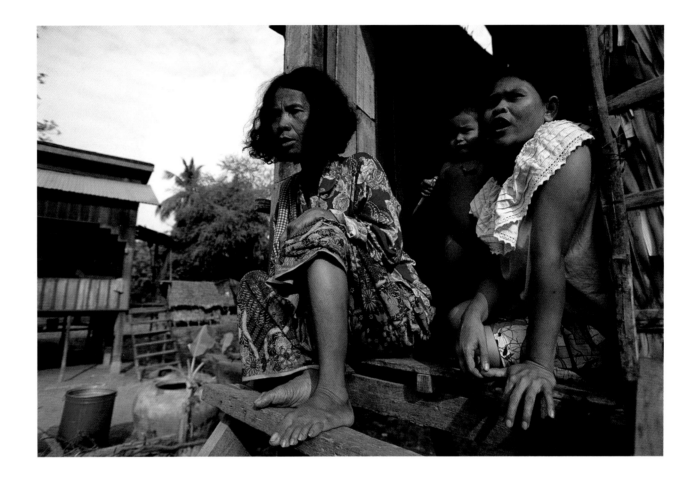

Cham Muslim women (left), dressed in their most colorful *baju kurung* — the pervasive blouse of silk printed in bold colors and lively geometric patterns — ride home on the back of a wagon after being honored at a local mosque on International Women's Day, a legal holiday in Cambodia. The more orthodox Cham conform to traditional Muslim practices in dress and worship, in part because of frequent contact and intermarriage with Malays.

Living among Buddhists and Christians, Cham families in villages like this one outside Phnom Penh (above) retain many of their pre-Islamic customs. While they believe in Allah, they also practice magic and sorcery, especially to treat serious illnesses or avoid violent death. Rural Cham may also recognize non-Islamic deities from the time when the ancient Kingdom of Champa, centered in Vietnam, practiced a form of Hinduism.

Families gather beside the fountain at the Baiturrahman Great Mosque in Banda Aceh on Sumatra before evening prayers. Daily prayer is one of five essential religious duties required of all Muslims, along with a profession of faith, almsgiving, fasting, and pilgrimage. Together, these central rituals are called the Five Pillars of Islam.

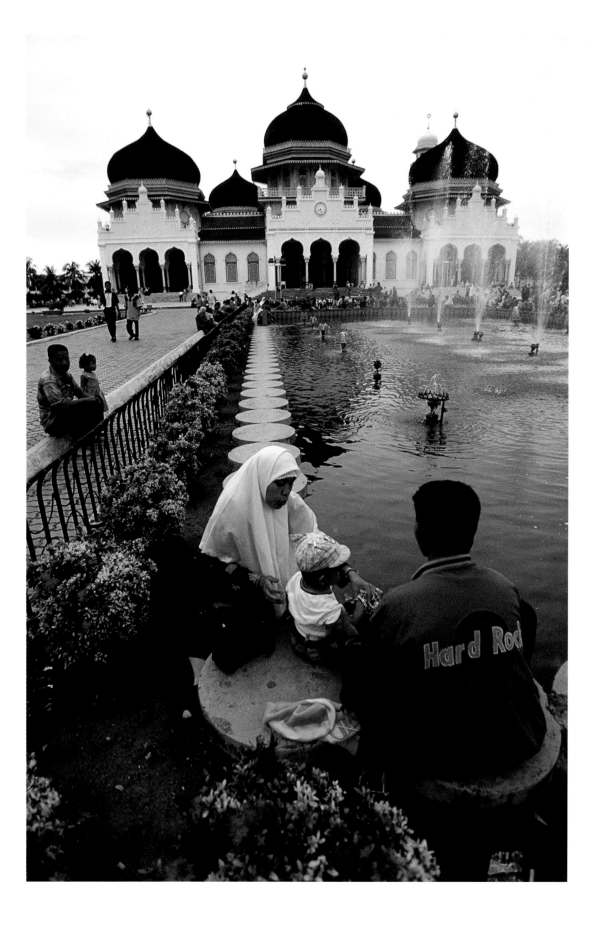

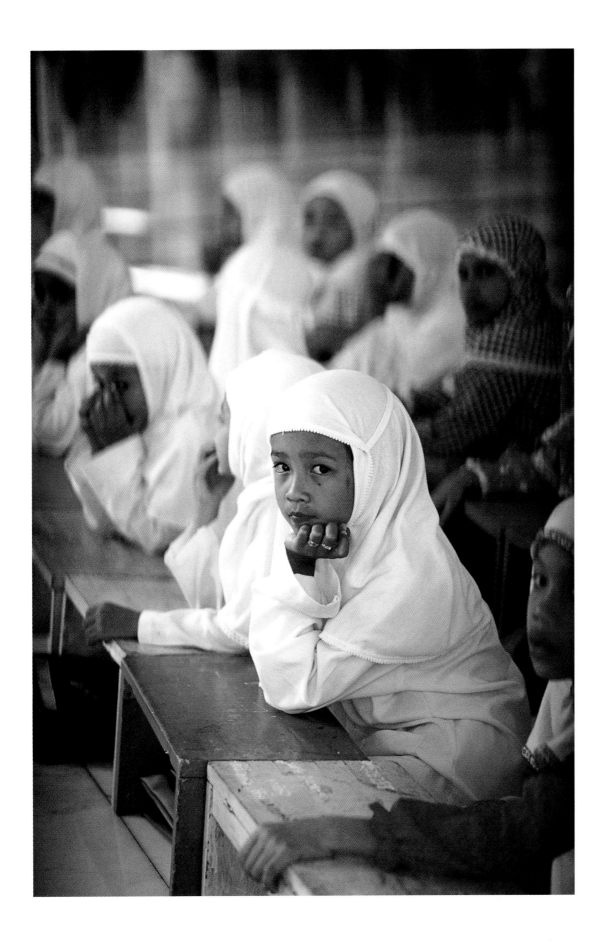

Across Muslim Southeast Asia, parents have turned to Islamic schools like this one in the rebellious province of Aceh to inoculate their children against Western values. They say the message children receive from American television, music, movies, and advertising is to buy brand names, eat fast food, and "shop until you drop."

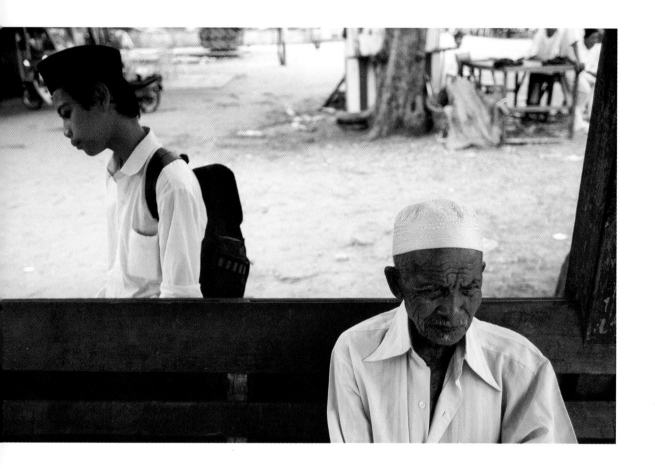

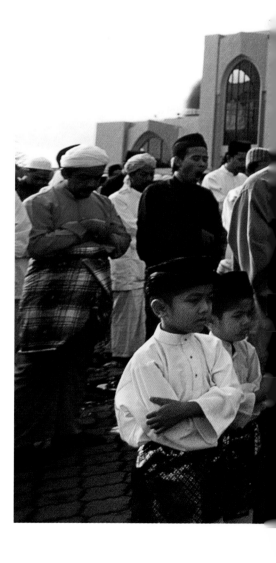

At a bus stop in the Malaysian city of Kuala Terengganu, an elderly hajji and a schoolboy from a nearby Muslim school mirror the generational divide that confronts Southeast Asian families. Muslim parents across the region say they worry about the erosion of respect for authority, blaming urbanization that divides families and generations, and the pervasiveness of Western popular culture.

Fathers and sons stand in neat rows at Kubang Kerian Mosque in Kota Bharu, fulfilling the obligation of congregational prayer for males on Fridays. They face in the direction of Mecca and listen to a sermon delivered by an *imam*, or prayer leader. In some conservative parts of Southeast Asia, Friday has replaced Sunday as the traditional day of rest.

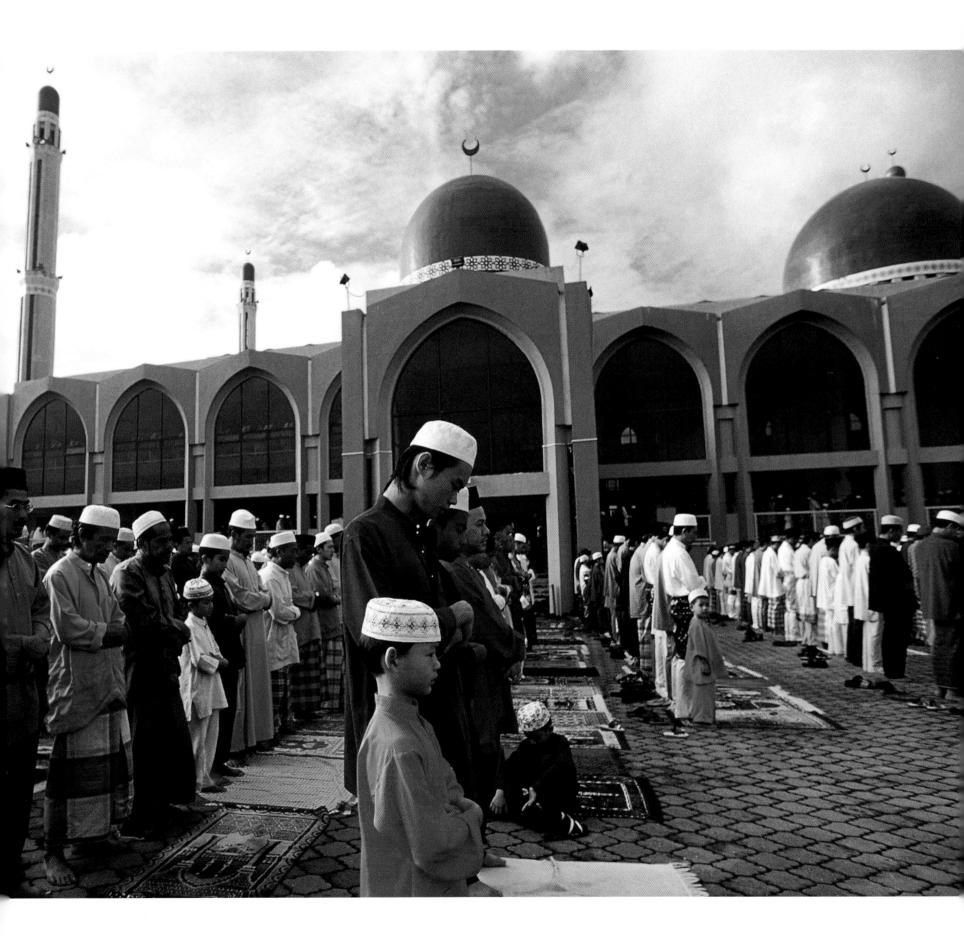

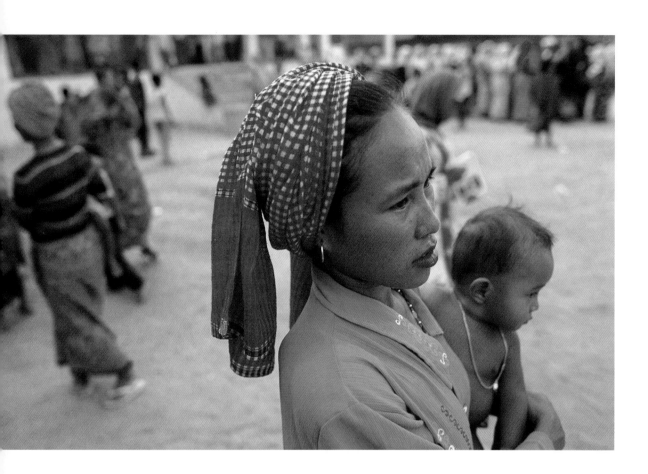

Muslim women (above) gather at a mosque in rural Cambodia. In the absence of work in desperately poor Cambodia, many are left alone to raise their children while fathers migrate — often illegally — to Malaysia and Thailand in search of work in factories or on fishing boats. International aid organizations paint a grim picture of rural poverty for Cambodian Muslims, who frequently have no electricity or sanitation.

Near Kota Bharu, a Malay Muslim family basks in the warm waters of the South China Sea (right) at a spot commonly called "PCB" — *Pantai Cinta Berahi* in Malay — or the Beach of Passionate Love in English. Bowing to resurgent Muslim sensitivities, local authorities have renamed the beach *Pantai Cahaya Bulan* — or Moonlight Beach.

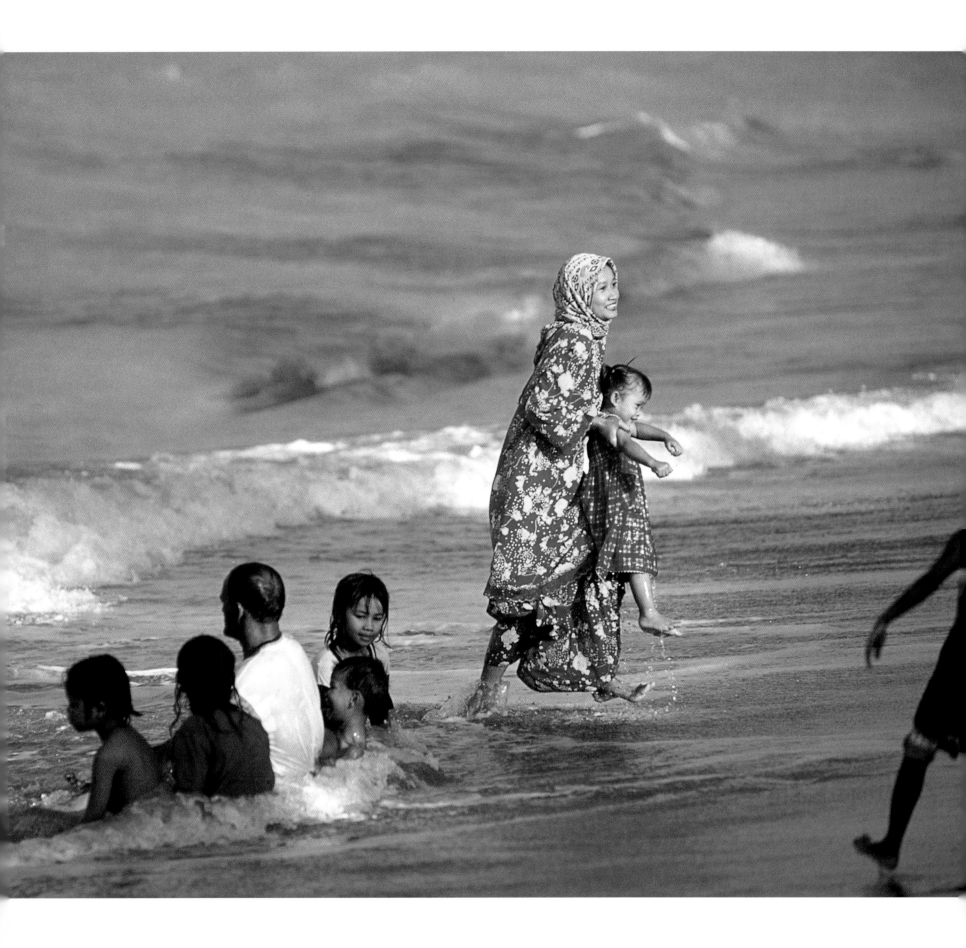

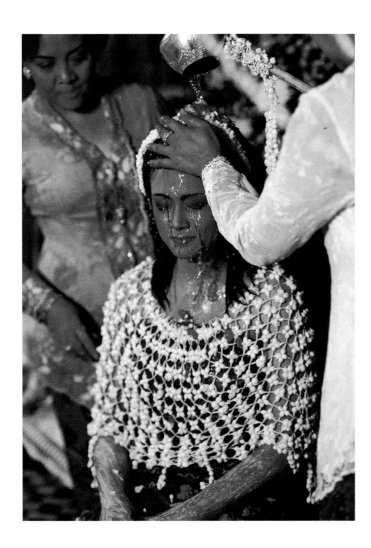

Weddings in Indonesia, the world's largest Muslim country, frequently combine pre-Islamic or local customs with unwavering Muslim rituals. An Australian-educated designer named Wati (above) undergoes a "purification" ritual of Javanese origin on the first day of a two-day wedding celebration at the home of her parents in a wealthy Jakarta suburb. In front of family and close friends, she bows before her father, Sutadi Suparlan (right), to ask permission to marry — another Javanese ritual.

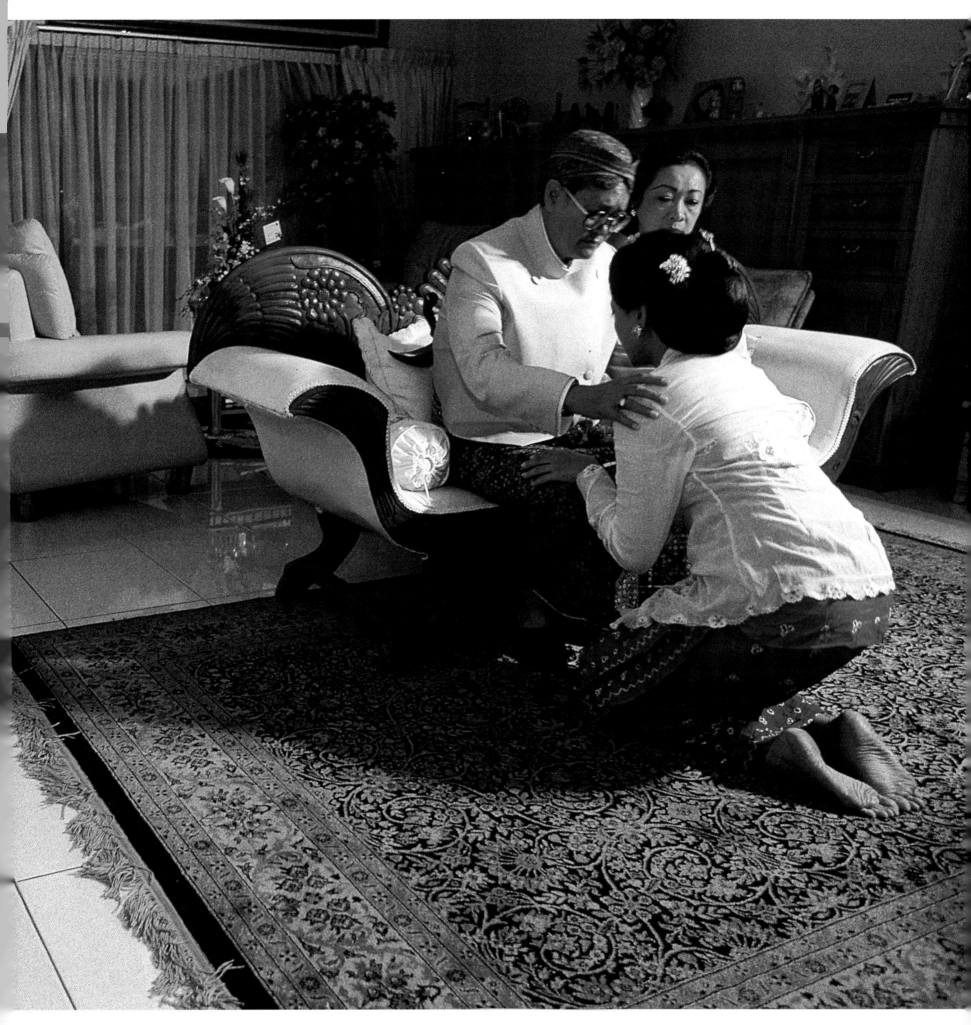

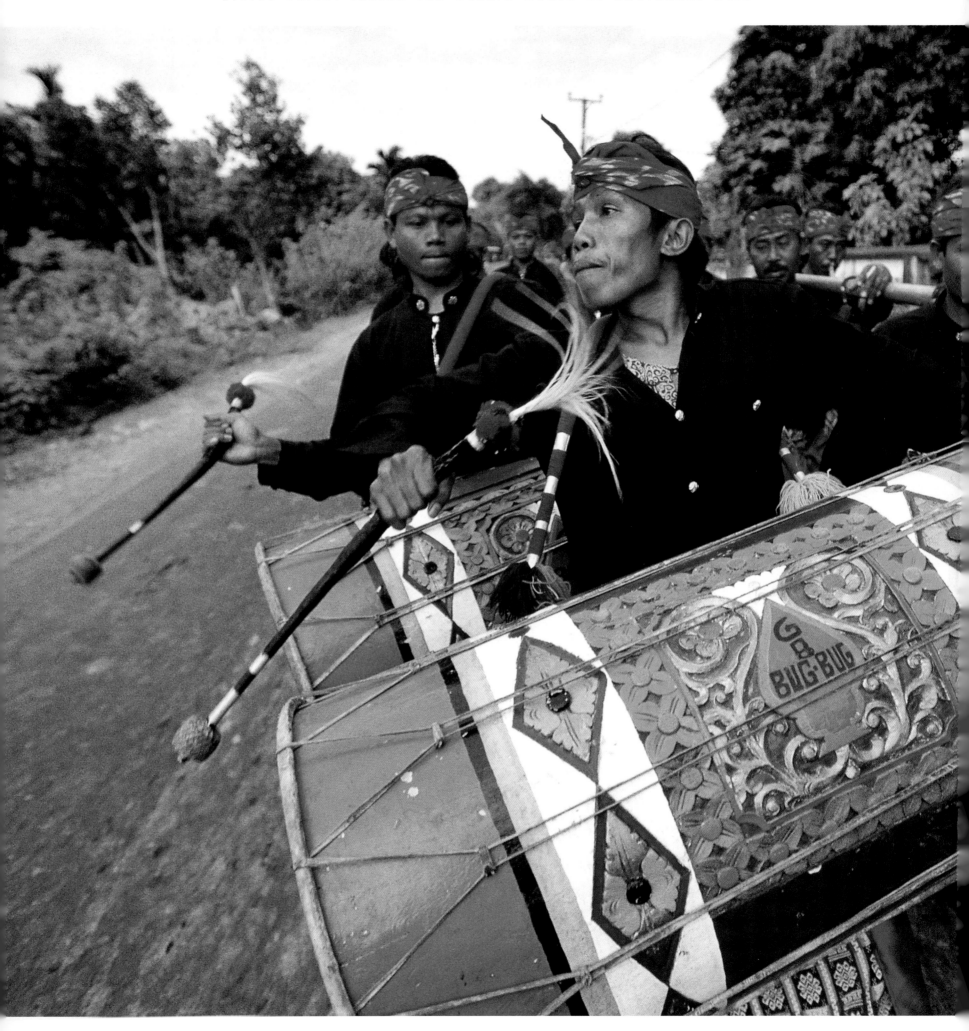

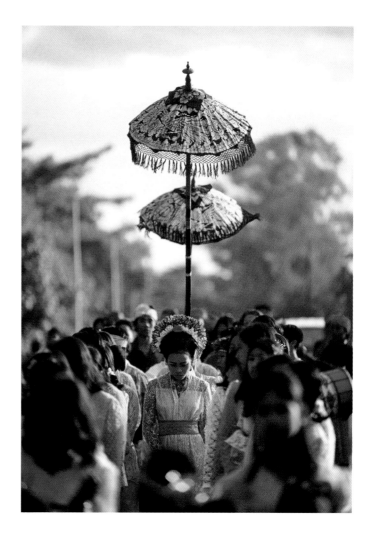

Drummers lead a wedding procession (left) on Lombok, one of the Lesser Sunda Islands of the vast Indonesian archipelago, where Muslim and Hindu traditions are intertwined. Beneath a traditional canopy, the bride (above) follows the musicians, walking with female attendants to the groom's home, where a Muslim cleric will perform the relatively short Islamic ceremony — an offer and acceptance of the wedding contract by the bride and groom before two witnesses, followed by several prayers.

INDEX

STEVE RAYMER

On my first trip to Moscow, in 1986, fresh from a year of studying about the Soviet Union at Stanford University, I felt primed to become the *National Geographic's* representative to a Cold War rival that I had only seen at arm's length in East Africa, Afghanistan, and parts of Southeast Asia. How little did I know. Getting close to Russians – with a camera and as an American working in an unfamiliar and sometimes hostile culture – was one of the most challenging tasks of my career, now entering its fourth decade. And when the Soviet Union collapsed in 1991, my wife, Barbara, and I had ringside seats to one of the momentous events of the 20th century. The collapse of the Soviet empire underscored once again what a privilege, and a responsibility, it is to be a journalist and all that that entails – being fair, accurate, and impartial.

There are many definitions of photojournalism, some more academic than others. University colleagues call it the fusion of the verbal and the visual, where words serve as a counterpoint to images, recreating an unrehearsed moment in the minds of our readers. But it is difficult to speak of photojournalism in cool and detached tones, in part because I have been in the midst of wars and famines, oil fields and opium poppy patches, and the sacred rituals of many faiths, trying to convey what I saw and what I had learned through my camera. It is no precise task.

In the simplest terms, photojournalists record moments of truth, moments that are often overlooked and sometimes too painful for the ordinary person to witness. In a larger sense, photojournalists chronicle society's achievements and its failures. They bear witness to history. And they give testimony in the court of public opinion that things happened, from something as horrific as the Khmer Rouge genocide in Cambodia to the simple wedding of a Native American couple on an impoverished Indian reservation in my home state of Wisconsin. I have seen both. Thanks to photojournalists, we have an enduring record of life's stories rendered in shadow and light and told through a universal language – the language of human emotion.

Of course, I couldn't put much of this into words when I left the University of Wisconsin, equipped with Bachelor of Science and Master of Arts degrees and my military service behind me, to join the staff of the *National Geographic* in 1972. Over the next 23 years, I would travel to some 85 countries, reporting on famines in Bangladesh and Ethiopia, the humanitarian work of the International Committee of the Red Cross in war zones around the world, and the illegal trade in endangered animals. Legendary editors like Bill Garrett and Bob Gilka gave me the creative freedom and financial support to undertake stories that were months in the making, including a year-long project on "The Opium Poppy: The Plant for Good and Evil." Their standard was a simple one: excellence.

In the end, my photographs illustrated some 30 *National Geographic* articles and numerous National Geographic Society books. With my wife, Barbara, I also wrote and photographed *St. Petersburg*, a 1994 book about Russia's imperial capital. And then it was time to move on. In 1995, I joined the faculty of Indiana University School of Journalism in Bloomington, teaching photographic reporting and editing, international newsgathering, and media ethics. With the university's encouragement, I also have done two photographic books about Vietnam, a country that I first saw as a young man in the midst of war and have now come to appreciate in a way I never thought possible when the Vietnam War ended in 1975. The publication of *Living Faith* confirms that I remain in Asia's embrace, lured by its exoticism, industriousness, pain, and many creeds.

ASIA IMAGES GROUP

Asia Images Group is a full service photographic agency specializing in images of the Asia-Pacific region. Our strength lies in the synergy created between three operating divisions working together as one company to meet the needs of clients worldwide. Asia Images Group (AIG) is made up of the following three operating divisions:

Asia Images Stock licenses images of Asian subjects and situations to advertising, corporate, design, and editorial clients in Asia and the rest of the world. Many of the images in this book are available for editorial and commercial use. In addition, clients can browse, search, license, and download our entire image collection via the internet. All images are available in high resolution digital format for immediate delivery worldwide.

Asia Images Network has photographers throughout Asia available for editorial, corporate, and advertising assignments. The Network saves clients time, money, and hassle by liaising between the clients needs for specific assignment photography in distant locations and photographers already based in major cities in Asia.

Asia Images Editions is our publishing division, specializing in publishing high quality photography books on Asian subjects and destinations. *Living Faith: Inside the Muslim World of Southeast Asia* is Asia Images Editions' first book.

For more information about Asia Images Group, please visit our website at www.asia-images.com, or email us at info@asia-images.com.